READING the Landscape

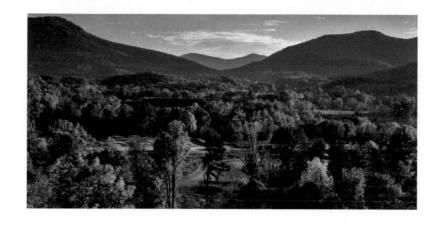

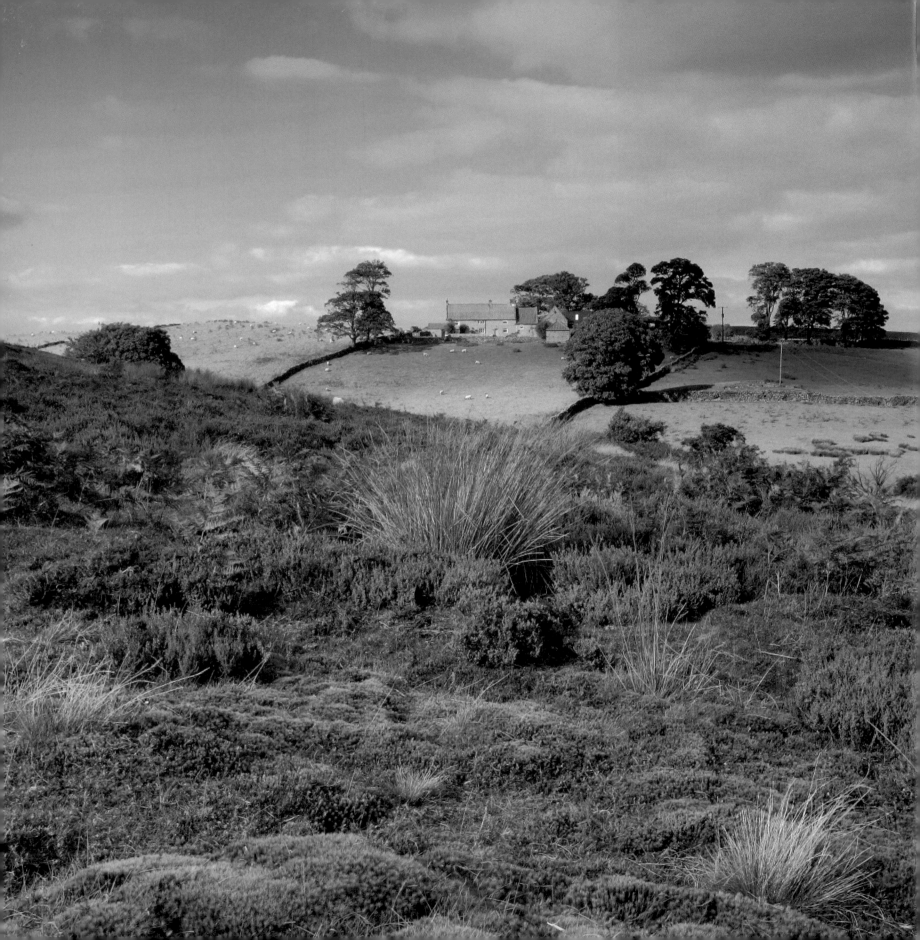

READING the Landscape

an inspirational and instructional guide to landscape photography

PETER WATSON

photographers'
pip
institute press

First published 2009 by
Photographers' Institute Press
an imprint of
The Guild of Master Craftsman Publications Ltd
Castle Place, 166 High Street,
Lewes, East Sussex BN7 1XU

Text and photographs © Peter Watson, 2009
© in the Work Photographers' Institute Press, 2009

ISBN: 978-1-86108-652-5

A catalogue record for this book is available from the British Library.

Associate Publisher: Jonathan Bailey
Production Manager: Jim Bulley
Managing Editor: Gerrie Purcell
Project Editor: Louise Compagnone
Managing Art Editor: Gilda Pacitti
Designer: Terry Jeavons

Set in Interstate

Colour origination by GMC Reprographics
Printed and bound in Kyodo Nation Printing in Thailand

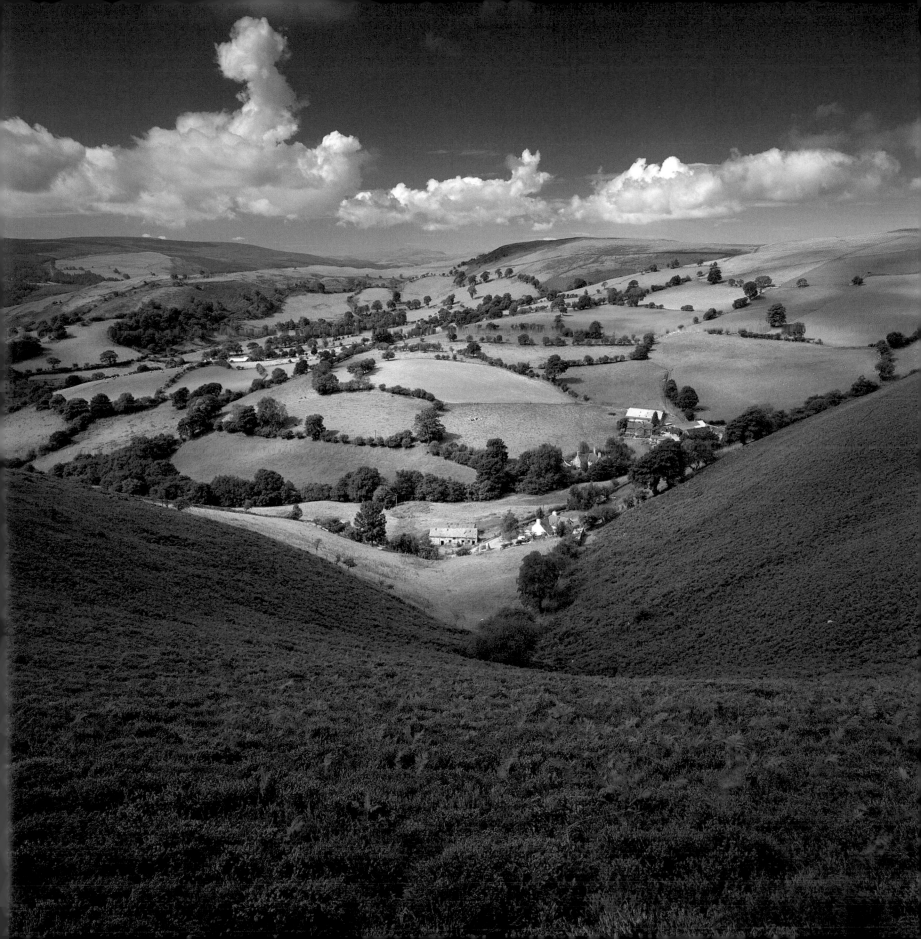

Contents

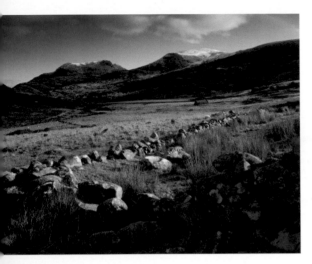

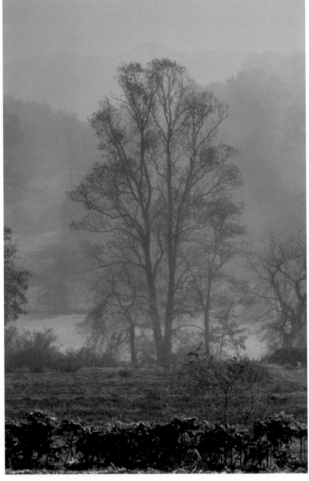

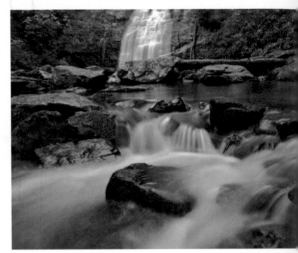

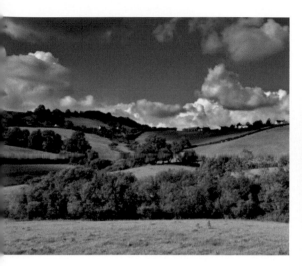

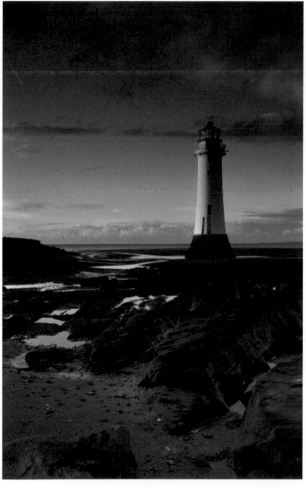

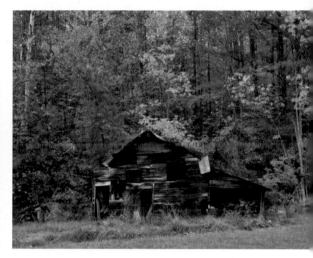

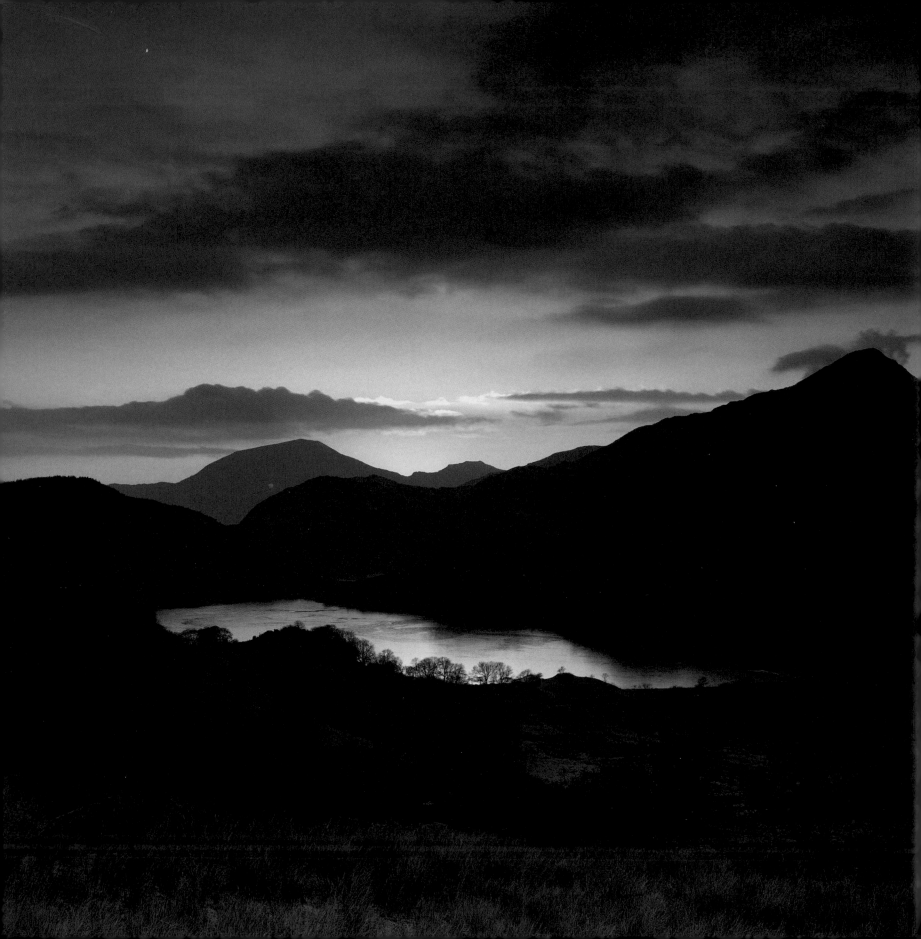

Introduction

Photography has, quite rightly, often been described as painting with light. Both painters and photographers are indeed practitioners of visual art but, similar though the two art forms are, there is a point at which they become divergent. Unlike the photographer, the painter is able to observe, interpret and embark on the creation of a picture in what is essentially one seamless act. The making of a photograph, however, is often a more prolonged process which, for a landscape image, can span many hours, days, weeks – and frequently much longer. This is because the outdoor environment is beyond our control, it can be demanding and there are no shortcuts. To succeed we must observe the landscape and create and impose order on a subject whose finer qualities are both ubiquitous and elusive.

This can be a challenge because – I can tell you from experience – there is more to the landscape than meets the eye. It is not, at first glance, what it appears to be. The fields, trees, mountains, rivers and lakes which are so apparent to the casual observer are, in essence, a collection of graphic lines, patterns, shapes, colours and textures. These are the elemental building blocks of a landscape image which, together with the sky and light, form the basis of the photographer's raw materials. How effectively we use those materials is intrinsically linked to our observation, reading and interpretation of the landscape. It is not only what we see; what makes the difference is how we see.

Throughout this book I have endeavoured to explain and demonstrate, by example, how I observe and interpret the variety of subject matter which is to be found across the length and breadth of the landscape. I hope, therefore, that by reading the pages to follow you will gain a comprehensive and rewarding insight into not only the many creative opportunities that exist, but also to my approach to reading the landscape.

Peter Watson

LLYN GWYNANT, SNOWDONIA, WALES
I frequently visit this hauntingly beautiful valley which lies deep in the heart of the Snowdonia Mountains. It never disappoints. There are some places which are simply sublime; they demand and reward the attention of the photographer. Llyn Gwynant is such a place.

CAMERA **Tachihara 5x4in**
LENS **Super Angulon 150mm (Standard)**
FILM **Fuji Provia 100**
EXPOSURE **1sec at f32**
WAITING FOR THE LIGHT **1 hour**

CHAPTER ONE
Mountains & the wilderness

Mountainous landscapes and wildernesses are, I believe, among the most challenging and difficult subjects to photograph. I say this, not because I wish to paint an overly pessimistic picture, but as a result of my early experiences of failure – which I recall with more than a twinge of discomfort. Imagine the situation: you escape from the urban sprawl, drive high into the mountains, park up and embark on a journey of discovery. The air is clean and refreshing, the trickle of a stream the only sound and grazing sheep your only company. You find yourself surrounded by majestic peaks and the sight of them takes your breath away. The splendour is all-embracing so you set up your camera and capture the marvellous spectacle. A few days later, hoping to relive the moment, you look at your photographs with bated breath. Then, with a sigh of frustration, you wonder what happened to the panoramic vista, the towering mountains or the sprawling forest? It's all there but, as a photograph, it is barely recognizable because it somehow lacks the scale and impact of the original scene and is hugely disappointing. So, what went wrong? It was a question I frequently asked myself during the early stages of my learning experience.

Transferring a vast and imposing three dimensional landscape onto a small piece of two dimensional film or image sensor isn't straightforward. Three into two doesn't go, so we have to compensate for this and make the most of the tools we have available. How the photograph is structured – from the closest foreground to the distant horizon – is critically important, as is the light and shadow falling on it. Ultimately, it is this combination of composition and light that will determine the outcome of a final image. This type of subject is demanding, but success is possible because it can be achieved through practice and experience. These can be acquired and developed over time – with, of course, the right technique, which I will attempt to demonstrate on the following pages.

LANGDALE, CUMBRIA, ENGLAND
I hadn't planned to make this photograph but I was drawn to it by the light. It was the shadow cast by the avenue of trees and the angled sunlight falling across the mountain that compelled me to stop and set up my camera. I would have welcomed a little more cloud and a stronger hint of autumn, but that perhaps will be next time.

CAMERA **Tachihara 5x4in**
LENS **Rodenstock 120mm (Semi Wideangle)**
FILM **Fuji Provia 100**
EXPOSURE **1/2sec at f32**
WAITING FOR THE LIGHT **45 minutes**

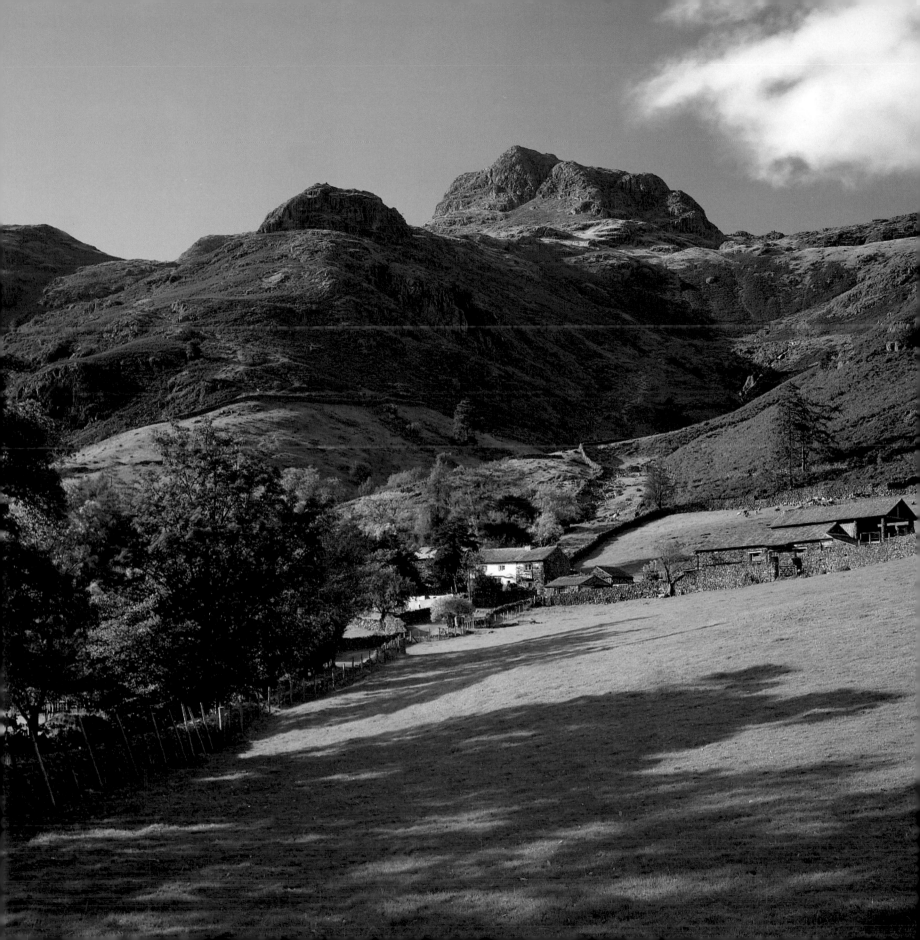

A Demanding Environment

The Wester Ross region of the Scottish Highlands is a land of spectacular lochs and mountains. Hauntingly beautiful it is a photographer's paradise, but its beauty comes at a price. There are few roads in the region and long treks are necessary if a full exploration of the terrain is to be made. Added to this is the challenge of the weather, which sweeps in from the Atlantic and is unpredictable and changeable – particularly during the winter months. I once spent three weeks there one November and it would literally alternate between sun, showers, gales, sleet, hail, plus, for light relief, the occasional rainbow. From one minute to the next the chameleon-like sky would completely change its appearance. It was fascinating to watch but, I have to say, also a challenge to work in such conditions.

This photograph of Culnacraig, taken along the north shore of Loch Broom, was finally achieved after five consecutive days of watching and waiting. At various intervals throughout each day I would climb the hill (which, I should add, had the miraculous ability to defy the laws of gravity because I swear it became steeper and higher with every ascent!) and survey the landscape.

My hopes would rise only to plummet as rain clouds rolled in to foul the sky. And so it continued until at last on the final day it all fell magically into place. It had been a testing time and, after several relentless days, I was on the verge of giving up. I was, it must be said, very, very fortunate because I doubt I could have maintained the punishing routine for much longer.

There are many photographers who feel that good fortune has a habit of deserting them as soon as they venture out to contend with the many challenges and vagaries of the landscape – and I can sympathize with such a view. I can look back on many mishaps, near misses (sometimes by a split second) and, with hindsight, squandered opportunities; but I can honestly say that my recollections carry no lingering regrets. This is because disappointments are part and parcel of the landscape photographer's experience. We operate in a demanding environment; it is always unpredictable, sometimes frustrating but also incredibly rewarding. Without the lows there would be no highs, no sense of achievement. The successes always eclipse the disappointments, and these are the memories I take with me.

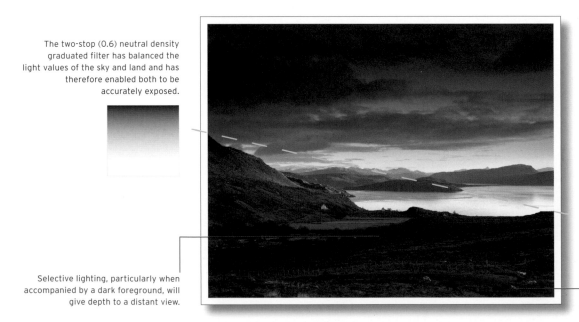

The two-stop (0.6) neutral density graduated filter has balanced the light values of the sky and land and has therefore enabled both to be accurately exposed.

81C warming filter

If sheep or cattle are present, watch for movement when using long exposures because blurred animals will look distracting. Ensure also that they are not cut in half at the edge of the frame.

Selective lighting, particularly when accompanied by a dark foreground, will give depth to a distant view.

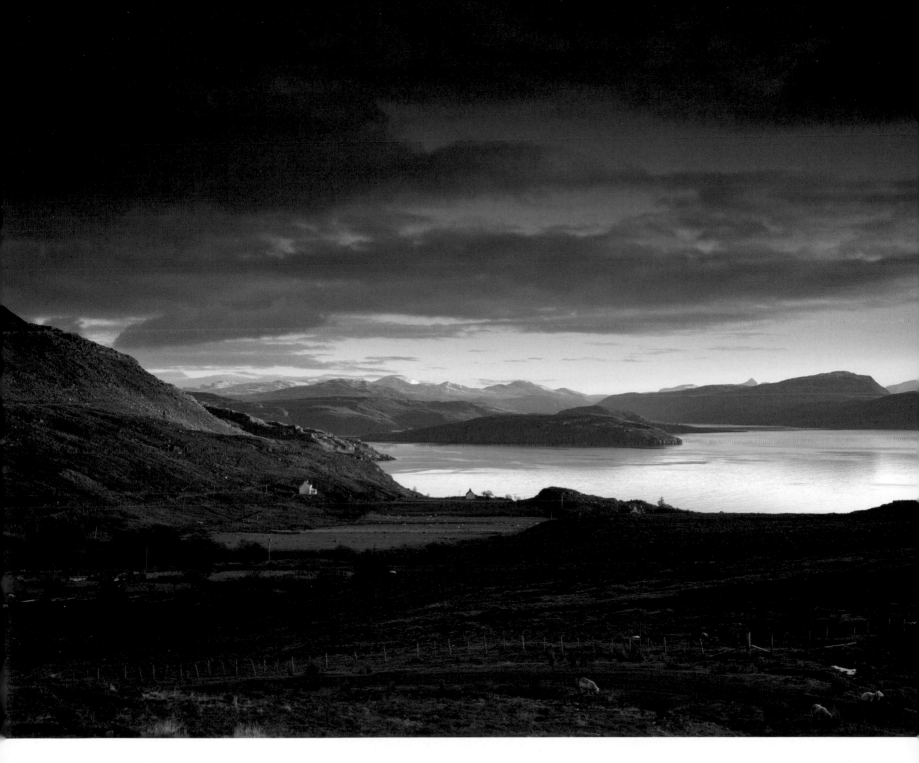

CULNACRAIG, WESTER ROSS, SCOTLAND

CAMERA **Tachihara 5x4in**
LENS **Super Angulon 90mm (Wideangle)**
FILM **Fuji Provia 100**
EXPOSURE **1/2sec at f32**
WAITING FOR THE LIGHT **5 days**

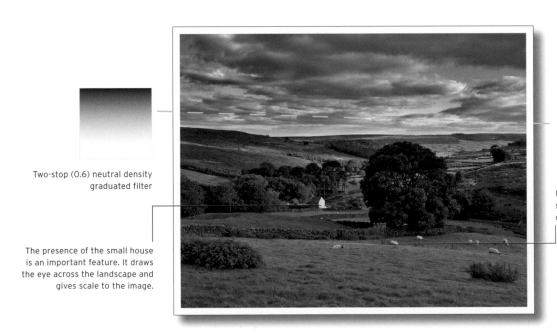

A Hidden Landscape

Britain's moors are, I believe, one of its most underrated treasures. To wander through these glorious wildernesses can be an invigorating and, for the photographer, a very fruitful and productive experience. What I particularly like about these vast open spaces is the fact that they remain attractive throughout the year and in all types of weather. This is due to the pronounced regional variations that can be found across the country, together with the existence of a healthy and vibrant biodiversity. This gives the moors a constantly changing appearance which, if you add seasonal and changeable conditions, virtually guarantees there will always be something new to see and, of course, to photograph.

There can also be surprises hidden away within these wildernesses. If, for example, you drive north across Danby Low Moor from Danby village there will be a clear, uninterrupted view of what you might reasonably imagine to be the entire moorland landscape. But this is not the case. If, like I did, you take one of the footpaths towards Clitherbeck, you will discover a valley surrounded by a hilly terrain that is virtually invisible from the road. It was with childlike enthusiasm that I eagerly followed a path and, to my delight, found what seemed to be a hidden world – another landscape buried deep in the landscape. My luck was in because my visit (late August) had been preceded by a week of frequent, heavy showers which had given the moor a fresh, verdant appearance. Everywhere was bursting with vitality and the rich, green hillside provided me with the perfect foreground onto which I could build a more expansive view.

The distant farmhouse is an important element in this image because it draws the eye to the centre of the picture and creates distance and depth. Buildings are very useful in this respect, particularly if they are isolated and in keeping with the environment they occupy. They can act as a cornerstone in a landscape and, if you find an attractive building nestling amongst a hilly or mountainous terrain, it can pay dividends to thoroughly investigate the surrounding area.

Two-stop (0.6) neutral density graduated filter

The presence of the small house is an important feature. It draws the eye across the landscape and gives scale to the image.

Use shadow and low sidelighting to define the contours of a hilly terrain.

DANBY LOW MOOR, NORTH YORKSHIRE, ENGLAND

CAMERA **Tachihara 5x4in**
LENS **Super Angulon 90mm (Wideangle)**
FILM **Fuji Provia 100**
EXPOSURE **1/4sec at f32**
WAITING FOR THE LIGHT **30 minutes**

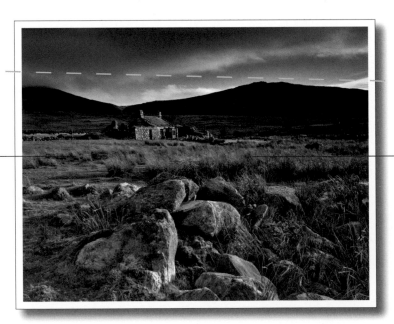

A Compromised Solution

When possible, and appropriate, I like to emphasize foreground in a photograph. If I can I will move in close, use a wideangle lens and build the image around a large, dominant object which might be positioned no more than two or three feet from the camera lens. Sometimes a picture might consist almost entirely of foreground, but there is no hard and fast rule and my approach to composition is largely intuitive and subjective.

When I first discovered this splendid old farmhouse I was drawn to a crumbling dry-stone wall which you can see in the distance, in front of and at a right angle to the ruined building. I instinctively headed straight to it and positioned it centrally in an attempt to use it to lead the eye towards the cottage. Strong as this arrangement was, I could see a problem arising because of the light. The low, slanting rays of the winter sun cast a dark shadow across one side of the wall. The contrast was harsh and in fact quite unpleasant. Despite my best efforts I could find no solution and, to my regret, was forced to abandon this composition and embark on a determined search for an alternative.

It wasn't that simple because the field in front of the farmhouse was an arduous combination of muddy morass and trouser-snagging thorn bushes. It was by no stretch of the imagination the type of terrain I would willingly choose to scour, particularly in midwinter during a howling gale. However, overcoming such deterrents is part of the challenge, and it is always satisfying to succeed under difficult conditions. So I buttoned up my jacket, firmed my resolve and addressed the task at hand.

Eventually I settled on the arrangement you see here. I am not dissatisfied with my choice but the picture is a compromise. The scarcity of interesting foreground in front of the cottage, together with the angle of the light, forced me to adopt a somewhat distant position which has resulted in the attractive farmhouse being relegated to a somewhat subordinate role. It has now become secondary to the foreground, which wasn't my intention, but the building still commands attention. On balance I think the compromised solution has worked out quite well – sometimes when Plan A doesn't work, you simply have to move on and switch to Plan B.

Two-stop (0.6) neutral density graduated filter

The open pathway leading to the farmhouse from the front of the picture helps to take the viewer into the centre of the photograph. It also improves the balance between the foreground and background elements.

To prevent the foreground from becoming too dominant, I chose a viewpoint that gives you a clear, uninterrupted view of the middle and far distance.

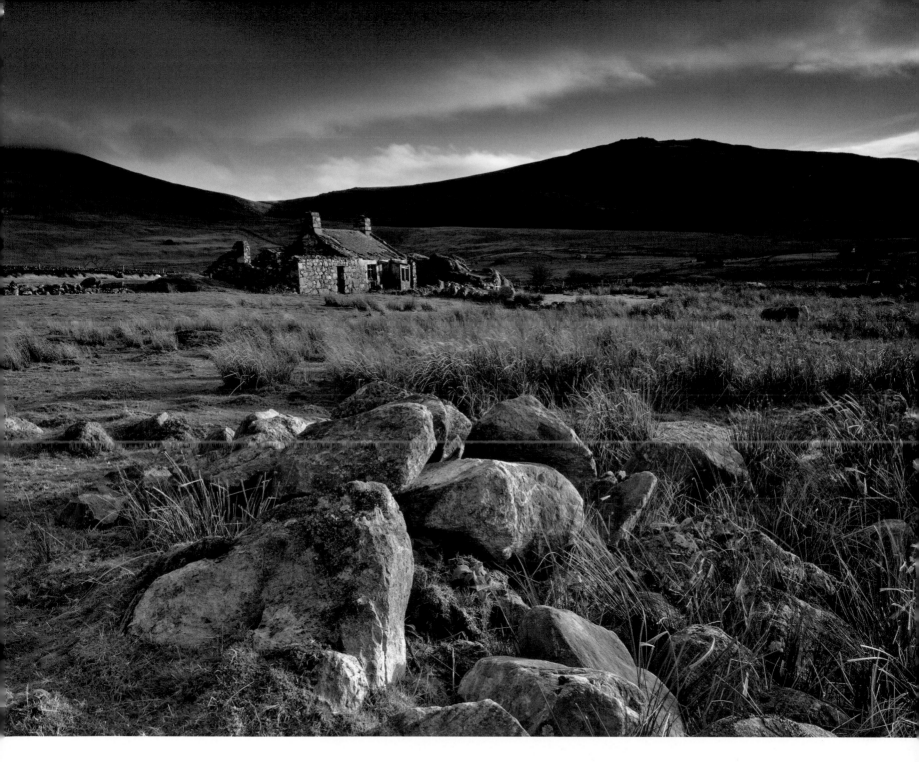

NEAR LLANLLYFNI, GWYNEDD, WALES

CAMERA **Tachihara 5x4in**
LENS **Super Angulon 90mm (Wideangle)**
FILM **Fuji Provia 100**
EXPOSURE **1/2sec at f22**
WAITING FOR THE LIGHT **40 minutes**

Using Shadow

Sun, showers, crisp blue sky, a scattering of cumulus clouds and a rugged mountain range, it was almost everything I could have wished for. I say almost because the picture was looking a little incomplete; the lower portion lacked interest and, despite an extensive search, I could find nothing to fill the void. However, I didn't want to waste the opportunity because otherwise everything else looked rather enticing.

After some deliberation I chose an elevated position that provided a good view of the expansive mountain pass. The floor of the valley added nothing to the photograph but clouds were rolling across the sky immediately above me and I was able to use passing shadows to obscure the featureless terrain. Shadow can be helpful in this respect, particularly in larger views, because it can be used to frame or support a subject and direct the eye to specific parts of a picture.

There was a stiff breeze blowing and clouds were billowing past at a brisk pace which would, if necessary, have enabled me to bide my time and wait for the right moment. The cloud in the corners couldn't have been better placed and I was fortunate that their appearance coincided with the dark shadow falling across the bottom of the picture. But that was only two out of three because I also wanted splashes of light on the mountain face with the farmhouse brightly lit. I thought I was going to be there for the long haul but miraculously the elements combined to order and I was able to make three exposures before the clouds passed.

This was the perfect sky for polarizing. The filter has enriched the blue and accentuated the cloud. It has also increased the contrast which, in a rugged mountain vista, can sometimes help to create a sense of drama. Here the polarizer has darkened the shaded areas and boosted the warm colour of the mountains which has given the photograph impact and vitality. It is a very, very useful filter and I would never be without it.

The presence of the farmhouse is essential. It gives scale to the photograph and conveys the size and grandeur of the mountain. It was also important that it was brightly lit and not in shadow. Always watch and wait for the perfect moment.

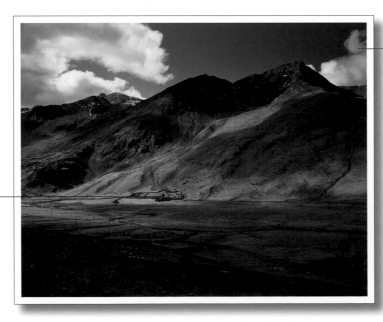

The cloud in the corner has partly obscured the uneven darkening of the sky, which can happen when using a polarizer.

The polarizing filter has darkened the blue sky without affecting the brilliance of the clouds. It has also enriched the colour of the mountain face and has slightly increased contrast which heightens the picture's drama and impact.

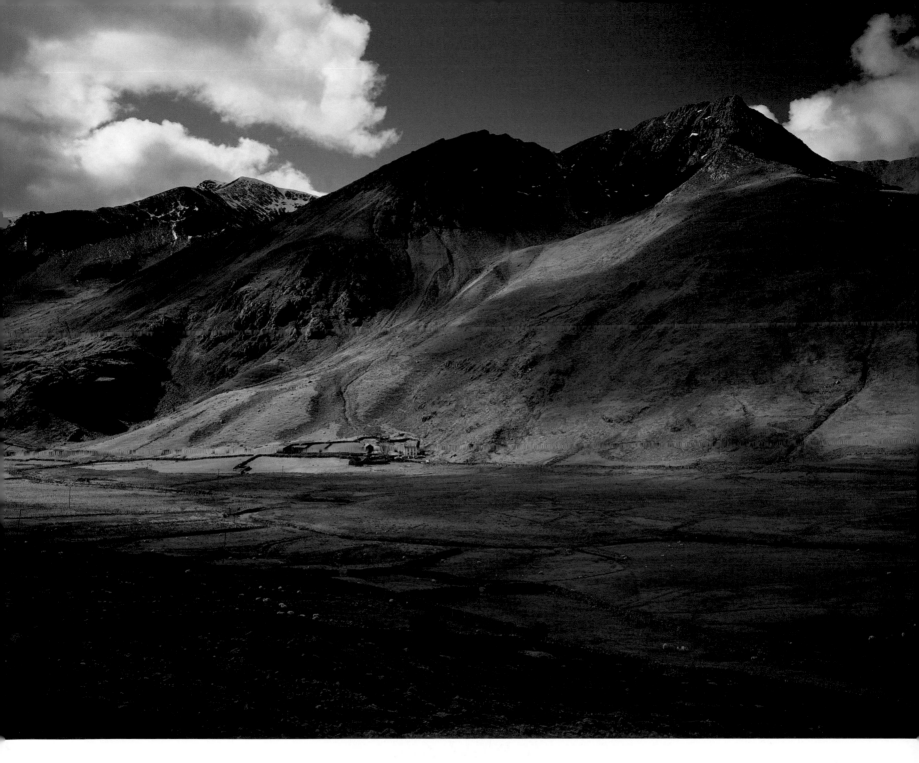

NANT FFRANCON, SNOWDONIA, WALES

CAMERA **Tachihara 5x4in**
LENS **Super Angulon 90mm (Wideangle)**
FILM **Fuji Provia 100**
EXPOSURE **1sec at f32**
WAITING FOR THE LIGHT **10 minutes**

A Graphic Portrayal

One of the quieter, less visited parts of the Snowdonia National Park lies between Rhydd-Ddu and Talysarn and, as most of it is uninhabited, the landscape here has a timeless, unspoilt quality. I visit the area often and am always fascinated by its constantly changing appearance, which is a result of the capricious weather that prevails in this mountainous area. It is engrossing to watch as scuttling clouds create patterns of light and shade that waltz over the hilly terrain briefly to give centre stage to less prominent features. I will happily spend many hours watching this dancing extravaganza because, in the right light, every tree, rock and indeed facet of the landscape becomes a potential subject.

I have photographed Llyn Dywarchen many times, from various angles, at different times of day and year and in every type of light. It is a testament to the beauty and diversity of this corner of Snowdonia that despite my voracious foraging I don't

as yet feel that I have exhausted the possibilities. In this image the lake and mountains act merely as a backdrop to the less spectacular, but equally striking, stone wall and isolated tree.

My choice of viewpoint was influenced by the quality of light and the position of the sun. The low backlighting creates just enough contrast to retain detail in the highlights and shadows, yet it is sufficient to give the crumbling wall and long grasses a three dimensional quality. This graphically portrays the raw, rustic nature of Snowdonia's wilderness.

A hilly or mountainous terrain will always respond to broken sunlight. Different combinations of light and shade can be used to spotlight specific features and reveal the character of a wilderness landscape. Lighting effects can be unpredictable and short-lived. Watch and wait for the optimum moment.

Leafless trees often appear as near silhouette and are, therefore, not affected by the presence of a neutral-density grey graduated filter. Here the two-stop (0.6) filter has been positioned horizontally which has improved the sky, but has not adversely affected the appearance of the tree.

Avoid harsh contrast in a backlit scene by using broken cloud to soften the light. This will ensure that detail is retained in both the darkest and lightest parts of the landscape.

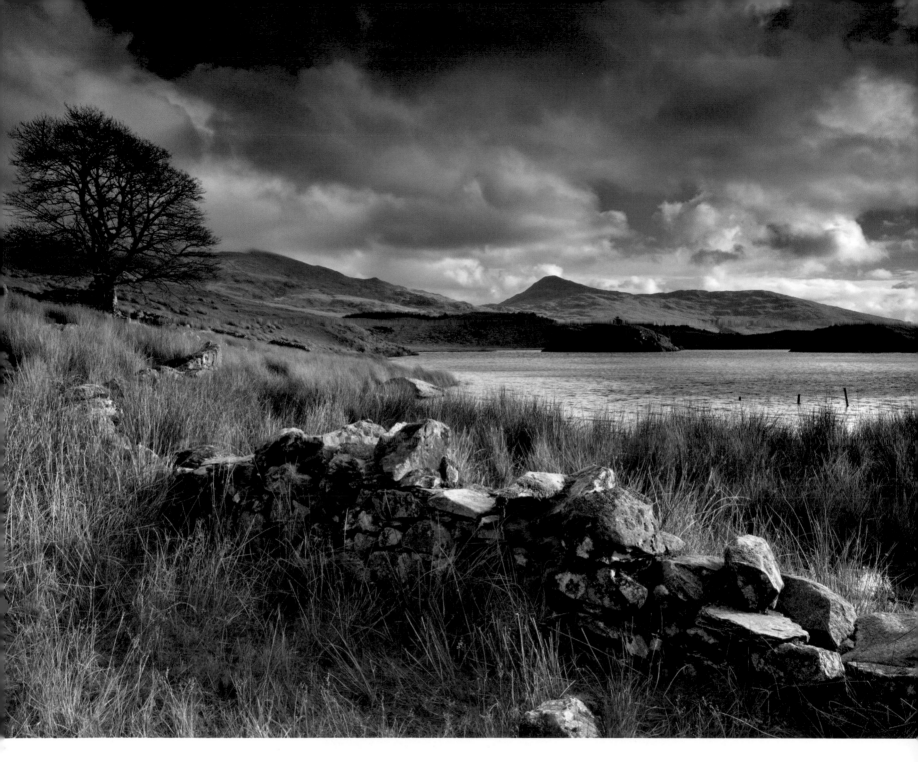

LLYN DYWARCHEN, SNOWDONIA, WALES

CAMERA **Tachihara 5x4in**
LENS **Rodenstock 120mm (Semi Wideangle)**
FILM **Fuji Provia 100**
EXPOSURE **1sec at f22**
WAITING FOR THE LIGHT **30 minutes**

Creating Depth

Northern Scotland is a land of sprawling wilderness. There is a stark, natural beauty to its landscape and an enduring, timeless quality in its lochs and mountains. Captivating images abound but the vastness and scale of the region can be a challenge to photograph. In order to capture the character of wilderness, an impression of space and distance must be introduced into the picture. This can be achieved by making use of interesting and attractive foreground elements.

As discussed earlier in this chapter, I like to include a strong foreground when appropriate, and I do this by using a wideangle lens and adopting a low position as close as possible to the foreground object(s). Not only will this lens, as its name implies, provide a wider than normal angle of view, it will – in addition to accentuating foreground – also stretch distance. The effect of this is that depth, scale and distance will all be brought emphatically into the picture. The viewer is thus given a sense of realism, of being there. It is this visual journey, from the front through to the back of the image, that creates the illusion of depth.

It is important that all elements of a photograph exist in equilibrium and, while foreground has a role to play, it shouldn't be allowed to dominate the picture. Having said that, it is quite surprising how much can be included without it becoming too overwhelming. If you look at the photograph opposite you will see that although half of it consists of foreground (which is fairly typical of my style for this type of image) the picture is evenly balanced. My advice therefore is: when photographing an expansive view don't hesitate to make the most of foreground. Seek it out, build your picture around it and use a wideangle lens to emphasize it.

A photograph which lacks a sense of depth will look flat and uninteresting and this will be particularly apparent with an open, sweeping view where scale and distance are important elements. Including strong, eye catching foreground in an image will give it a three dimensional quality, as well as impact.

One-stop (0.3) neutral density graduated filter

The darker tonal quality of the distant mountain range strengthens its presence. This tonal variation can often be achieved by positioning a one-stop (0.3) neutral density graduated filter at horizon level and allowing it to darken both sky and mountains.

Polarizer (fully polarized)

The combination of the polarizer and warming filter has enriched the colour of the moorland grass. The filters have also improved the colour and texture of the foreground rocks.

81C warming filter

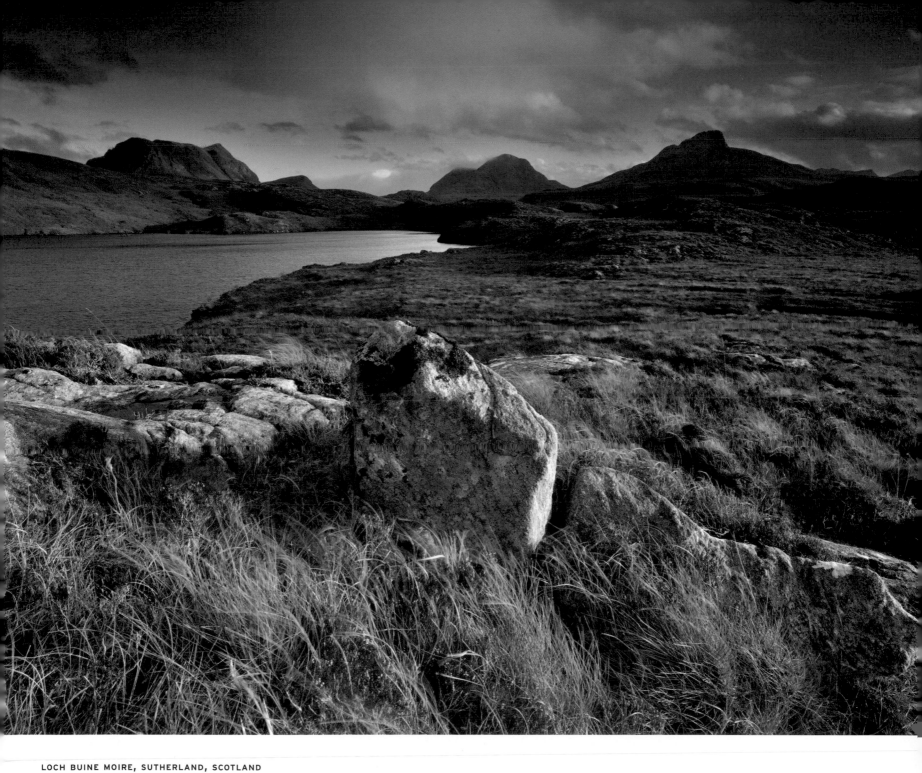

LOCH BUINE MOIRE, SUTHERLAND, SCOTLAND
CAMERA **Tachihara 5x4in**
LENS **Super Angulon 90mm (Wideangle)**
FILM **Fuji Provia 100**
EXPOSURE **1/2sec at f22½**
WAITING FOR THE LIGHT **1½ hours**

The Effect of Light

Looking at this photograph of the Assynt mountains, you might assume that a steep and arduous climb was needed in order to reach this lofty viewpoint, but that wasn't the case because it is in fact easily approached. A narrow road passes through the hills (you can see it in the bottom left of the picture) and provides stunning views of the rugged landscape. I will always remember turning a bend in the road to be greeted by this magnificent sight. I was utterly compelled to stop and take it all in.

This type of expansive view responds well to low sidelighting, particularly in a sky of passing, broken cloud. It is fascinating and also an invaluable experience to spend time watching how the appearance of the landscape is transformed as different combinations of light and shadow play across a mountainous terrain. For new photographers this is an important and often indispensable part of the learning curve and I urge you to seek out a similar location and study this effect in detail. It is a revelation to witness at first hand the relationship between land and light. Understanding this relationship lies at the heart of successful landscape photography and there is no better way to familiarize yourself with this than simply to stand, watch and absorb the effect that passing light and shade has on the ground below.

The direction of the light is also important. In order to delineate the contours of a landscape I prefer to use low level sidelighting. This low-angled light penetrates the landscape and reaches parts which normally go unnoticed; it gives the land shape and depth and reveals and emphasizes its hidden undulations. If landscape is your subject of choice, then it is essential that you understand the profound effect light has on it and use this knowledge to your advantage. It is without doubt the most powerful tool you have.

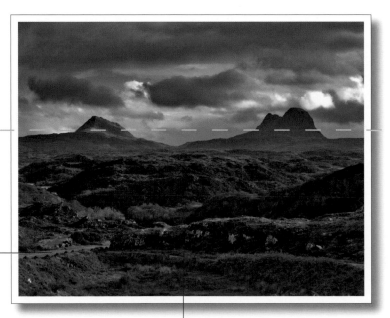

As a rule I prefer to exclude roads from a rural landscape but in this instance I think the presence of the narrow road provides additional relevant information about the nature and scale of the landscape.

Two-stop (0.6) neutral density graduated filter

Again I have intentionally allowed the neutral density grey graduated filter to fall below the level of the mountains to give them a more pronounced appearance.

Low, directional sidelighting is essential if a hilly terrain and distant view is to be effectively depicted.

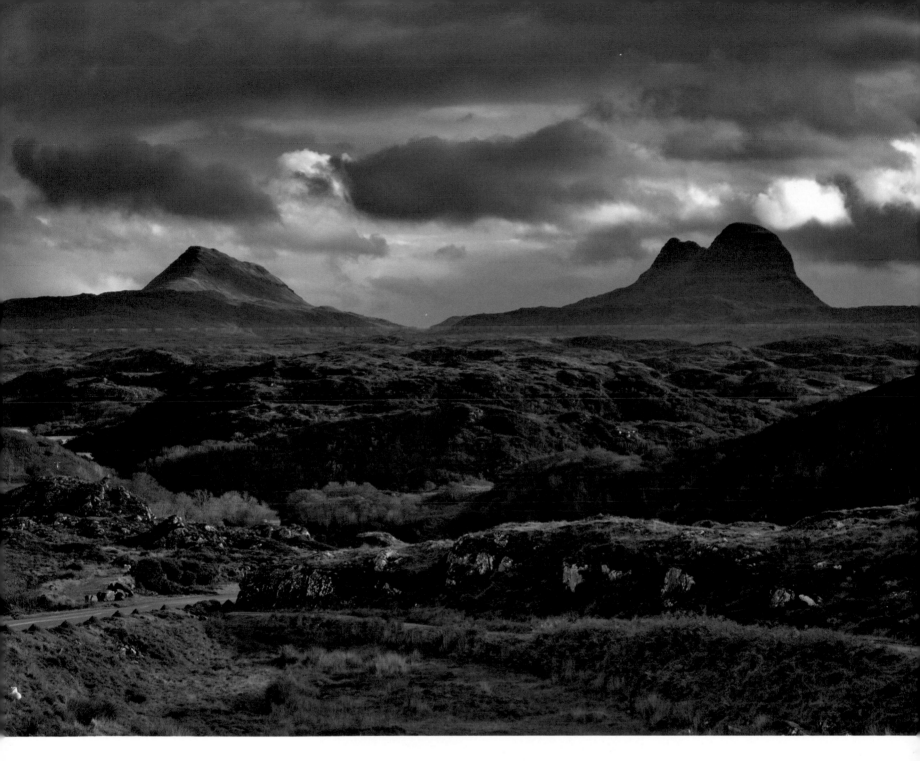

ASSYNT, SUTHERLAND, SCOTLAND

CAMERA Tachihara 5x4in
LENS Super Angulon 210mm (Short Telephoto)
FILM Fuji Provia 100
EXPOSURE 1/2sec at f32
WAITING FOR THE LIGHT 2 hours

An Unstructured Quality

Discovering this derelict barn was, I must say, a most welcome and uplifting moment. I was in need of something to raise my spirits because I'd been driving and walking through forests and mountains for several hours but had little to show for it. It had been a frustrating experience – no cloud in the sky when I wanted it, no water in the waterfall where I wanted it. It was nothing to complain about really, it had just been one of those almost-but-not-quite days until, that is, I spotted the tumbledown shed nestling in the wooded valley.

I sensed that my frustrations were about to end because my sighting of the old building coincided with a sudden improvement in the sky. A brisk breeze was blowing which brought with it some welcome cloud and on top of that the aspect of the view was perfectly angled in relation to the position of the sun. All the components were falling flawlessly into place and, as I took stock of my windfall, the disappointments of the previous few hours vanished from my mind. Suddenly the day was looking promising.

The position of my viewpoint was influenced by the dark patch of foreground. This is a key feature because it gives the picture depth. Remove it and the photograph suddenly looks flat and two dimensional. My other consideration was the somewhat unstructured appearance of the landscape. It doesn't, in my view, detract from the appeal of the photograph, but there is no doubt that the presence of the barn is absolutely essential. Remove this and the jumbled growth of the wilderness becomes all too apparent. The building is the cornerstone of the picture and prevents it from becoming little more than an image of tangled trees, bushes and a multitude of other flora.

A wilderness can sometimes be too wild. If it is to be photographed successfully, elements of shape and form should be introduced to balance the disarray.

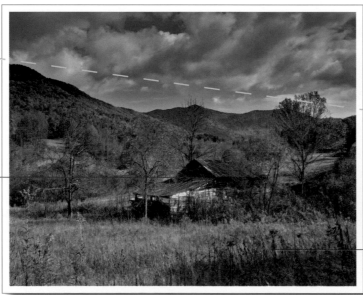

Two-stop (0.6) neutral density graduated filter

To show a building ensconced in its environment, place it in a central position. Here, completely surrounded by wild overgrowth, the barn is depicted as losing the battle to survive against the forces of nature, which is appropriate to the theme of the photograph.

In the absence of other features, a dark patch of foreground can be used to create depth in an image.

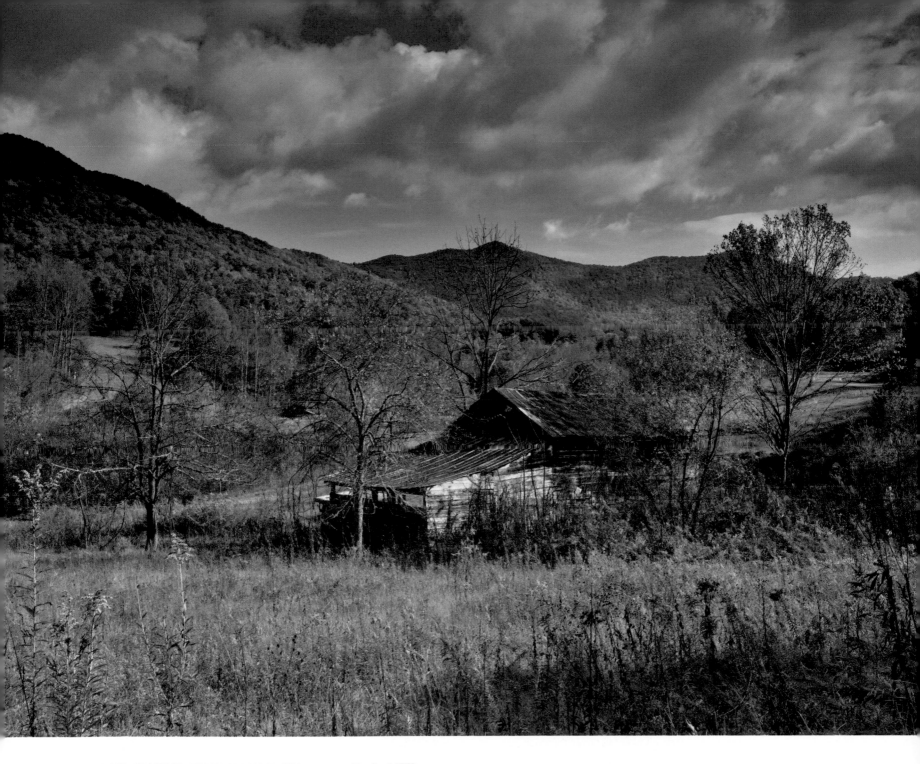

LEATHERMAN GAP, FRANKLIN, NORTH CAROLINA, USA

CAMERA **Mamiya 645ZD**
LENS **Mamiya 80mm (Standard)**
FILM **Image sensor**
EXPOSURE **1/4sec at f22**
WAITING FOR THE LIGHT **30 minutes**

The Missing Link

Buildings are, as I have previously discussed, a potent force in rural images. Photograph a landscape with a building in it and the viewer's attention will be immediately drawn towards it. This is often useful but can also be a hindrance and I am, therefore, always cautious about where I position them. A carelessly placed building can distract the eye and upset the rhythm in a photograph. An extreme position to one side of a picture might, for example, look a little unsettling unless the building is counterbalanced by an object of equal interest on the opposite side of the image. It is not essential that a second building be used to create symmetry, it could be anything which catches the eye, such as a tree, mountain or even a cloud; you just need something to make an equal contribution to the arrangement.

Buildings, or indeed any signs of population, are few and far between along the northern tip of Scotland. This is the perfect land for timeless, evocative images but it can be challenging, particularly across the stretches of flat, open moorland, which are common in parts of this region. The moors here are enriched with long, colourful grasses that always photograph well; unfortunately grass on its own, however colourful it may be, rarely makes a complete picture. Something more is usually required, and I was faced with such a predicament during my last visit to this remote part of the country. Whatever composition I chose, the picture tended to peter out towards the horizon. I needed something in the distance to draw the eye as well as maintaining interest across the entire image.

Thirty minutes later I found the answer. That tiny crofter's cottage – miniscule in comparison to the rest of the picture – was all that was necessary. This is the missing link because it draws the observer into the picture and then onto the horizon. This is a simply structured image where the scale and remoteness of the Scottish Highlands have been brought into perspective by the most basic of elements – an isolated and diminutive building standing proudly on the distant horizon. Yes, a potent force indeed.

Curiously, the size of a building in a photograph doesn't seem to be particularly important because it appears to possess a magnetic quality that, irrespective of size, will attract the viewer's eye.

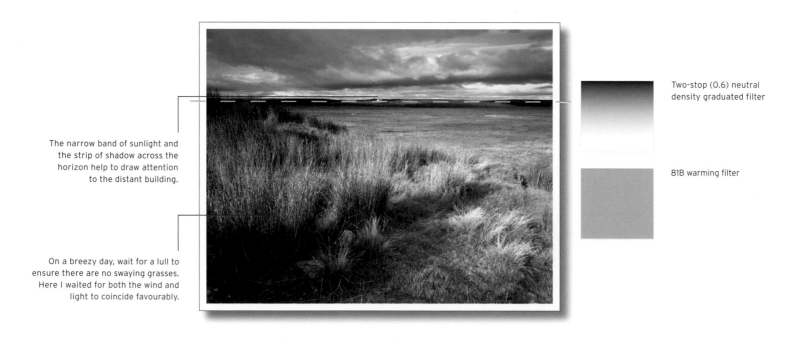

The narrow band of sunlight and the strip of shadow across the horizon help to draw attention to the distant building.

On a breezy day, wait for a lull to ensure there are no swaying grasses. Here I waited for both the wind and light to coincide favourably.

Two-stop (0.6) neutral density graduated filter

81B warming filter

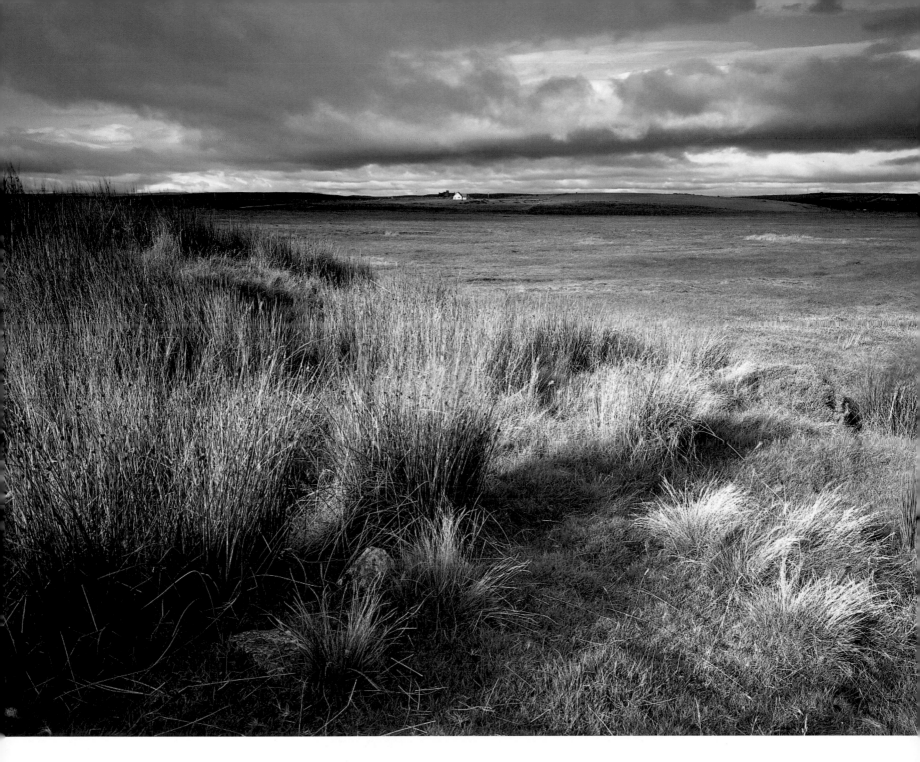

NEAR BETTYHILL, SUTHERLAND, SCOTLAND

CAMERA **Tachihara 5x4in**
LENS **Super Angulon 90mm (Wideangle)**
FILM **Fuji Provia 100**
EXPOSURE **1/2sec at f32**
WAITING FOR THE LIGHT **20 minutes**

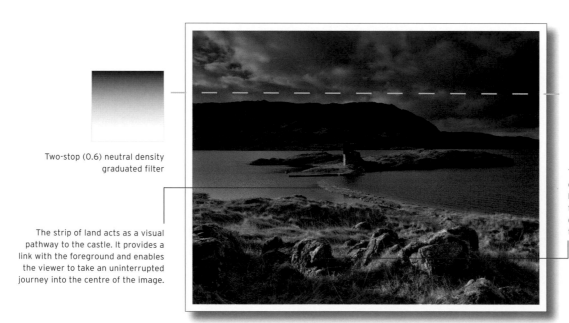

A Divine Union

I was heading for the coast and hadn't intended to stop en route – even though my journey took me past Loch Assynt and the ruins of Ardvreck Castle. Rain-filled clouds loomed overhead as I approached the remote lake but suddenly the sun, with impeccable timing, broke through and bathed the castle in the most glorious light. I stopped in awe, completely transfixed. It was an utterly captivating sight and, as I sat gazing, all thoughts of the coast vanished from my mind. I now had other priorities; the coast would have to wait.

There were a number of viewpoints to consider, but time wasn't on my side as the respite from the rain threatened to be short lived. So, after a somewhat hurried survey of the area, I settled on the arrangement you see here. It was the rugged terrain and the slope of the land leading to the castle which caught my eye, together with the fact that the aspect of the position enabled me to make the most of the exceptional light. The winter sun was low in the sky to my left and, from where

I was standing, approximately 15 degrees in front of me. This produced partial backlighting, the effect of which is apparent in the photograph. The light just clips one side of the castle leaving the front of the building in shadow. It also illuminates the foreground rocks in a similar manner, and it is these frontally shaded areas that give the picture depth and a tangible, textured quality. This combination of light and shadow also brings an emphatic presence to both the castle and the rocky hillside, which wouldn't be the case with more frontal lighting. This type of light is quite simply superb – it has become my lighting of choice for larger, expansive views. This was a most memorable moment, a moment when light and land joined together in divine union.

Consider carefully the angle of light you are using. If the sun is positioned slightly in front of the camera, it will produce a combination of back and sidelighting and this can have an exquisite effect on many types of landscape.

Two-stop (0.6) neutral density graduated filter

The strip of land acts as a visual pathway to the castle. It provides a link with the foreground and enables the viewer to take an uninterrupted journey into the centre of the image.

This angle of light – a combination of side and backlighting – will emphasize form and bring a three dimensional quality to foreground objects.

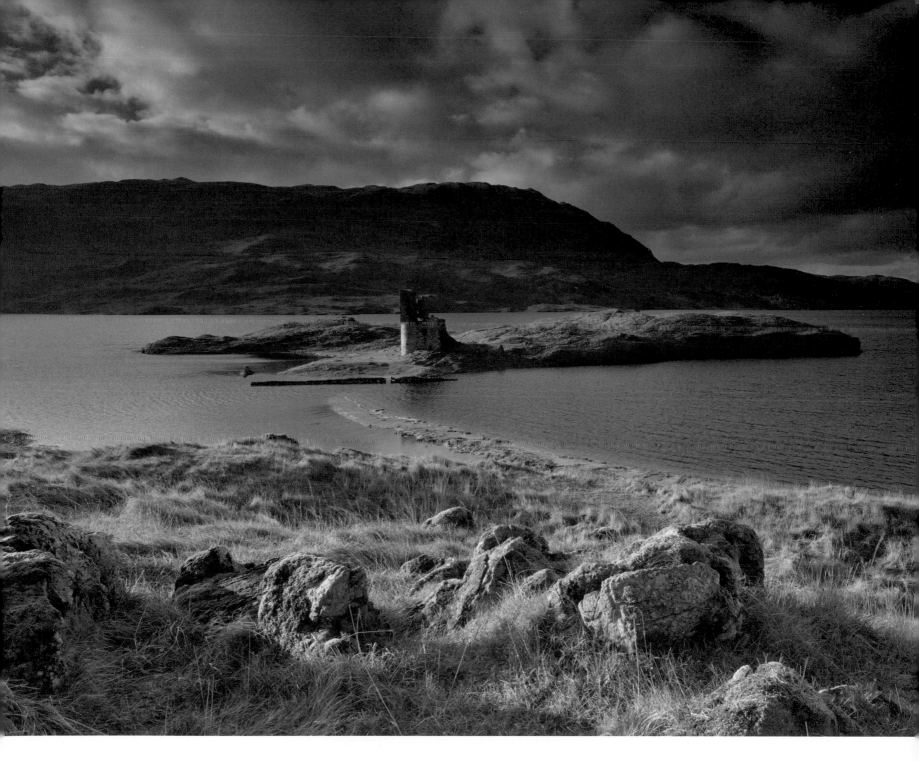

ARDVRECK CASTLE, SUTHERLAND, SCOTLAND

CAMERA **Tachihara 5x4in**
LENS **Super Angulon 90mm (Wideangle)**
FILM **Fuji Provia 100**
EXPOSURE **1/4sec at f22**
WAITING FOR THE LIGHT **Immediate**

A Flawless Landscape

I had been exploring the Staffordshire/Peak District border for several days and was heading for another location when, from a distance, I spotted an isolated barn. Old buildings are always worth investigating and, having an hour or so to spare, I decided to take a closer look. My sense of anticipation grew with every step. I didn't encounter any obstacles and, as I approached, could see no flaws. It all looked promising and the barn was, to my delight, quite marvellous. Built of rustic stone, it nestled in its surroundings in front of a sweep of hills that spanned the distant horizon. All I needed was a strong foreground, something that would reflect the rugged character of the Staffordshire moors. And, lo and behold, after some scrambling and searching, I found what I was looking for. Yes, I could see that I had a photograph!

There was, of course, more to it than that. It's one thing seeing a potential photograph and quite another turning that potential into reality. It takes time, patience and, very often, luck. I had the time - I was going to be there for another week - and with just a little luck, I should at some point have a favourable light and sky, but it was by no means plain sailing. During the days that followed there were a number of frustrations and disappointments, and it was fortunate that I was able to devote a considerable amount of time to capturing this image. I lost count of the number of return visits I made, but I think it was on the fifth or sixth day that I finally experienced the right conditions.

It was also on this day that a group of photographers, led by a workshop leader, joined me. When I say joined me this is not strictly true. They were photographing from the roadside while I was buried in a hollow somewhere close to the barn, 100 metres away. It wasn't obvious to me what they were photographing, it crossed my mind that they might be bird photographers but the lack of telephoto lenses (and indeed birds) argued against this. It had to be landscape - photographed from a distance and with, at the time, a rather weak sky. Heaven knows what their results were like. Had it been appropriate to offer it, my advice to them would have simply been: (A) scrutinize a landscape thoroughly before you photograph it, (B) don't be afraid to get up close and personal with your subject and (C) wait as long as necessary for the right light and sky.

81C warming filter

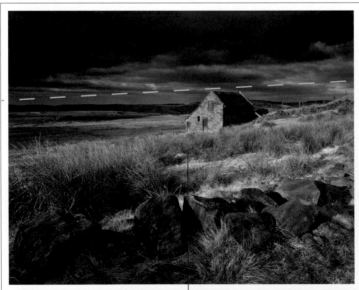

Two-stop (0.6) neutral density graduated filter

Grey skies are always lighter than they appear to be. Use a neutral density graduated filter to capture the drama and detail in cloud.

To make the most of foreground, photograph from a low position and move in as close as your depth of field will allow.

For maximum depth of field, use the smallest possible aperture and focus on the hyperfocal distance (see page 187).

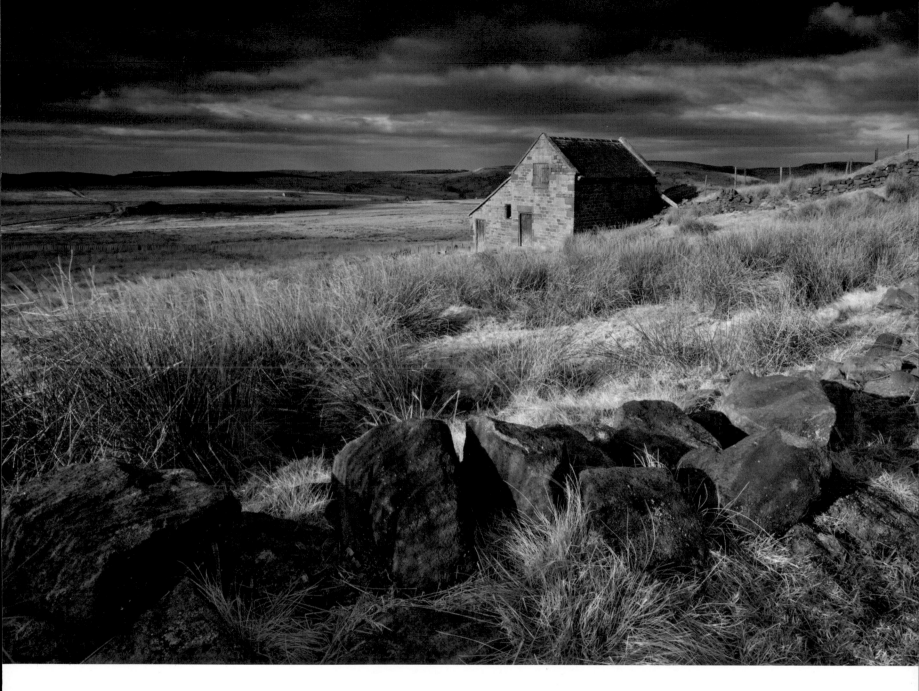

BRUND HILL, STAFFORDSHIRE, ENGLAND

CAMERA **Tachihara 5x4in**
LENS **Super Angulon 90mm (Wideangle)**
FILM **Fuji Provia 100**
EXPOSURE **1sec at f32**
WAITING FOR THE LIGHT **5 days**

Sunlight and Mist

Warm, showery days and cool, clear, still nights are the perfect conditions for a misty dawn and this was precisely the weather I experienced during a trip to the North Yorkshire Dales. It was the middle of May, the hills and valleys were bursting with vitality and every morning I was up with the lark making the most of it.

When photographing a mist-enshrouded landscape, the key to success is to have the right density of mist. This isn't a case of pot luck because if you are there at daybreak, you can watch and wait as the mist gradually clears. Too much can look monotonous when photographed while too little can lack mood and atmosphere. As a rule I prefer to restrict mist to playing a supporting role, rather than have it enveloping the landscape.

On the morning I took this photograph, there wasn't a breath of wind, so the mist lingered for several hours. I was, therefore, able to wait for the sun to rise above the hilly horizon and bathe the valley in gentle light. Sunshine and mist work supremely well together, particularly if the scene is backlit. In the right setting this combination can bring a magical radiance to a photograph.

I decided to use a short telephoto lens to enable me to frame the picture tightly and exclude the sky. At the time of making the exposure, the sky had a vapid, milky white appearance and including it would have weakened the image. Had the sky been a deep blue, or perhaps a bright red/orange, I would have happily brought it into the picture because a strongly coloured sky contrasts well with mist and enhances its presence.

A disappointing aspect of this image is its lack of warmth. I would have liked to have used a warming filter but the abundance of greenery deterred me. A predominantly green landscape can take on an unnatural hue when warmed and I am therefore always reluctant to tinker with the natural colour.

Mist can evaporate very quickly and you need to be poised and ready to capture the optimum moment. Here it is already beginning to dissipate, to the detriment of the photograph.

If the sky is weak, consider excluding it by using a telephoto lens to magnify the landscape. This can be effective when photographing from an elevated viewpoint.

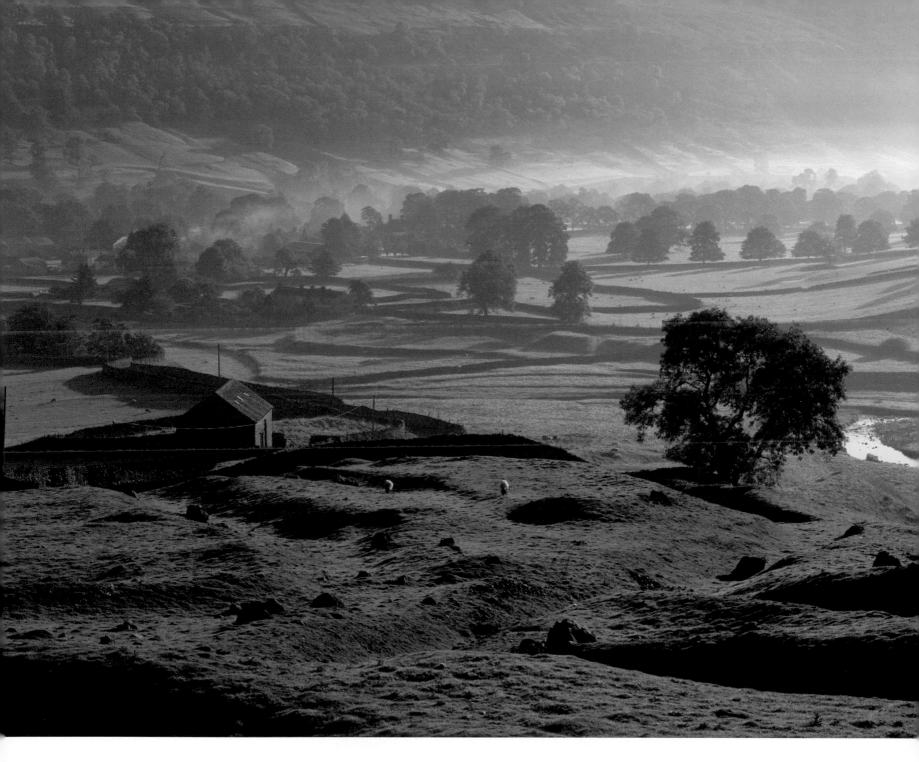

NEAR ARNCLIFFE, YORKSHIRE, ENGLAND

CAMERA **Tachihara 5x4in**
LENS **Fujinon 300mm (Short Telephoto)**
FILM **Fuji Provia 100**
EXPOSURE **1/4sec at f22**
WAITING FOR THE LIGHT **2 hours**

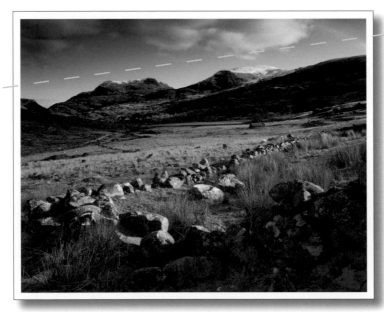

A Work in Progress

Snowcapped mountain peaks have always appealed to me. Photographed against a crisp blue sky, they will shine like a beacon and this is what I had in mind during a winter visit to the rugged Rhinog Mountains. It was mid January, cold, frosty and perfect – I thought – for what I had planned. Unfortunately the execution of my conceived photograph has not quite lived up to what I'd visualized and, admittedly, I only have myself to blame.

Although I arrived early in the morning, the sunlight was already strong and the level of contrast was a little high for my liking. You can see the extent of it on the stones in the foreground and middle distance. Unfortunately the boulders' pale grey colour exacerbates the problem and I was anxious not to compound it further by using a polarizing filter. One of the sometimes unwelcome side effects of a polarizer is the darkening of shadows, and I decided not to use it on this occasion. Instead I added a one-stop ND graduated filter, which has darkened the sky slightly but has not improved the rest of the image in any way. This was, with hindsight, a mistake.

The consequence of my decision was twofold: beginning with the sky, you can see that it is too pale, it should be a much deeper, more intense blue. This has resulted in a weakening of the visual impact of the mountain ridges; they have lost their presence and have partially faded into the background. There should be much greater distinction between the sky and mountains, and a polarizer would have achieved this. The second failing is an overall lack of vibrant colour. Instead of impact and vitality the photograph has an understated, muted quality which, although not unpleasant, is not what I intended. Again there is no doubt that a polarizer would have improved this. There would have been a slight increase in contrast but this would have been a justifiable price to pay.

So, although I consider the image to be acceptable, I know that it could – and should – have been better, and I look forward to a return visit to the Rhinogs with relish. This, then, is a work in progress and evidence that landscape photography is essentially one vast, highly rewarding, learning experience.

One-stop (0.3) neutral density graduated filter

The sky and mountains lack impact. A polarizing filter would have brought a discernible improvement, both to the sky and the flat, rather mundane piece of land in the middle distance. Not using the filter was my error of judgement which I hope to be able to rectify in the future.

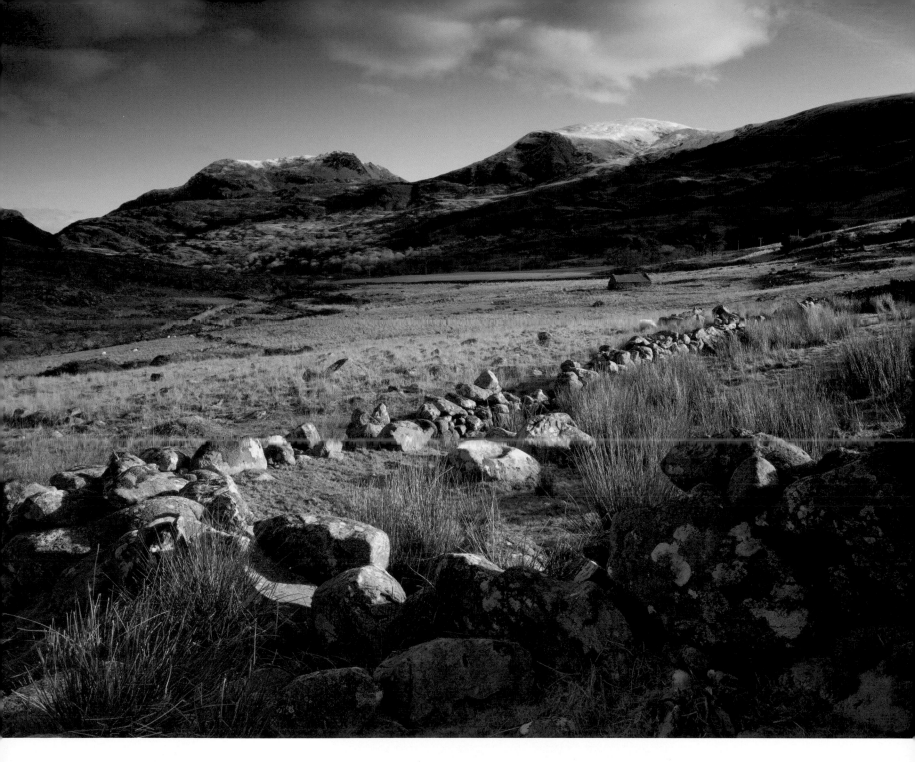

THE RHINOG MOUNTAINS, SNOWDONIA, WALES

CAMERA **Tachihara 5x4in**
LENS **Super Angulon 90mm (Wideangle)**
FILM **Fuji Provia 100**
EXPOSURE **1/2sec at f32**
WAITING FOR THE LIGHT **15 minutes**

Looking Beyond the Familiar

The Snowdonia National Park is rightly renowned for its splendour, but it's not the only attraction that North Wales has to offer. Travel a few miles to the northeast of Snowdonia and you will find yourself in the depths of the Clwyd Mountains and, to the south of this range, Llantysilio mountain. The landscape in this part of the country is an enticing combination of mountains, hills and farmland. Although not particularly rugged the mountains are, in their own way, still majestic. I have visited this area throughout the seasons and have never been disappointed because there is always something new to photograph.

The photograph on the right was taken at the beginning of October, and you can see that there is just the faintest whisper of autumn to it. Not surprisingly, the heather is no longer in flower but the colourful ferns have – to a degree – compensated for this. However, the main attraction of this location is the sweeping contours of the landscape itself. The steep bowl-shaped hillside that tumbles all the way down to the foot of the valley, which in turn climbs remorselessly to the peak of the mountain, is simply magnificent. Add to this the lofty vantage point which provides such a fine view of the distant hills and you have a landscape that must have been forged with the photographer in mind.

This plummeting, rolling terrain is typical of the somewhat neglected Clywd Mountains and serves as a reminder that grandeur in a landscape is not confined to places that happen to be on the tourist map. Look beyond the familiar and you will find the undiscovered – and of course the unphotographed.

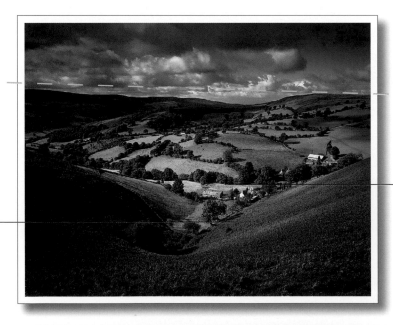

Majestic locations require majestic light. This photograph is structured around the steeply contoured hillside, and it was essential that I gave it due prominence. This could only be done with the appropriate combination of light and shadow. Here the narrow bands of sunlight mirror and repeat the plummeting contours and depict the magnificence of the landscape.

Two-stop (0.6) neutral density graduated filter

Use light sparingly to accentuate a hilly terrain. Watch as shadow sweeps across the landscape and release the shutter the moment the important features are lit.

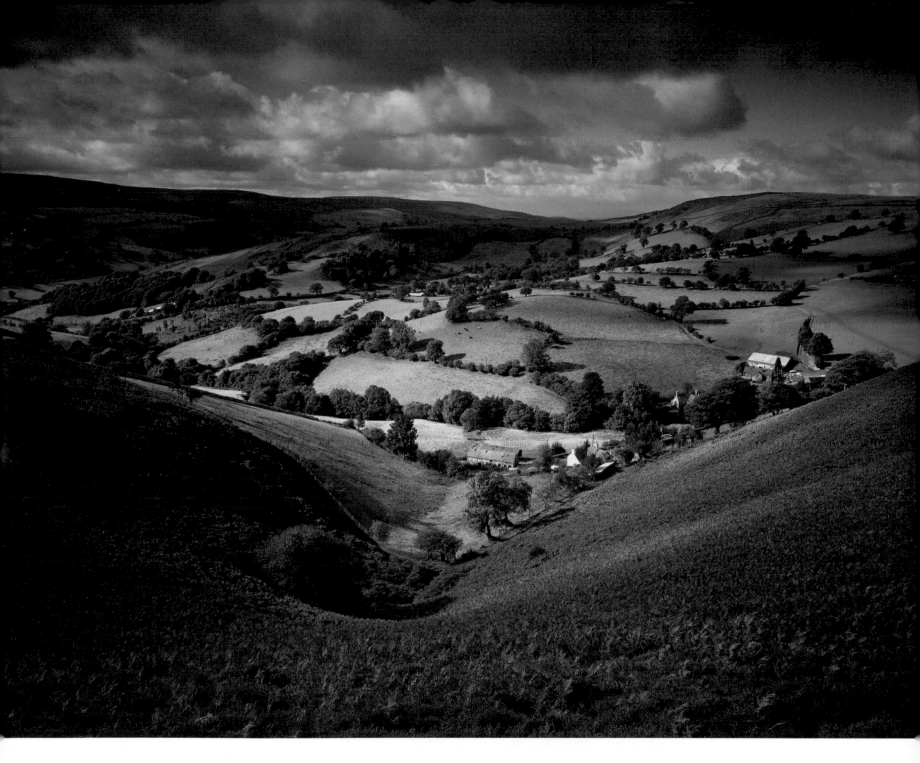

LLANTYSILIO, CLWYD, WALES

CAMERA **Tachihara 5x4in**
LENS **Super Angulon 90mm (Wideangle)**
FILM **Fuji Provia 100**
EXPOSURE **1/4sec at f22**
WAITING FOR THE LIGHT **1½ hours**

A Limited Opportunity

Rarely do I photograph under a cloudless blue sky; it's not to my liking and I avoid it whenever possible. But very occasionally there are exceptions when I will break my rule, normally because there is no alternative, as was the case with this image taken in the Snowdonia wilderness.

It was January and the sun was permanently low in the sky. The old farmhouse was in a sheltered position close to mountains and, at that time of year, was lit by direct sunlight for just one hour per day, when the sun was at the peak of its arc. The building needed to be brightly lit and I was restricted to having only a single hour to make my image. I was there for the week so each and every day, as regular as clockwork, would arrive a few minutes before the magic hour, set up my equipment and wait, ready to make an exposure the second the elements coincided in a favourable manner. I was hopeful of success

because the conditions I sought were modest: sunlight peeking over the mountains to my right, with a defined cloud structure as a backdrop. That was it, a simple requirement and in time – a week at the most – I should have my photograph.

In theory my expectation was realistic but, sadly, the week passed by without a glimmer of hope arising. It was either raining or overcast until at last, on my final day, there was sunlight. But there was no cloud, and I was caught in a dilemma. Do I capture the image without my normal style of sky or do I reject the opportunity? The answer to the question is on the opposite page. But was it the right decision? Admittedly, I have a certain fondness for this photograph, although a more dramatic sky would have undoubtedly improved it. This is, therefore, another work in progress, and I will return to it one day. I am happy with that – it would be terrible to run out of locations.

Polarizer (half polarized)

A clear blue sky can suffer from uneven darkening when fully polarized (particularly when using a wide-angle lens). To avoid this I used only half polarization, but this has resulted in the sky looking weak. With hindsight a fully polarized effect would, I think, have been preferable.

The shadow is already beginning to encroach along the front wall of the farmhouse and is becoming intrusive. This is more likely to happen in mid-winter, particularly if the building is situated in a steep valley. Unless you are fortunate enough to be able to take the photograph in the limited time available, the only solution is to return at another time of year when the sun is in a higher position.

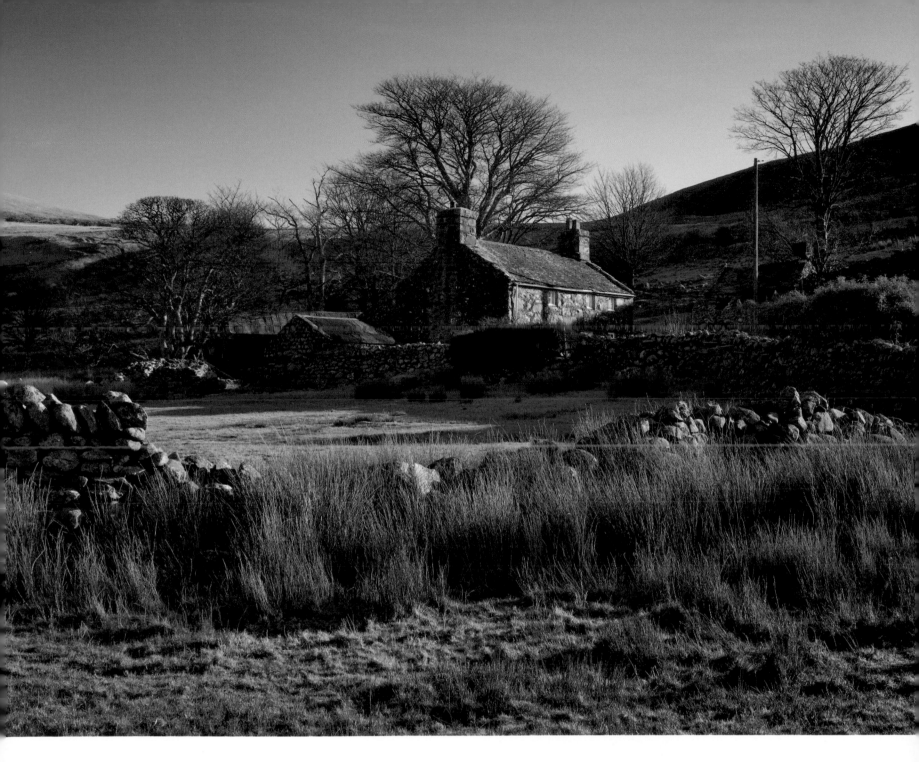

NEAR LLANBEDR, SNOWDONIA, WALES

CAMERA **Tachihara 5x4in**
LENS **Super Angulon 90mm (Wideangle)**
FILM **Fuji Provia 100**
EXPOSURE **1/4sec at f22**
WAITING FOR THE LIGHT **6 days**

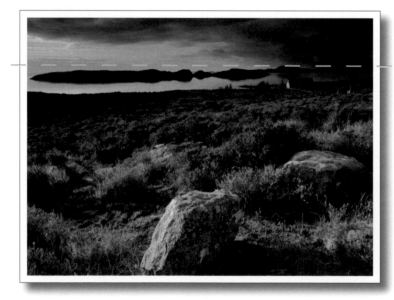

A Most Special Place

A local fisherman helped me to find my bearings in this remote corner of the Scottish Highlands and, eager to be of further assistance, he also pointed me in the direction of, I quote, one of the finest walks in Scotland.' Walking wasn't what I had in mind, but my new acquaintance was endearingly persuasive. 'There's something about the light. The views can be spectacular on a good day, it's the light you see, there's something about the light.' I must admit I wasn't totally convinced, but at the same time I was intrigued. So, with an open mind I set off in search of the promised spectacular.

This part of Scotland is essentially one vast and beautiful wilderness of steep hills, lakes and peat bogs. There are few footpaths which means that progress is slow, but everything seems to move at a slow pace in this remote region, and it is all part of the timeless Highland experience. The one exception to this is the weather, because it can change in the blink of an eye, from rain one minute to sunshine the next. Pictures can suddenly appear only to vanish into thin air moments later, so it pays to remain alert at all times.

I didn't know what to expect as I climbed the hill; it was overcast and gloomy but, upon reaching the summit, it was not only the arresting sight of the Summer Isles that greeted me but also a glimpse of clear sky on the horizon. Wildly guessing that the rain was about to stop, I raced back down the hill to collect my equipment and breathlessly made it back just in time to catch the moment. And what a moment it proved to be; not only was the view indeed spectacular but there was also something else. This was indeed, as my new acquaintance had promised, a most special place with a unique and almost mystical atmosphere.

Photograph taken, I remained rooted to the spot as the day drew to an end. I was in no hurry to leave and I realized that the fisherman was right because there was something keeping me there. It was an exquisite, captivating moment and an occasion I will always remember. It was the light, you see, there was something about the light.

The viewpoint was the critical factor in the making of this picture. Specifically it was the height of the camera and the position of the isolated cottage that concerned me. I felt it was essential that the building was not allowed to cut into the horizon because the distant islands were fighting to make their presence felt. Had anything interrupted the view of them their contribution would have been greatly compromised. It was, therefore, essential that I raised the camera sufficiently to avoid this but at the same time I wanted to retain the impact of the foreground.

Two-stop (0.6) neutral density graduated filter

81C warming filter

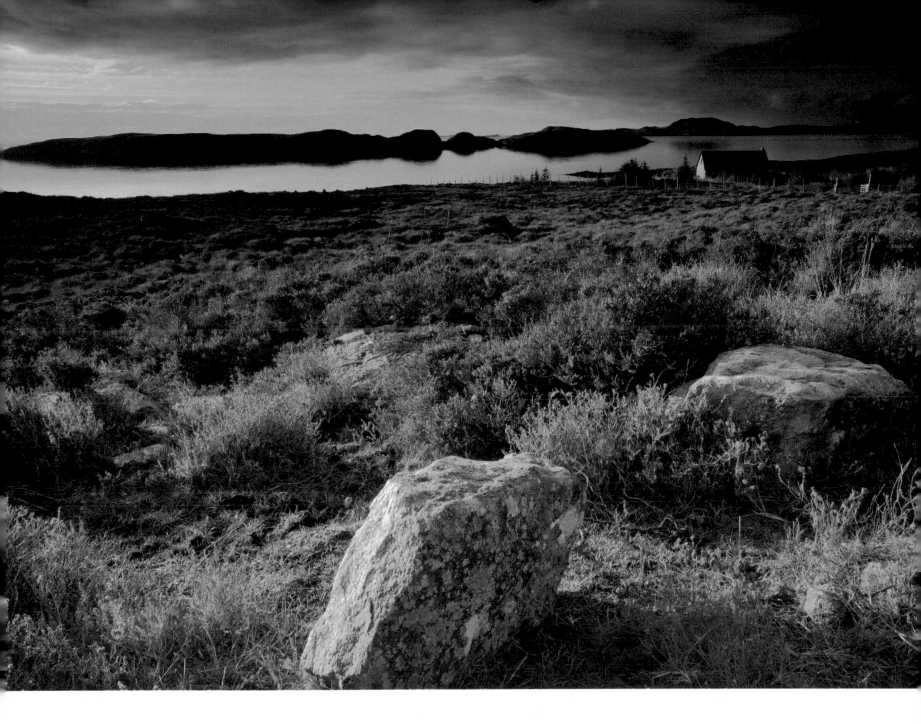

THE SUMMER ISLES, FROM CULNACRAIG, WESTER ROSS, SCOTLAND

CAMERA **Tachihara 5x4in**
LENS **Super Angulon 90mm (Wideangle)**
FILM **Fuji Provia 100**
EXPOSURE **1sec at f22½**
WAITING FOR THE LIGHT **Immediate**

Creating Depth and Scale

The creation or, more accurately, the retention of the depth and scale of a mountain vista or any distant view is one of the biggest challenges a photographer faces. Without depth, the image will look flat and lack impact. It will bear little resemblance to the original scene and it is, therefore, crucial that this aspect of producing a landscape photograph is understood and mastered.

I suggest you begin by finding a mountainous or distant scene, preferably one in an elevated position. Visit it on a sunny day when there is broken cloud in the sky, and spend a number of hours at the location. During that time you will be able to observe the visual effect of different combinations of light and shadow as they play across the landscape. You will also have the opportunity to note the subtle changes in the visible contours of the terrain as the sun passes through its arc. This is an important part of the learning curve and time invested in gaining understanding and appreciation of the quality of light, and its effect on the appearance of a distant view, will give you invaluable experience. You will begin to look at the landscape in a different way, you will start to see it as a photographer sees it – as a collection of shapes, patterns, curves, depth and repeated features.

Look also for foreground features, preferably those which invite the viewer towards the middle distance. Receding lines such as footpaths, roads, rows of trees and hedgerows are helpful in this respect. Photograph the view with varying amounts of foreground and from different distances. Try to get as close as you can, i.e. within the limits of your depth of field (maximize this by using the smallest possible aperture) and then step back progressively, positioning your camera at different heights as you do so. A higher position will give you a better view of the middle distance, but this will be at the expense of foreground impact. The objective is to

PONT PEN-Y-BENGLOG, SNOWDONIA, WALES
Close-up images can also be found in a wilderness. When searching for the wider view, remain alert for other opportunities closer at hand.

create a balance between foreground and background and this will become easier as you develop your expertise. Use also different lighting conditions; a shaded (or slightly shaded) foreground can help to draw the eye towards the horizon, and this can also be an effective means of depicting depth. Trees and buildings, because of their known size, are useful too. They bring a sense of scale to a landscape particularly when positioned in such a way that they display a gradually diminishing size.

This is the first step in the learning process. By comparing the results of your initial attempts you should begin to gain first-hand experience of light and composition.

MAROON BELLS, COLORADO, USA
The foreground trees have given depth and scale to the image and help to convey the size and grandeur of the background mountains.

FINSBAY, ISLE OF HARRIS, SCOTLAND
The foreground rocks, cottage in the middle distance and the background mountains are a simple but very effective arrangement. The three elements provide visual stepping stones for the viewer to follow, and give the photograph a three dimensional quality.

CHAPTER TWO
Trees, forests & woodland

I think I speak for many photographers when saying that trees epitomize the beauty of the landscape. With or without leaves, in groups or standing proudly in isolation, they bring the landscape alive and provide a feast of photographic opportunity. Throughout the year, in all types of weather, trees, forests and woodland are always there for the photographer and they can be the source and inspiration of many fine and distinguished images.

There is endless scope and variety to be found but, in order to experience all the delights of our wooded areas, it is important to visit them at different times of day and in different lighting conditions. A misty summer dawn, with rays of sunlight piercing a forest interior can, for example, look absolutely stunning but the magical effect is likely to be short-lived; the mist will evaporate as the temperature rises and at that point the ethereal quality will be lost. But it's not just about misty mornings because seasonal changes ensure that the photographer's day is active throughout all hours of daylight. Spring wildflowers photograph well in the soft light of an overcast sky as do autumn foliage, tree bark, roots and fungi. Speckled sunlight can also bring a sparkle to forest interiors as can backlighting, particularly during autumn.

To ensure that your image has impact it is important to have a clearly defined focal point. It could be a pleasantly shaped tree, a winding footpath, a display of flowers or perhaps an attractive building buried deep in the woods. It could in fact be almost anything, as long as it is visually appealing and appropriate to the theme of the picture. Also, unless there is good reason not to, it is preferable to exclude the sky (or patches of sky) as its presence tends to be distractive and can weaken the theme of a photograph.

NEAR SHREWSBURY, SHROPSHIRE, ENGLAND
Spring was in full bloom when I chanced upon this colourful spectacle. My timing could not have been better but I claim no credit for this as it was a completely unplanned and unforeseen encounter. The angle of the sidelighting was also perfect, although the sunlight is perhaps a little harsh. I would have preferred softer shadows and more subdued highlights but this is a minor criticism. The image is simply a celebration of spring and I am thankful that I happened to be in the right place at the right time to capture it.

CAMERA **Tachihara 5x4in**
LENS **Super Angulon 90mm (Wideangle)**
FILM **Fuji Provia 100**
EXPOSURE **1/2sec at f32**
WAITING FOR THE LIGHT **Immediate**

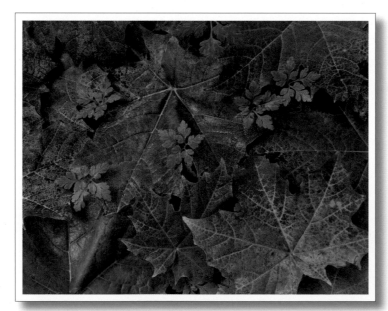

A Profusion of Colour

Autumn is for many photographers their favourite time of year and for good reason. Take a walk in the woods when the colours are at their peak and you are likely to find pictures queuing up to be taken. Colour is everywhere but there can be so much of it and so much choice that it becomes overwhelming, and a profusion of colour can easily degenerate into a confusion of colour. To avoid this confusion being transferred to your film or sensor keep the arrangement simple. Look for defined shapes and patterns and also texture details; they might not be immediately apparent but they can be found. If, for example, you look down, not up, and cast a discerning eye over the bounty of recently fallen leaves you can often discover a treasure trove of colour of a graphic simplicity.

I was, not surprisingly, surrounded by colour when I visited New England during the peak of the fall season but, inviting as it was, I often found it was the leaf-carpeted forest floors that held the greater appeal. You can guarantee there will be pictures hidden in the depths of any autumn-tinged forest, but finding them is another matter. They can be as elusive as the most timid wildlife and there is, sadly, no short cut to tracking them down. You will, therefore, understand why I was jumping with joy when I caught sight of this delightful parcel of clean, variegated leaves and wild Cranesbill. The verdant greenery and the warm autumn hues were a perfect combination of contrasting colour and form with the added bonus of there being only minimal rearrangement required prior to my photographing it. I removed a little debris, cut back a few stray strands of grass and made three exposures. The leaves were damp so I used a polarizing filter to suppress the surface reflections and that was it, the photograph was taken in a matter of minutes. My search through the forest had, however, taken over three hours, but my time had been well rewarded and, considering that my investment of time per image is normally measured in days, not hours, it had also been highly productive.

Polarizer (fully polarized)

The polarizing filter has reduced, but not entirely eliminated, the surface reflections on the shiny leaves. It is surprising how reflective foliage can be and the use of a polarizer should always be considered.

Bright sunlight should, as a rule be avoided when taking close-ups of colourful subjects. Even flat, diffuse light will produce subtle highlights and shadows in a subject which has a degree of depth or an irregular surface.

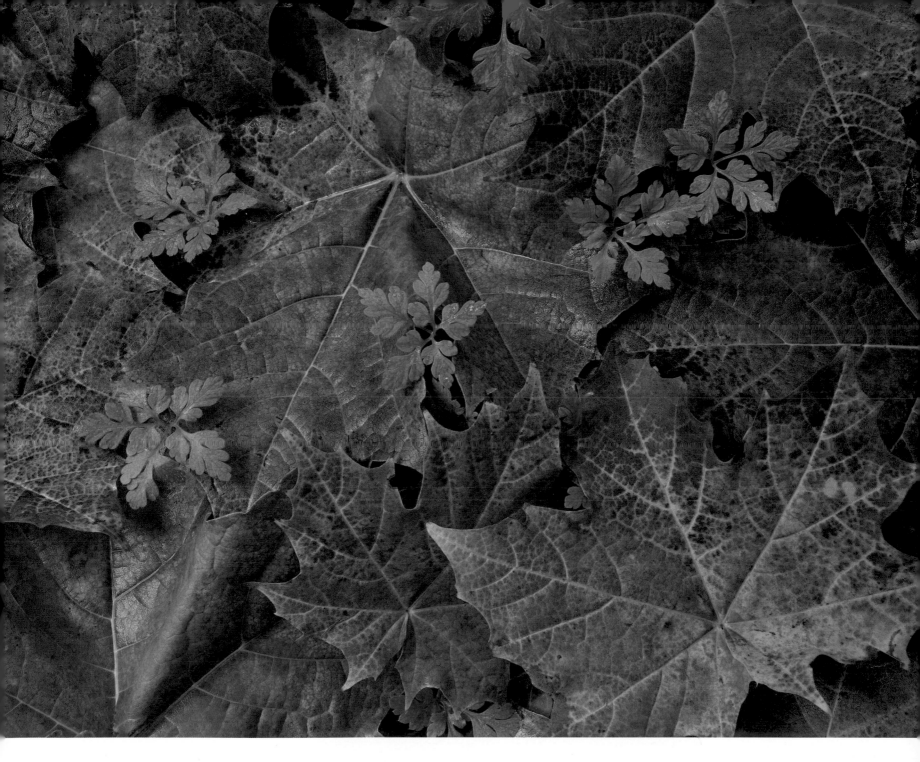

NEAR EAST HIRAM, MAINE, USA

CAMERA **Tachihara 5x4in**
LENS **Super Angulon 150mm (Standard)**
FILM **Fuji Provia 100**
EXPOSURE **2sec at f22**
WAITING FOR THE LIGHT **Immediate**

Eliminating Dead Space

As a rule I tend to photograph using a wideangle or standard lens. They suit my style, but there are occasions when a telephoto lens becomes indispensable. The longer focal length of these lenses enables specific parts of the landscape to be isolated and unwanted elements (such as a weak sky) excluded. Another effect of using a telephoto lens is the compression of distance. This can increase a picture's impact by eliminating dead space and it can also heighten a photograph's graphic qualities. A longer focal length is, therefore, a particularly useful option because – in addition to the compositional choices it provides – it can also be used to create images which would not be possible with lenses of a wider field of view.

I initially saw this group of trees from a distance when they were backlit, with the sun blazing down behind them. The contrast was at the time too severe but when I returned four hours later the scene was lit from the side and wispy cloud had softened the light. The sky was unattractive but this was of no concern to me because I had planned to exclude it and concentrate on the mass of colourful foliage. The sky has no role to play in this image because the theme is autumn colour and there is enough of it to fill the frame without the need for any supporting elements. That said, I was happy to include the rows of bushes at the bottom of the picture. The photograph would succeed without them but they make a contribution by acting as a lead for the eye to follow and by helping to depict the main subject in its wider environment.

I was tempted to add a warming filter but decided against it because of the presence of the green trees and bushes. I am always reluctant to tinker with green because it is prone to take on an unattractive yellowish tinge when warmed. Instead I used a polarizer which has enriched, but not altered, the colours.

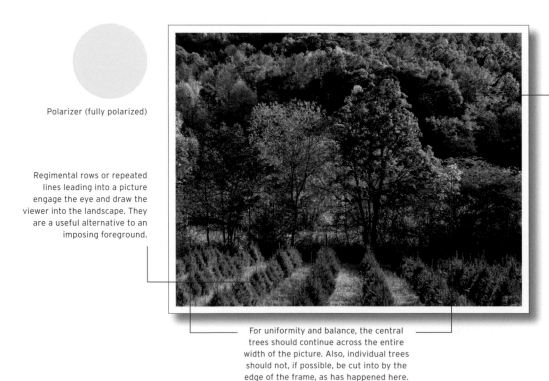

Polarizer (fully polarized)

Regimental rows or repeated lines leading into a picture engage the eye and draw the viewer into the landscape. They are a useful alternative to an imposing foreground.

The shadow falling on the distant trees is an important detail. The dark patch in the background has prevented the main tree group from merging with, and being swallowed up by, their colourful surroundings.

For uniformity and balance, the central trees should continue across the entire width of the picture. Also, individual trees should not, if possible, be cut into by the edge of the frame, as has happened here.

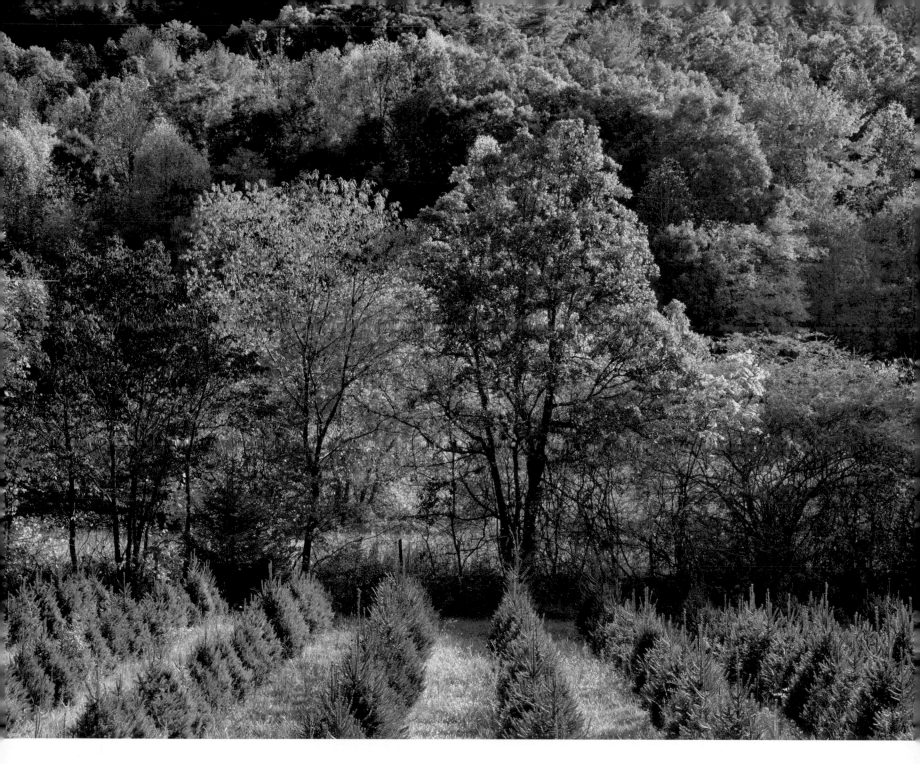

NEAR BLAIRSVILLE, GEORGIA, USA

CAMERA **Tachihara 5x4in**
LENS **Fujinon 300mm (Short Telephoto)**
FILM **Fuji Provia 100**
EXPOSURE **2sec at f45**
WAITING FOR THE LIGHT **4 hours**

A Perfect Partnership

When viewed as a photograph, the sky is seen as a solid object with colour, shape and sometimes depth. Such a transition arises as a result of the prodigious power of photography which, miraculously, has the ability to transform the intangible into the tangible. The sky, with its array of moods, whims and nuances, is in fact a quite superb subject for the camera. Photography is a medium tailor-made to capture it in all its glory.

Consider, for example, this agreeable but otherwise quite unremarkable scenic view in the picture opposite. Now imagine it without that solitary cloud. What would be the point of photographing it? Or, imagine it with the cloud positioned off-centre, somewhere towards the left or right side of the image. It wouldn't be easy on the eye, would it? It would look jarring and unsettling and would not, in fact, be a pleasant sight at all. This, then, is a graphic example of a landscape, picturesque as it may be, being unable to stand up on its own. It needs the sky – a particular type of sky – for it to make its presence felt. Without the cloud dotting the 'i' of the tiny tree there would be no photograph. Equally, the cloud on its own would be rather lost, it needs the landscape, and again the right type of landscape, in order for it to make a telling contribution to a photograph. This illustrates, I feel, why the sky and landscape must – absolutely must – be brought together sympathetically as equal partners in a balanced, symbiotic union.

Consider the landscape and sky together, as two distinct yet connected halves of a picture. They are inextricably linked and this can be used to great advantage by the observant photographer. Get it right and two and two can indeed make five. This image necessitated the use of a relatively long telephoto lens. It has resulted in a slight loss of definition, which is an unavoidable effect of a high degree of magnification.

Polarizer (fully polarized)

For this type of photograph to succeed, it is essential that there is no other cloud present. The picture is structured around the single tree and cloud, they are equal partners and it was their display of equality that prompted me to make the image. In this landscape two's company; three (or more) would have undoubtedly been a crowd.

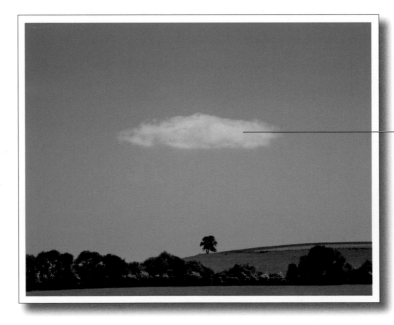

A shapely cloud can quickly disintegrate and it is beginning to happen here. You will need to keenly observe the sky and work quickly if you are to capture a perfectly formed cloud in the required position.

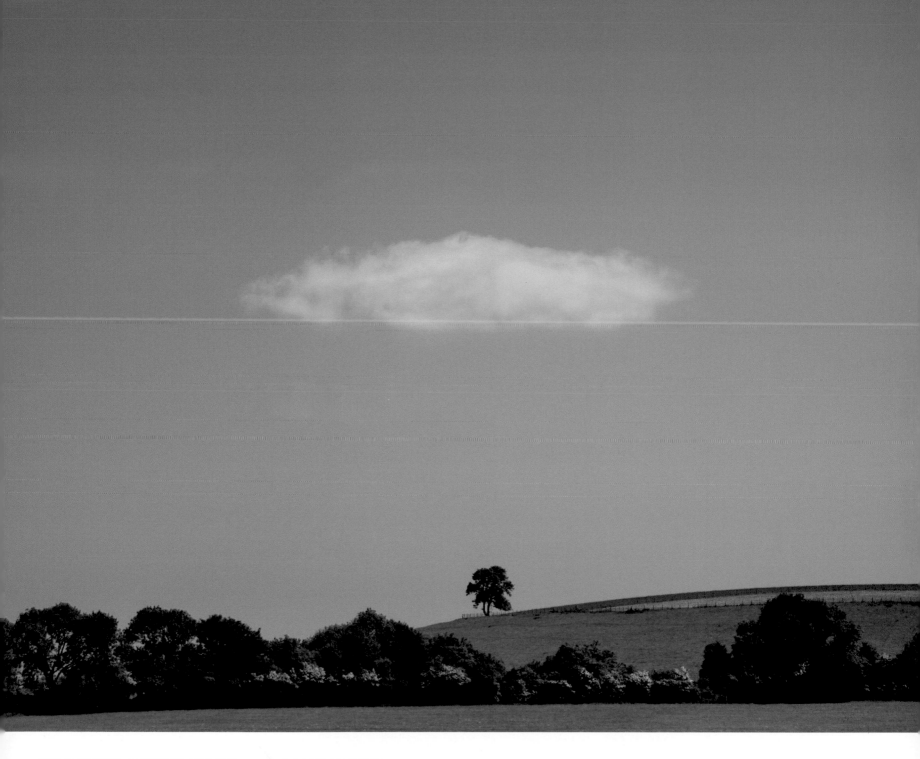

TEGLEASE DOWN, HAMPSHIRE, ENGLAND

CAMERA **Tachihara 5x4in**
LENS **Fujinon 300mm (Short Telephoto)**
FILM **Fuji Provia 100**
EXPOSURE **1/8sec at f16½**
WAITING FOR THE LIGHT **4 hours**

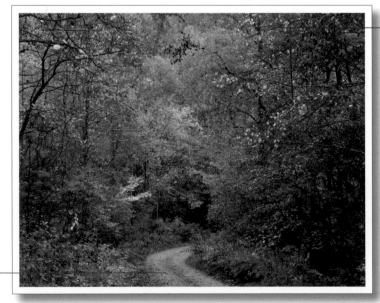

A Sense of Scale

Ensconced in the inner depths of the sprawling Chattahoochee Forest, I contemplated my situation and then hesitated; I was caught in a dilemma. My instinct was to exclude most of the towering trees and concentrate on a specific feature. This would have enabled me to impose a sense of order on the leafy jumble that surrounded me. I was, however, concerned that a tightly framed image would fail to communicate the character and overwhelming scale of the forest. However, while a more open composition might have helped in this respect, I wondered how it would look when photographed. This is because a wide forest view can be uninspiring and monotonous if it lacks a clearly discernible focal point. Neither solution was ideal so the answer was to combine both elements. I therefore needed an open, general view that could be built around a distinctive, clearly defined feature. Simple! All I had to do was find it.

I searched and searched but, despite my best efforts, I couldn't find the combination I was seeking. It was becoming a large scale version of a needle in a haystack; I knew there was a picture there somewhere but knowing it was there didn't help me to find it. The odds were stacked against me and eventually the fading light forced me to compromise. With little time left, I decided to use the narrow, winding road to enable me to introduce a sense of depth and scale to the image and visually take the viewer into the heart of the forest. The outcome has been reasonably successful and, although the composition wasn't at the time my first choice, the picture has since grown on me. It has a painterly quality and a looseness which is appropriate for this type of subject and, importantly, it succeeds in depicting the character and magnitude of the forest, which was always my main objective.

To communicate the perspective and scale of a landscape, include familiar objects of a known size such as buildings, roads, fences and trees. Roads can also be used to accentuate depth and distance in a photograph.

Polarizer (fully polarized)

The narrow road gives the image scale and acts as a visual lead into the forest.

The impact of a forest or woodland image can be diminished if the sky is allowed to intrude. It was important that I excluded it and restrict the composition to just an unbroken expanse of foliage.

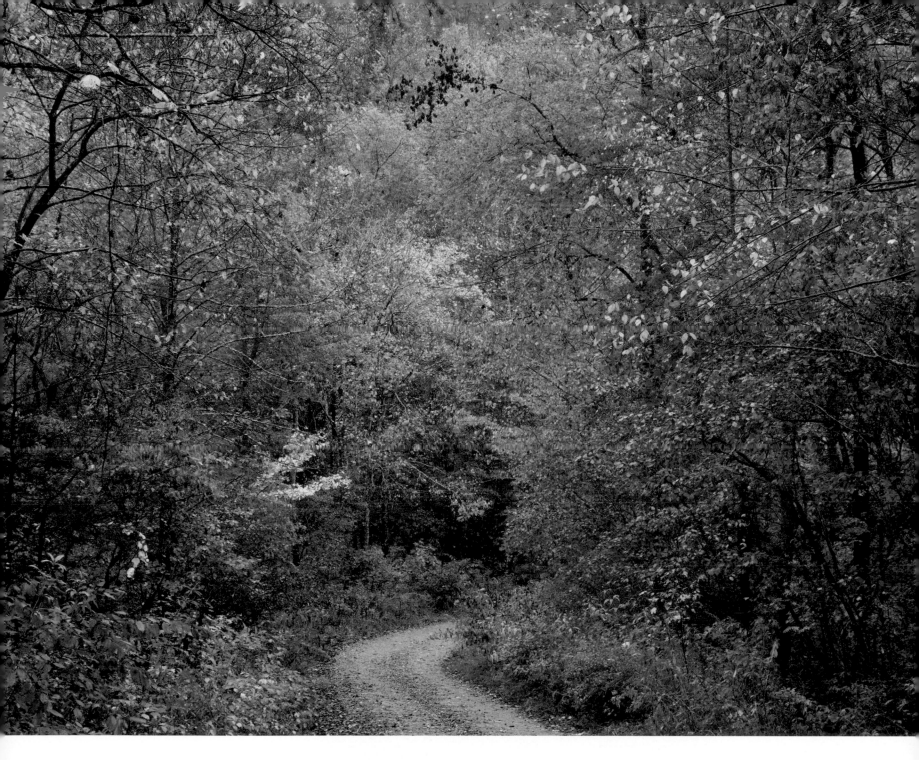

CHATTAHOOCHEE NATIONAL FOREST, GEORGIA, USA

CAMERA **Tachihara 5x4in**
LENS **Super Angulon 90mm (Wideangle)**
FILM **Fuji Provia 100**
EXPOSURE **1sec at f22**
WAITING FOR THE LIGHT **Immediate**

A Photographer's Friend

It is a mistake to think that once deciduous trees lose their leaves, they also lose their photographic appeal. When stripped bare they reveal their intricate structure and an inner, hidden beauty. In their skeletal form trees lose much of their dominance and will blend into a landscape, giving it a wintry complexion. They are, as I have said many times before, a photographer's friend. In all weathers, all seasons, they are a tremendous asset and a catalyst to creativity.

I spend many a happy hour tree hunting and, following a path uphill towards a dry-stone wall, I sensed I was in luck. At the top of the hill I could see an isolated tree, and realized that it overlooked the valley and distant mountains. Also, the aspect of the view was perfect because the sun was in front of me, but slightly to one side, which produced a combination of both back and sidelighting. This is known as Rembrandt lighting because of the painter's preference for depicting this type of light in his portraits. Well,

if it was good enough for Rembrandt it's good enough for Watson. So off I went, climbing the hill in eager pursuit of my very own masterpiece.

With a little scrambling around, I found a good position. You can see that the effect of the light is to brightly illuminate just one edge of the tree trunk, while the branches remain in silhouette (aided by a grey graduated filter, which I positioned over the entire sky). Another important feature is the stone wall, which has also been brought graphically into the picture, again because of the direction of the light highlighting its rugged surface. Then, in the distance, the side/backlighting has given shape and depth to the hills and mountains. And all of this is simply a result of the direction and quality of light.

Leafless trees can add foreground interest without dominating or obscuring the wider landscape.

The silhouetted tree branches have been emphasized by the graduated filter, which I placed level with the mountain horizon.

The angle of light – for which there is little margin for error – is of great importance. It reveals and emphasizes the detail in both the tree and the stone wall and gives the picture drama and impact.

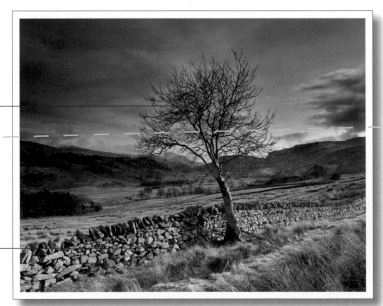

Two-stop (0.6) neutral density graduated filter

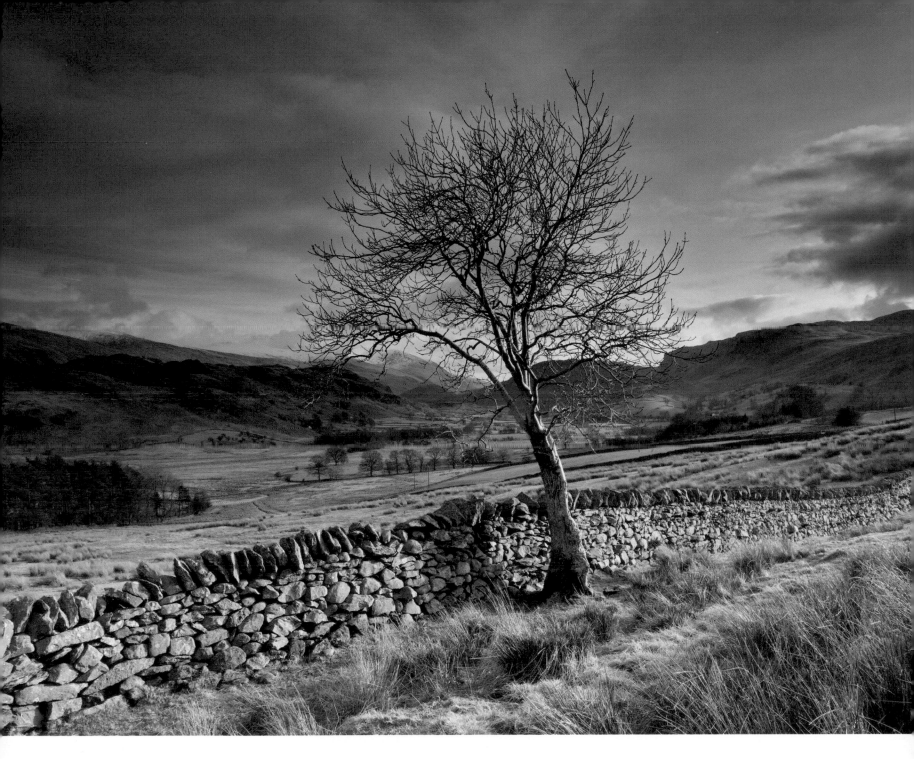

LOW RIGG, CUMBRIA, ENGLAND

CAMERA **Tachihara 5x4in**
LENS **Super Angulon 90mm (Wideangle)**
FILM **Fuji Provia 100**
EXPOSURE **1/2sec at f22½**
WAITING FOR THE LIGHT **15 minutes**

A Compelling Group

Open views can benefit from the presence of distinct features of a gradually diminishing size. Trees are very helpful in this respect because they can be used to create depth, scale and perspective in a landscape image. An example of this is this picture of rolling farmland in the Brecon Beacons. The receding lines of the field and the boundary hedge are important features, but it is the centrally placed tree that plays the essential role. It is the focal point of the entire image, the fulcrum on which the rest of the picture hangs. The tree gives a sense of perspective to the photograph because its distance from the camera is clear and unambiguous and this is one of the reasons that I didn't hesitate to place it in central, prominent position.

Important though the tree is, there are also other factors at work in this picture. In the distance the farm buildings, because of their perceived and measurable size, reinforce the impression of depth and, stretched across the width of the landscape, they couldn't be better placed to achieve this. Together with the hedgerow,

field and tree they form a compelling three dimensional group which has been consolidated by the tree's dominant position. I must now mention another crucial element; it is of course the low, right-angled sunlight. It is important because without this raking light it is a certainty that the picture would, despite its composition, have failed. The first casualty would have been the flowing lines of the harvested hay; they would have virtually disappeared and, as a result, the arable field would have been reduced to a void, featureless patch of scrubland. The tree, too, would have suffered by losing the roundness and depth to its shape as, indeed, would the trees on the distant hills.

This, then, is a landscape which can only be successfully photographed if a number of precise conditions are met. The starting point, however, and the catalyst to creating the image, was the presence of the tree. Without it there would have been nothing to spark my interest and, ultimately, no photograph. It is little wonder that I regard trees with a deep, abiding reverence.

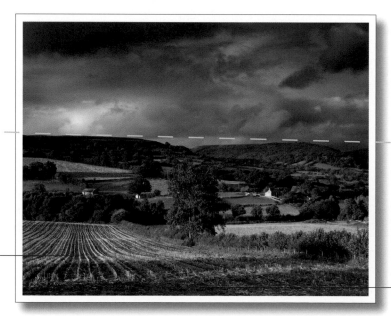

Lines leading from the camera to a distant building, or an object of similar and recognisable size, have a pronounced aesthetic quality and are very depth-creating. When possible choose a viewpoint which makes the most of these graphic elements.

Two-stop (0.6) neutral density graduated filter

In the absence of strong foreground, shadow can be used to provide a foundation on which the rest of the image can be built.

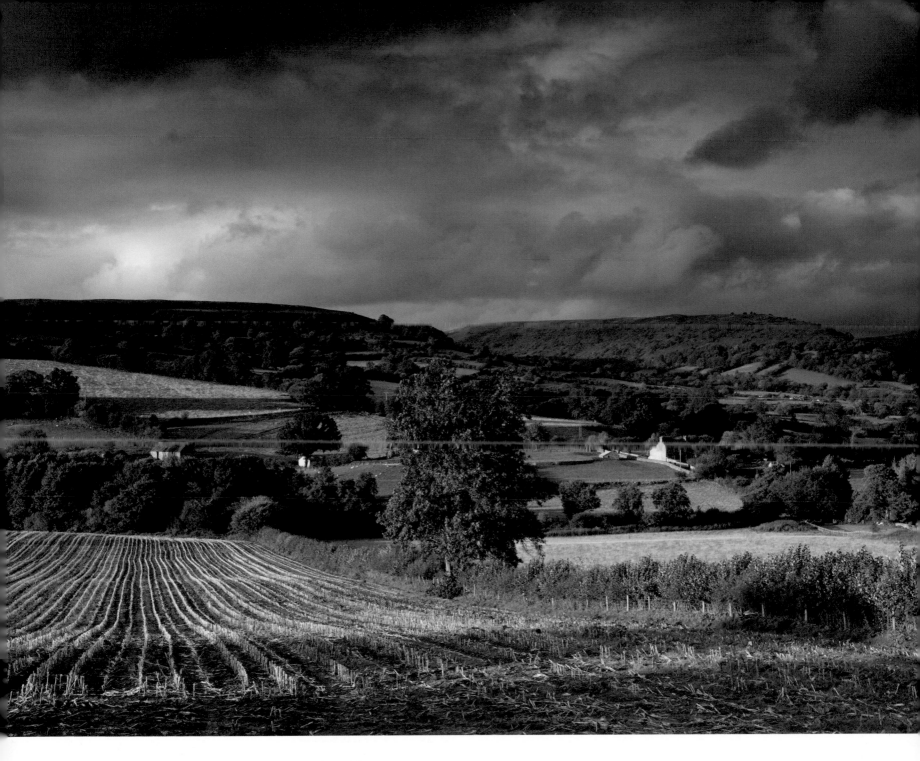

NEAR LLANGYNIDR, BRECON, WALES

CAMERA **Mamiya 645ZD**
LENS **Mamiya 80mm (Standard)**
FILM **Image Sensor**
EXPOSURE **1/4sec at f16**
WAITING FOR THE LIGHT **45 minutes**

Addressing Minor Details

On the evening I photographed this sunset, the sky had looked promising and my hopes were high. Unfortunately, during the final minutes - always the critical moment with a sunset - clouds began to dissipate and my ambitions of capturing a showstopper failed to materialize in the way I had optimistically imagined they might. Although, therefore, this picture is quite unremarkable, I have included it for a very important reason.

You will see that the foreground tree is positioned at the meeting point of two converging lines along the horizon and this was no accident. I took care to place the camera in a position that ensured these two elements met. Had they not done so, the arrangement would have looked careless and a little unsettling. The bright spot on the horizon would have drawn the eye, and the tree would have been swallowed up by the dark foreground.

Watching a sunset develop can be engrossing and it can be all too easy, in the heat of the moment, to overlook apparently minor details, but so often it is the minutiae in a photograph that determine the extent of its success. Whenever possible I, therefore, plan and construct my picture in advance before my attention turns to sky watching. I don't like to rush such matters; I try to consider each and every element and think carefully about how they should be arranged. In this image it is fairly simple because there are only the mountains and the tree to consider, but it was absolutely essential that I married them together as sympathetically as possible. Unfortunately, because of the deterioration of the sky in the final moments, it hasn't proved to be a marriage made in heaven, but it could have been. That, perhaps, will be next time.

81C warming filter

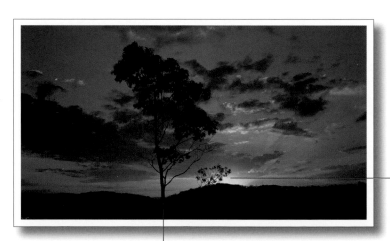

These protruding branches are an unfortunate intrusion and a distraction. My options were limited and, unfortunately, I had to accept their presence.

The alignment of the tree with the dip in the foreground where a glimpse of the distant mountains is possible was crucial. Anywhere else and the picture would have amounted to no more than a random snapshot.

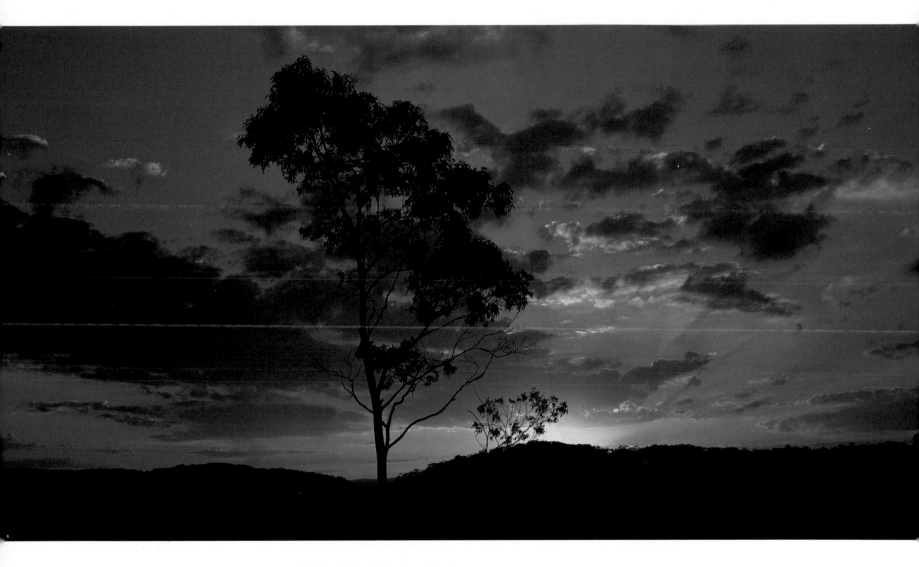

KATOOMBA, NSW, AUSTRALIA

CAMERA Tachihara 5x4in (12x6cm format back)
LENS Super Angulon 150mm (Standard)
FILM Fuji Provia 100
EXPOSURE 1/4sec at f22
WAITING FOR THE LIGHT 50 minutes

A Backlit Canopy

The Appalachian Mountains are, during the autumn weeks, awash with colour. It's everywhere and, at times, there is almost too much of it. In bright sunlight, under a clear blue sky, the colour appears to peak. Although the landscape will look spectacular, such conditions are an obstacle to successfully photographing the spectacle. Vivid colour and strong light mix like oil and water; they do not make a happy partnership and are rarely brought together successfully. The one exception to this is when backlighting is used. Leaves lit from behind become translucent and will display a shimmering, golden sparkle. This can give a photograph a vibrant, dynamic quality.

Backlighting was the only option I had during an early morning exploration of the banks of the Little Tennessee River in North Carolina. The sky was completely clear, but the occasion was saved by the watery morning light which penetrated every fibre of the tree's sweeping canopy of leaves with, crucially, a relatively low level of contrast. This is always the critical factor in this type of image because too much contrast will cause detail to be lost in either (or sometimes both) the highlights or shadows. Adjusting exposure will not compensate for this, therefore the only solution is to wait for partial cloud or mist, or haze, to weaken the sunlight. Had the contrast been too high, then the main casualty would have been the tree's trunk. It would have been reduced to a silhouette and would have spoilt the picture to such an extent that I probably wouldn't have taken it.

I was also fortunate because the tree was surrounded by colourful grass and tall foliage. This has strengthened the lower portion of the image and has helped to create what is effectively a glowing wall of colour. The sparkle on the water's surface also contributes to this and it was an added and most welcome bonus over which, of course, I had absolutely no control.

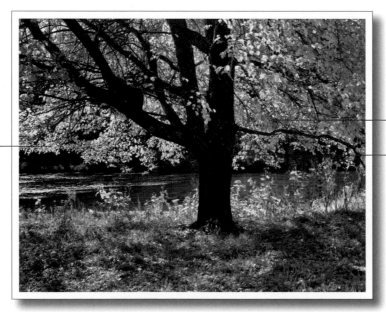

81B warming filter

Backlit leaves photograph well against a dark or shaded background.

Levels of contrast can be high in a backlit image. Here the early morning hazy sunlight has enabled detail to be retained in both the highlights and shadows.

Take care when calculating the exposure value of a backlit landscape. An abundance of highlights can create a false reading and can lead to the image being underexposed. Bracket your exposure in steps of half or one third of a stop.

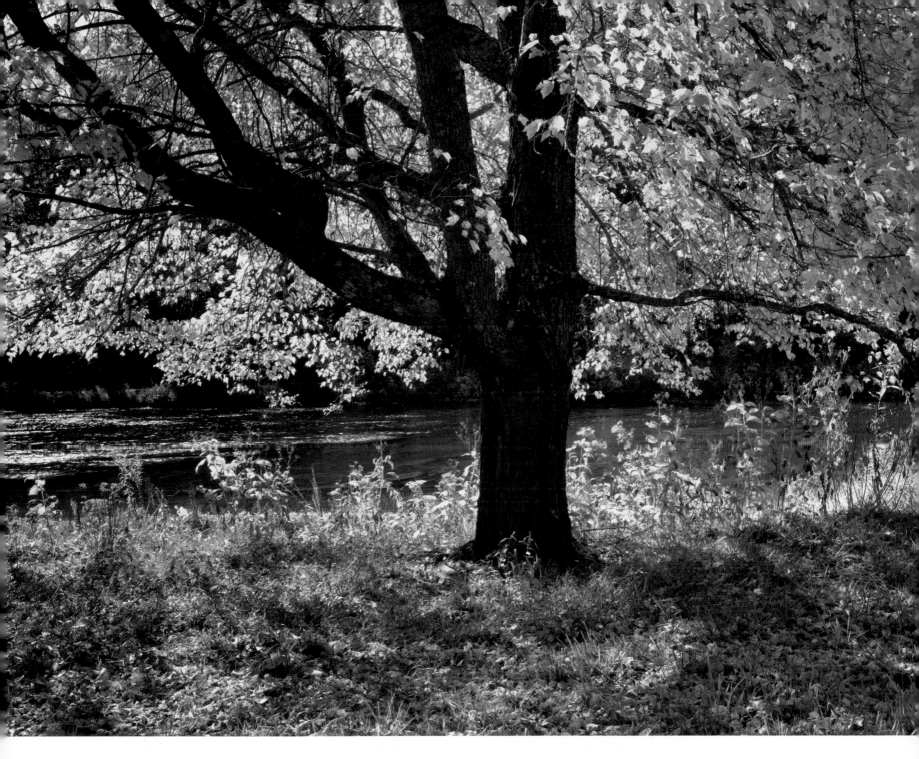

THE LITTLE TENNESSEE RIVER, NORTH CAROLINA, USA

CAMERA **Tachihara 5x4in**
LENS **Super Angulon 90mm (Wideangle)**
FILM **Fuji Provia 100**
EXPOSURE **1/2sec at f32**
WAITING FOR THE LIGHT **Immediate**

The Essential Ingredient

I was taken aback when I stumbled (literally, in fact) upon this leafy corner of my local nature reserve. My surprise was due to the fact that, despite many earlier visits, I had not previously noticed it. Perhaps I had never been there at the height of autumn, at that particular time of day when it was sunny and backlit. Whatever the reason, it was of no importance because this little piece of paradise was now firmly in my grasp.

Other than a slight warming of the picture, via the use of an 81B filter, there was virtually nothing I could do to improve what nature was offering me. My thoughts were instead devoted to the position and height of my camera. How much of the tree trunk should I include? And the roots; should I adopt a low position and give them prominence, or slightly higher perhaps, which would provide a better view of the leaf covered forest floor? These, then, were my only concerns and I must say it is a rare and cherished pleasure to be able to address the aesthetics of a photograph without the shackles of the more prosaic matters that so often dominate the image making process.

Having considered my options, I set my camera at a height of four feet as this gave me a balanced view of the foreground tree roots and also the mid and far distance. From that position everything seemed to fall naturally into place, with the individual elements – the tree trunk, roots, fallen leaves and background trees – all making an equal and cohesive contribution. Then, on top of that there was of course that gorgeous backlighting. Without it casting its spell over the forest interior there would have been little point in taking the image because, strong as the structure is, it is the quality of light that is the essential ingredient and the key to the picture's success.

An apparently mundane woodland scene can be transformed when backlit during the peak of autumn. Visit areas of potential at different times of day to familiarize yourself with the lighting conditions and monitor the locations as the season progresses to ensure that you don't miss the optimum moment.

81B warming filter

You can't see it here but in order to prevent lens flare I held an umbrella (always a useful accessory) just above the camera. Lens flare should always be avoided in a photograph.

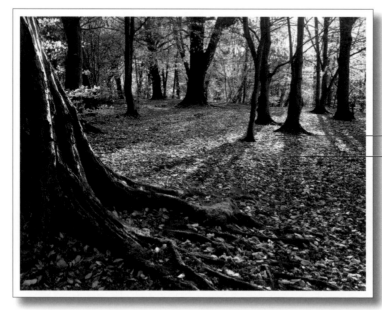

Fallen leaves look more colourful when photographed under diffuse light. This can be clearly seen by comparing the appearance of the sunlit and shaded parts of the woodland floor.

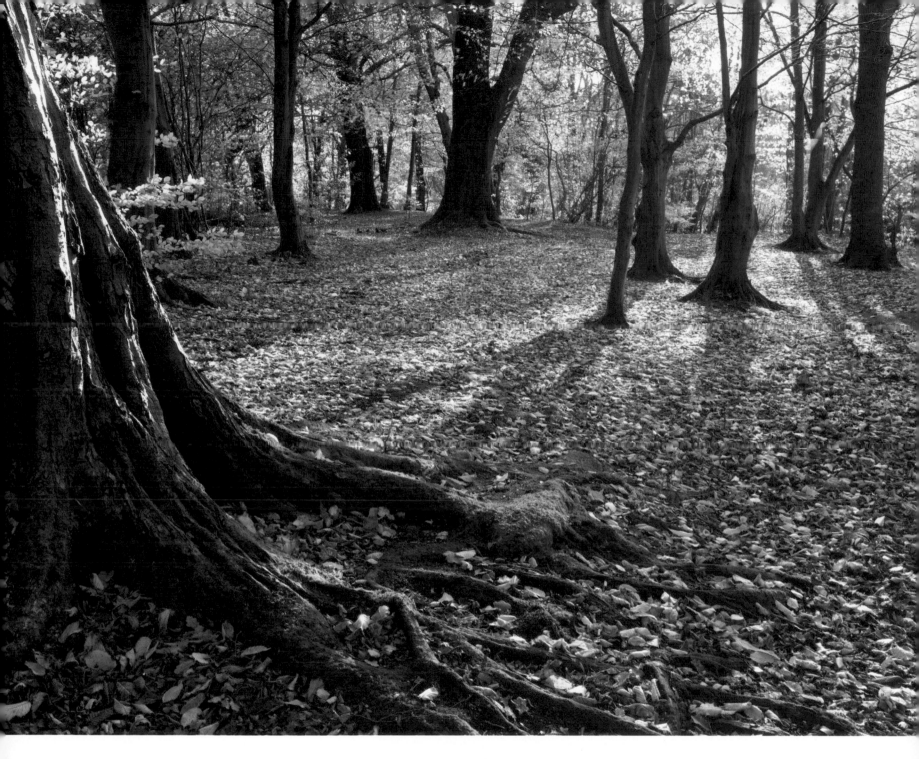

DIBBINSDALE NATURE RESERVE, WIRRAL, MERSEYSIDE, ENGLAND

CAMERA **Tachihara 5x4in**
LENS **Super Angulon 90mm (Wideangle)**
FILM **Fuji Provia 100**
EXPOSURE **1/2sec at f32**
WAITING FOR THE LIGHT **20 minutes**

A Colourful Combination

This picture is in some respects similar to the image on page 55. Again, there is a mass of colour that on its own would be difficult to make sense of as a photograph. However, although I needed something to act as a foil to the colourful conglomeration, this time there was no necessity for me to undertake a painstaking trawl of the forest because it was staring me in the face and was, in fact, the reason I decided to make the image.

This tiny, secluded shed and the surrounding forest make such a perfect pair that I didn't hesitate to set up my camera. There was no debate, no doubt in my mind that together they would make a fine picture. Although the old building is clearly the main subject, this is an image of a complementary, equal partnership. Take away the shed and you obviously lose the photograph, but without the all-embracing forest the little building would look rather sad and pointless and wouldn't make a pretty picture.

This image is an example of the whole being greater than the sum of the parts and in this respect it is by no means unusual, particularly when a picture consists of just two elements. Remove either one of the elements and you are very likely to be left with a lot less than half of the original pair.

Although I had no desire to remove anything from this landscape I would, if I could, have made one addition. The group of colourful bushes in front of the shed (to the right) should, for balance and completeness, be repeated on the left. There is dead space in that part of the image which, in an ideal world, shouldn't be there. But I'm not complaining. If it was an ideal world, there would be no challenge in attempting to photograph it and if there's one thing landscape photographers thrive on, it's a challenge!

Polarizer (fully polarized)

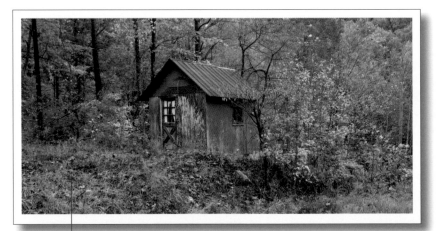

I would have preferred to have used a higher viewpoint which would have enabled me to place the cabin in a lower position. Reducing the grass bank and replacing it with more of the surrounding trees would have undoubtedly been an improvement but this would have necessitated the inclusion of the sky (you can see it beginning to creep in at the top of the picture) and I was reluctant to accept this.

This empty space, lacking in colour and visual interest, detracts from the theme of the image. The picture would have been improved by the presence of foliage across the entire width of the foreground.

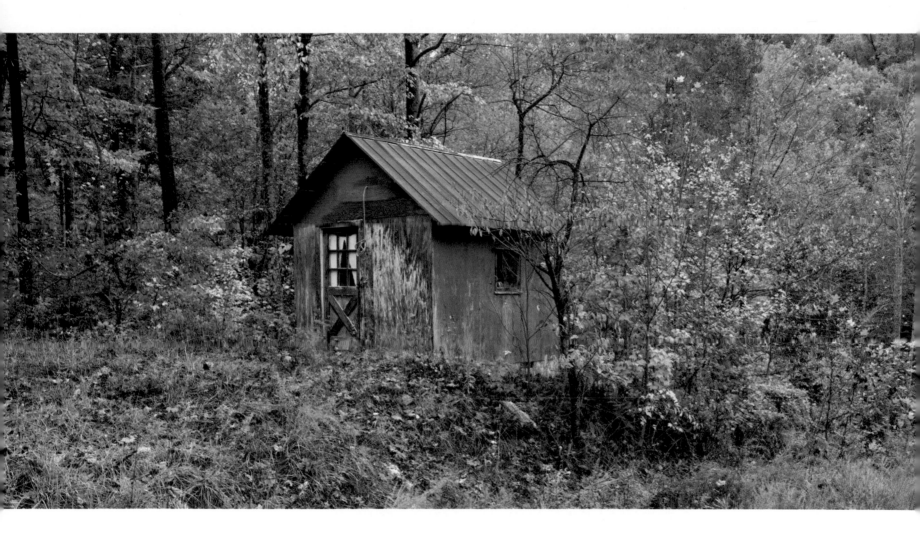

TENNESSEE VALLEY DIVIDE, GEORGIA, USA

CAMERA **Tachihara 5x4in (12x6cm format back)**
LENS **Super Angulon 150mm (Standard)**
FILM **Fuji Provia 100**
EXPOSURE **1sec at f22**
WAITING FOR THE LIGHT **Immediate**

An Unusual Hindrance

When looking at this image, I am always taken back to the day I took it: late afternoon, mid October, in the Appalachian Mountains near Bryson City, North Carolina. With camera mounted on tripod, I stood at my vantage point watching as the sun gradually dipped towards the horizon. I was there for a very memorable two hours, although at the time it seemed much longer. As the afternoon drew to a close, the light gradually softened, grew warmer and cast ever lengthening shadows across the steeply sloping mountain range. The angle of the sunlight also became more acute and, because of these changing conditions, I made an exposure every thirty minutes for comparative purposes. Of the four I made that afternoon, my preferred image, which is the picture you see here was, surprisingly, the first one I took.

I had expected the light gradually to improve the appearance of the trees and mountains, and for many types of landscape this would have been the case. However, on this occasion, the weaker light and longer shadows were of no benefit. This was a little disappointing, because the image hasn't lived up to my expectations and it could have been better. Perhaps a stronger, more dramatic sky would have helped but sadly, that wasn't to be. Clouds were few and far between during the week I spent in this part of North Carolina and I was, for most of the time, restricted to photographing in the early morning and late afternoon when there was, briefly, some modelling and shape to the landscape.

However, such occasions are not unusual and my vivid recollection of the day has nothing to do with the light or weather. It was something quite different; it was in fact the horde of ladybirds that were swarming across the sky, liberally coating every surface in their path – trees, camera, tripod and photographer included. I am only thankful that they are not apparent in the photograph, which I thought was likely to be the case, and I was concerned about it at the time. So, the image is, if nothing else, ladybird-free and although it is by no means wonderful it could, I suppose, have been a lot worse.

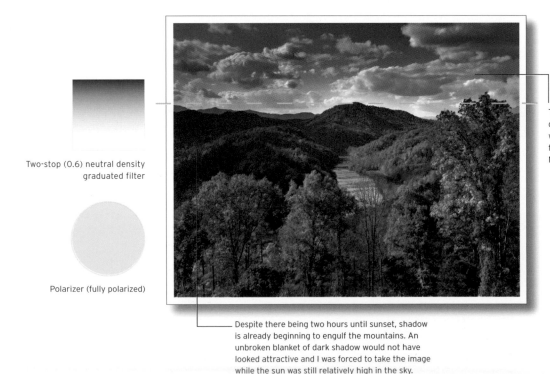

Two-stop (0.6) neutral density graduated filter

Polarizer (fully polarized)

There is a limit to what filters can do to improve a sky. Here it is weak and lacks character despite the use of both a polarizer and ND graduated filter.

Despite there being two hours until sunset, shadow is already beginning to engulf the mountains. An unbroken blanket of dark shadow would not have looked attractive and I was forced to take the image while the sun was still relatively high in the sky.

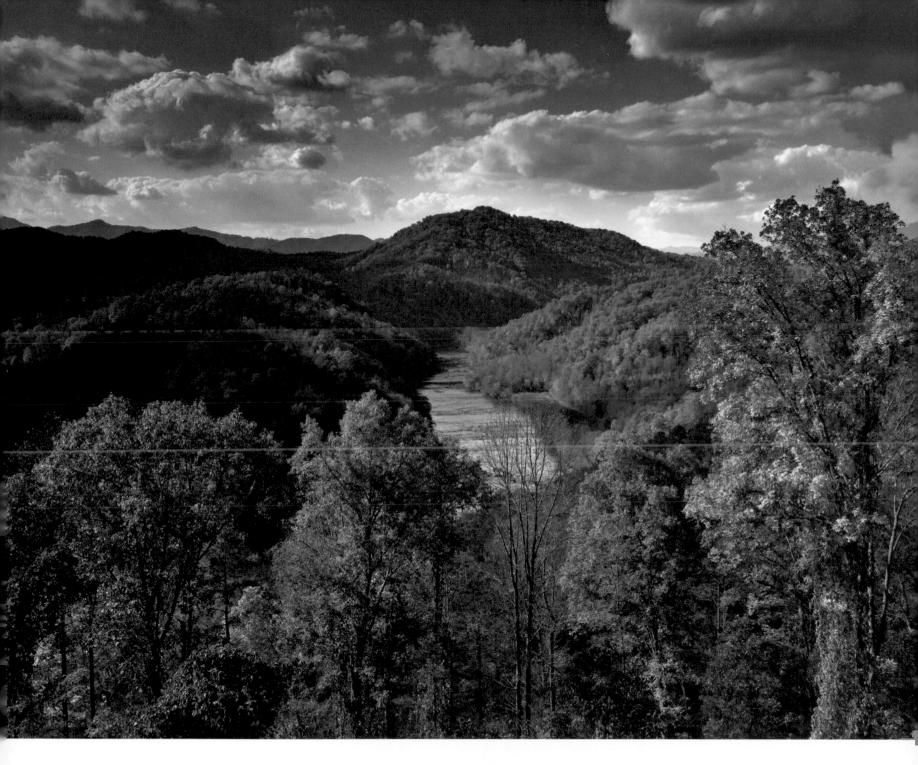

THE APPALACHIAN MOUNTAINS, NEAR BRYSON CITY, NORTH CAROLINA, USA

CAMERA **Tachihara 5x4in**
LENS **Rodenstock 120mm (Semi Wideangle)**
FILM **Fuji Provia 100**
EXPOSURE **1/4sec at f22**
WAITING FOR THE LIGHT **2 hours**

A Glimpse of Nature

This is not typical of my normal style, and it is probably as close as I will ever come to photographing wildlife! It was, I must say, a slightly eerie experience. There was an unearthly silence and stillness to the place and I vividly imagined that an army of hidden eyes was watching me, following my every move. I stood rooted to the spot for a few moments then, having decided to abandon my exploration into the centre of the forest, I retraced my steps to the safety of my car. It was of course simply to collect my camera and tripod and I was soon fearlessly back to confront and capture this rare glimpse of wild nature.

I was in fact a little apprehensive, but it was the proximity of four-legged, not eight-legged, creatures that was the source of my anxiety. Two golden retrievers had made an appearance and were scampering around and, of course, they were heading in my direction at a worryingly fast pace. The spiders' webs would have disappeared before my eyes had they been trampled down and I wasted no time in setting up my camera. Fortunately, the photograph was relatively straightforward to make. There were no specific lighting conditions to wait for because the overcast sky produced the perfect, soft light and neither were there any filters required. I was also fortunate because there was little wind to speak of and, therefore, no swaying grass to contend with. It was just a simple matter of composing the picture to give emphasis to the foreground and focusing carefully to ensure I had front to back sharpness. Photograph taken, I was soon on my way and I happily left the dogs to battle it out with the ranks of arachnids.

Polarizer (fully polarized)

Perfectly still long grass requires perfectly still air – particularly when photographing close-up. Watch carefully and wait for any breeze to drop before releasing the shutter.

The woodland patch was much smaller than it now looks. This is a result of my using an ultra wideangle lens which stretched the tiny field and enabled it to fill the frame.

NEAR MALHAM TARN, YORKSHIRE, ENGLAND

CAMERA Tachihara 5x4in
LENS Super Angulon 75mm (Wideangle)
FILM Fuji Provia 100
EXPOSURE 1sec at f22
WAITING FOR THE LIGHT Immediate

A Notable Occasion

Wide variations between day and night temperatures regularly occur in the high elevations of the North Carolina mountains and, if you add a touch of autumn and clear overnight skies, you have the perfect conditions for misty, atmospheric mornings. That certainly was my experience during my time in this part of America and it was not uncommon for the day to start under a blanket of fog and then end under a cloudless blue sky. The photographic opportunities were, of course, sandwiched somewhere between these two extremes. It was both enjoyable and invigorating to attempt to capitalize on nature's daily moody offerings.

The day I took this photograph was also a memorable and notable occasion for me because this was the first time I seriously used a digital camera. This was the day when I finally threw caution to the wind and left my film in its box. Vowing to myself that if and when I joined (or possibly briefly visited!) the digital age, I would as far as possible adhere to my tried and tested technique. I, therefore, focused manually and measured exposure with my handheld spot meter. Multi-spot metering was, however, quite unnecessary for this particular image because (apart from the sky) it has an evenly distributed range of light values. An average reading of the landscape by the camera would have sufficed, particularly as it has a sophisticated histogram playback facility, which indicates exposure accuracy. So, I guess, I was just being stubborn with myself.

The image was captured without difficulty, and is reproduced here in all its digital glory. My only concern – and this had nothing to do with the camera – was by how much I should darken the sky. This can often be difficult to judge when photographing in mist. It can be a problem because a graduated filter that is too strong can turn the sky black, while one too light can lead to overexposure and the atmospheric quality would then be lost. I decided to use a one-stop filter (this is always a good choice if you're unsure) and it has had the desired effect, with both colour and mist being evident in the sky.

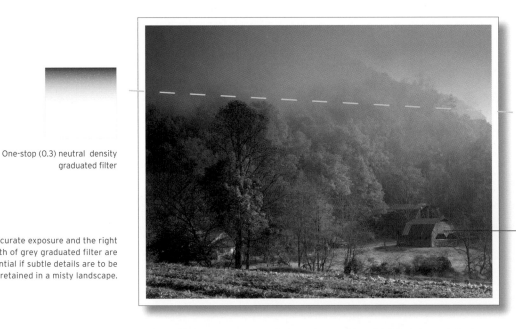

81B warming filter

One-stop (0.3) neutral density graduated filter

Accurate exposure and the right strength of grey graduated filter are essential if subtle details are to be retained in a misty landscape.

Note how the building, as always, gives scale to the picture.

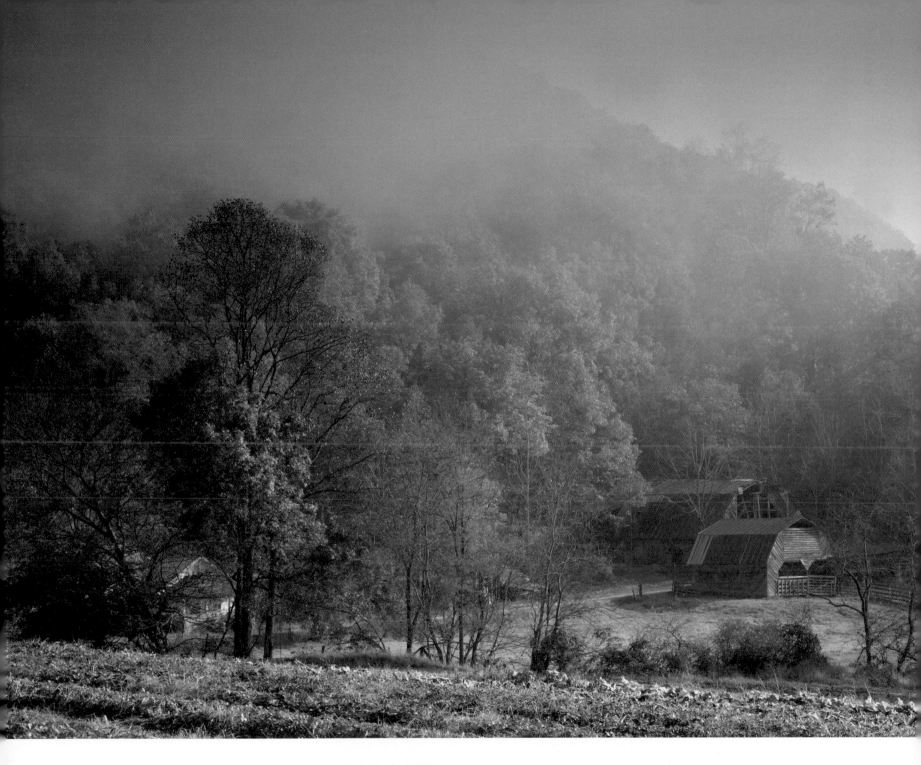

OAK GROVE, NEAR FRANKLIN, NORTH CAROLINA, USA

CAMERA **Mamiya 645ZD**
LENS **Mamiya 80mm (Standard)**
FILM **Image Sensor**
EXPOSURE **1/4sec at f16**
WAITING FOR THE LIGHT **1 hour**

A Limited Time Frame

My digital odyssey continued the following day when I once again ventured into the mist-enshrouded hills and mountains with my borrowed camera. The air was cold and damp and, for most of the morning, a dense fog lay stubbornly in the valleys. It can be difficult to evaluate locations in fog but I'd scoured the area the previous afternoon and had a viewpoint in mind which I had found and visualized as an image. I was, therefore at the location in good time, ready and waiting for the mist to lift.

Eventually (and also quite suddenly) the sun began to penetrate the murky atmosphere, and I quickly set up and waited for the most favourable moment. I wanted a specific density of mist, not too much and not too little, sufficient to create mood but without obscuring the detail in the image. As is often the case, the optimum conditions were short lived; within ten minutes of the emergence of sunlight, the fog had dissipated and the familiar cloudless blue sky prevailed for the remainder of the day. It was, therefore, fortunate that I had researched the area, knew where I was going and was prepared to make the most of the brief opportunity to capture the image. Planning and preparation are always important but, when there is a limited time frame in which to make the exposure, they are a fundamental requirement. You have to be poised and ready to pounce at a second's notice because it is highly probable that there will be no time for investigation, indecision or second thoughts.

When photographing in fog or mist, it is important to regularly check that your camera lens is clean. Moisture can form on its surface and should be carefully removed with a lens cloth. A plastic bag placed around the camera with an opening cut out for the lens is also a useful means of protecting the body.

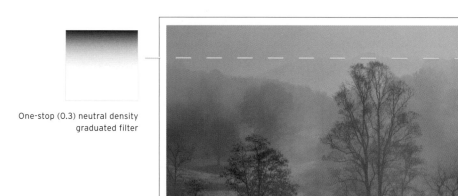

One-stop (0.3) neutral density graduated filter

Unlike the photograph on the previous page, there was no warming filter used here and this, together with a lack of sunlight, has given the image a much cooler atmosphere. Compare the two pictures and the marked difference in their appearance is clearly apparent.

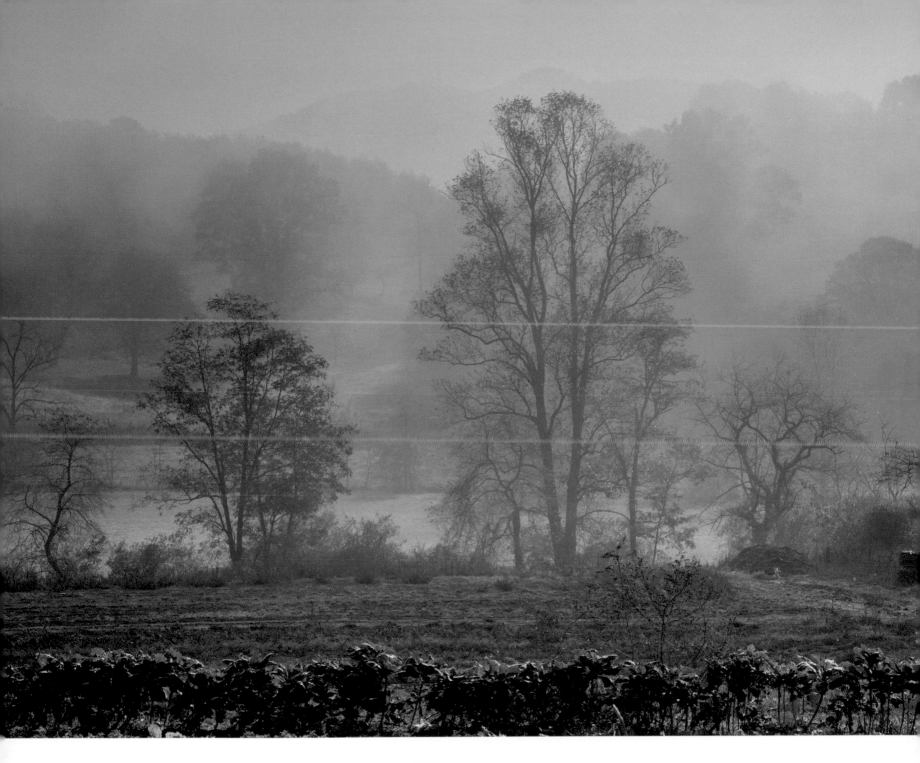

OAK GROVE, NEAR FRANKLIN, NORTH CAROLINA, USA

CAMERA **Mamiya 645ZD**
LENS **Mamiya 80mm (Standard)**
FILM **Image Sensor**
EXPOSURE **1/4sec at f22**
WAITING FOR THE LIGHT **1½ hours**

A Fertile Valley

Good locations can yield many photographs and if you find somewhere which has potential it can be rewarding to devote time to its exploration. One such place is St John's in the Vale, which lies deep in the northern part of the Lake District. Surrounded by rugged fells and mountains, it is an impressive location and is somewhere I never tire of visiting. I like to search for new viewpoints or create different versions of images I have previously made and my attempts to produce original pictures are often assisted by the region's capricious weather. It can be relied upon to keep the valley alive and vibrant and this helps to make it a fertile ground for the inquisitive photographer.

One of my earliest photographs of the valley was constructed around a barn, which you can see in the distance. I depicted it against a dark, stormy sky. At the time I felt there were a number of other images to be considered but heavy rain put an abrupt and unwelcome end to my plans that day. This time however the weather was less threatening and I was able to make a thorough assessment of the area without the risk of interruption.

There were, as I had hoped, a number of options and, after an hour or so of investigative pacing, crouching and scrambling over streams and hillocks, I chose to relegate the barn to a background supporting role. It was the tree which had caught my imagination and I felt duty bound to give it centre stage. Despite its leafless state, it radiated warmth and colour and from where I stood it had perfectly balanced form. I photographed from a low position in order to raise the tree's lower branches above the roof of the barn. It was important that there was no overlapping because, while the tree is the main subject, the barn still makes a contribution and its presence had to be clear and uninterrupted.

81C warming filter

One-stop (0.3) neutral density graduated filter

The dark shadow on the barn wall is a small but important detail. It prevents the building from being swallowed up and disappearing into the background.

The relationship of the barn and tree is the essential feature in this picture. I wanted to show them as a single, unified element and prevent them from competing for the viewer's attention. I therefore positioned the barn to allow it to be embraced, but not obscured, by the more dominant tree.

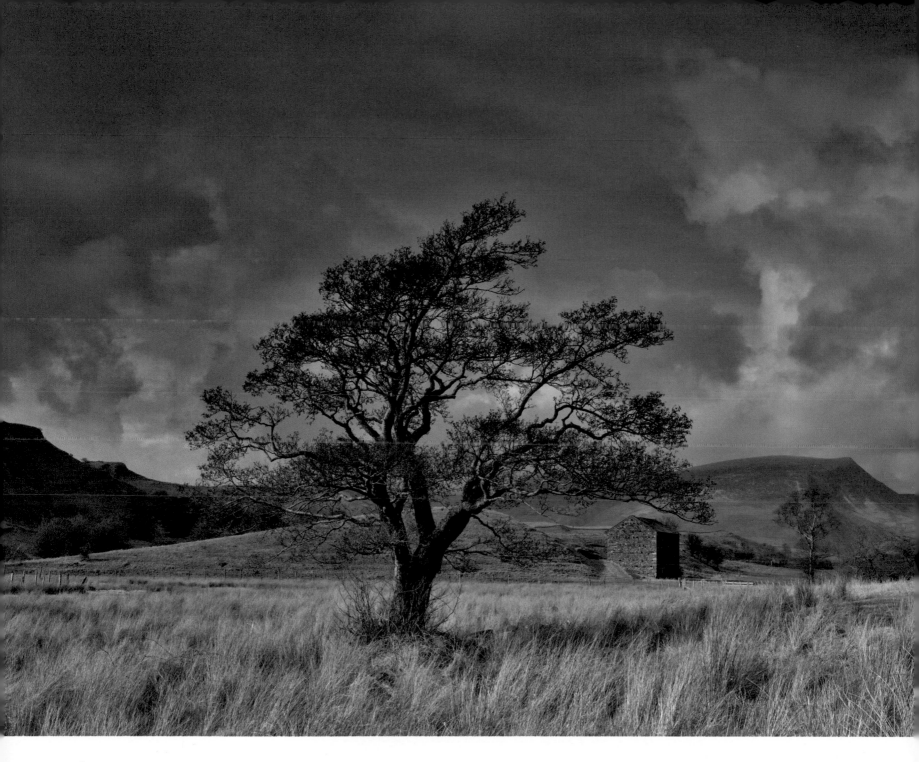

ST JOHN'S IN THE VALE, CUMBRIA, ENGLAND

CAMERA Tachihara 5x4in
LENS Super Angulon 150mm (Standard)
FILM Fuji Provia 100
EXPOSURE 1/4sec at f22
WAITING FOR THE LIGHT 1½ hours

A Softer Focus

The range of filters that I carry in my case is small: five ND graduated, two warming, a polarizer and a soft focus. I very rarely use the latter – and, when I have, it has often been with subsequent regret! The soft focus filter is, therefore, an accessory employed with extreme caution and one which I view with a degree of ambivalence. My instinct is always to produce as sharp an image as possible, but there are occasions when a photograph might benefit from a slight softening. A glowing, dreamlike atmosphere can be created which can suit certain subjects, such as a backlit, leafy forest interior, for example.

The use of soft focus is clearly apparent in the picture opposite, and this time I am quite satisfied with the result because there is no doubt that it has improved the photograph. I know this because I took the precautionary measure of removing the filter for one exposure and, having compared the two images, I much prefer the softened version. The filter has been a success because there was a hint of mist in the air and this, together with the early morning backlighting, has created the ideal conditions for the soft focus effect. On this (rare) occasion, therefore, I have no regrets.

What I am unhappy about, however, is the intrusive patch of sky above the footpath. Try as I might, I couldn't avoid it. I searched and searched for alternative viewpoints, then experimented with lower camera angles and, as a last resort, tried to use a tighter composition with a longer lens, but all my attempts were to no avail. So unfortunately the white sky had to remain. It's not a catastrophe but the picture has, unquestionably, been diminished by it.

A soft focus filter creates, as its name implies a soft focus effect. It should, however, be understood that this is not the same as out of focus. Using minimum depth of field, or an intentional lack of sharp focus, is not an alternative. The only way soft focus can be achieved is by adding a soft focus filter to a pin sharp image.

Soft focus filter

A soft focus filter will produce flare (not lens flare) and halo effects when used with backlighting. This can enhance the soft focus appearance.

The sky is an unwanted intrusion. Had it been possible I would have excluded it.

The decreasing width of the footpath – which is accentuated by the cross shadows – gives the photograph depth and a three dimensional quality.

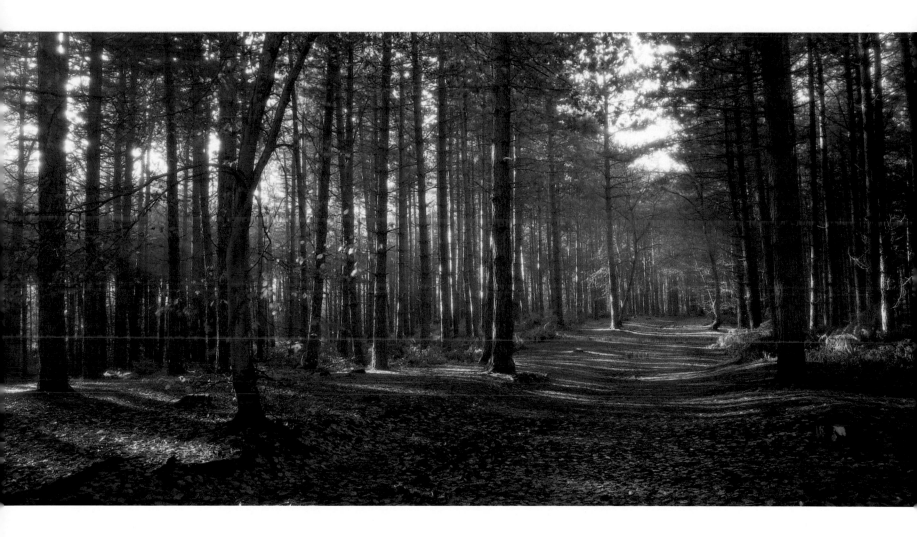

DELAMERE FOREST, CHESHIRE, ENGLAND

CAMERA Tachihara 5x4in (12x6cm format back)
LENS Super Angulon 90mm (Wideangle)
FILM Fuji Provia 100
EXPOSURE 1/2sec at f22
WAITING FOR THE LIGHT Immediate

Capture a year in the life of a tree

Trees are an attractive subject and can be the basis of many fine images. Look for specimens which have a uniform shape; damaged or misshapen trees do not photograph well and should be avoided. Depending on the theme of your image, they can be in leaf or leafless. Bare trees taken in winter can look dramatic while those which are green and leafy can create feelings of calm and serenity.

A useful – and also very enjoyable – exercise is to find a deciduous tree in a convenient, rural location and photograph it at different times of the year. As well as variations in the light and sky, you will also experience, throughout the year, subtle (and sometimes not so subtle) changes in the appearance of the tree itself. You will be able to experiment with different lighting conditions – stronger light will create impact and drama while softer light will reveal colour, texture and detail. This is also an opportunity to assess the role of filters. Photograph both with and without a polarizing filter and compare the effects and, if shooting on film, it is useful (again for comparison purposes) to use a warming filter for some of your autumn images. Photographing a year in the life of a tree can be both educational and engrossing and I encourage you to embrace such a project.

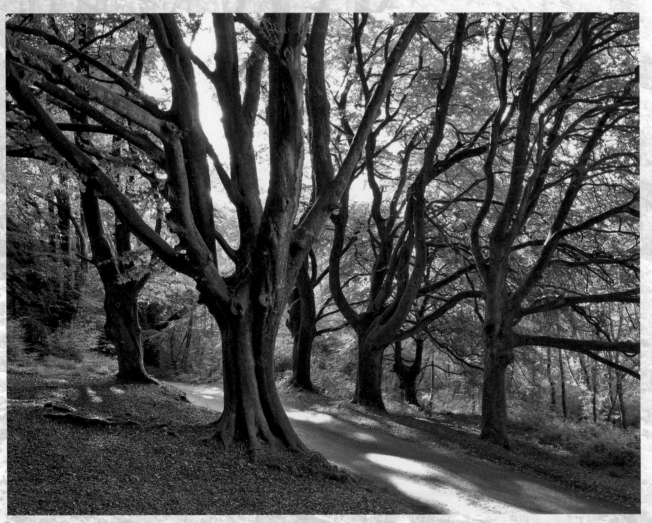

GITTISHAM HILL, DEVON, ENGLAND
(Left)
Groups of trees can be a rewarding subject to study. Tree trunks and branches can be a compelling arrangement of shapes and curves. Monitor their appearance throughout the year as well as in different lighting conditions.

PEACHTREE, NORTH CAROLINA, USA
(Top right)
It is the trees, not the barn, that are the attraction in this image. Their golden leaves are in perfect contrast to the deep blue sky. This colour contrast has been enhanced by the use of a polarizing filter.

CHATTAHOOCHEE NATIONAL FOREST, GEORGIA, USA
(Bottom right)
Adverse weather conditions, particularly frost and wind, can have a ruinous effect on fragile leaves and, as a result, the seasonal colourful climax can be short lived. To ensure you catch deciduous trees at their peak, visit them regularly and monitor their appearance as autumn approaches. Photographing with soft, diffused light will produce saturated colour particularly when a polarizing filter is used.

Become acquainted with a forest or woodland

Woodland and forest can be a fertile source of images. The year is always rich and varied – winter mists, spring and summer wildflowers, autumn colours and fungi are a few examples that come to mind – and this means there are endless opportunities for creative photography. Familiarize yourself with a conveniently located wooded area (the denser and older, the better), and visit it regularly through the seasons. Monitor its appearance throughout the year and at different times of day. Look carefully at the quality of light and how it can have a profound effect on a forest interior. Backlighting can be beautiful, particularly in autumn, while flat light will perfectly suit close-up photography of, for example, fungi, flowers and tree bark.

Images can abound but they are not always obvious. Fallen leaves and tree roots can make interesting subjects but can be easily missed. Be vigilant, the photograph you're looking for might literally be under your feet!

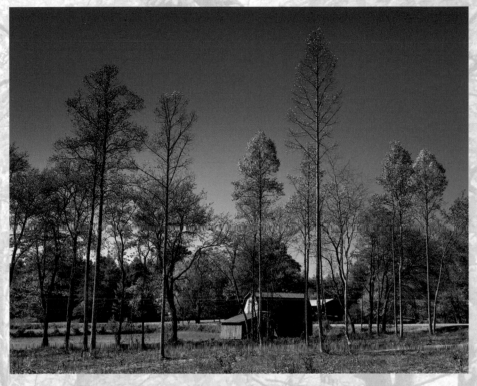

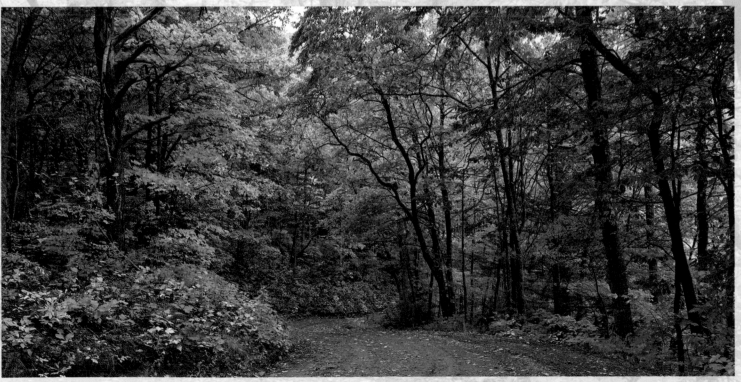

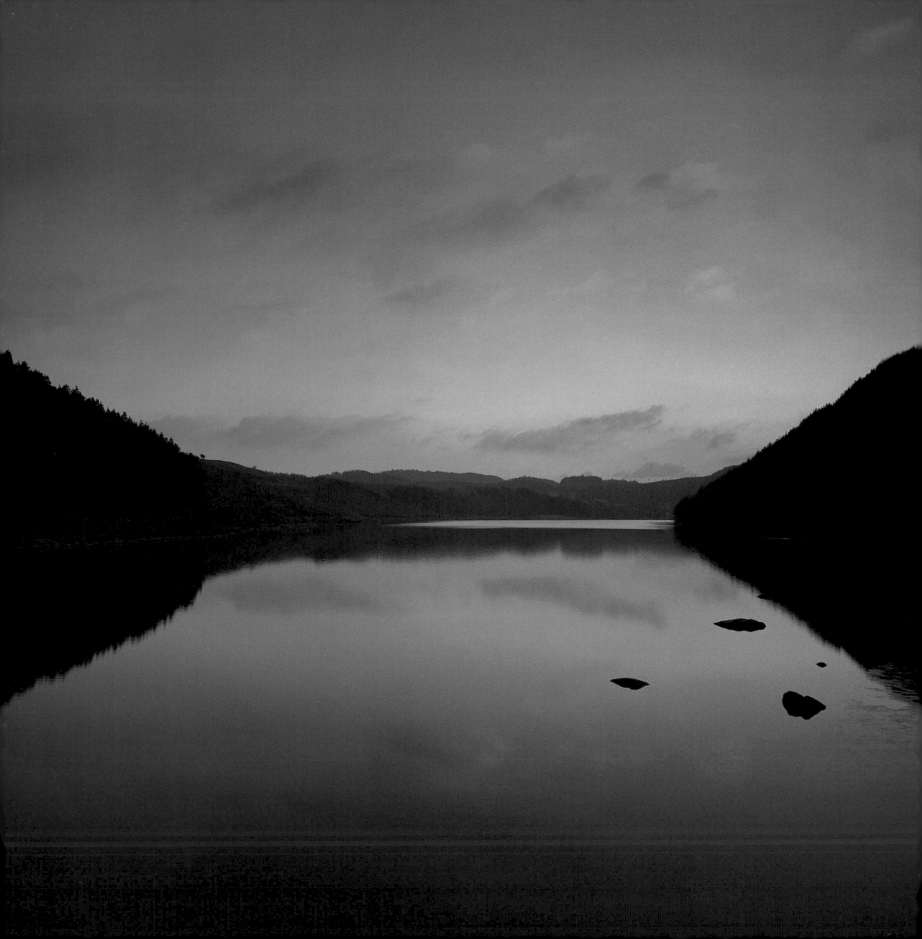

CHAPTER THREE
Lakes, rivers & waterfalls

The source of life and the source of beauty, water is the most basic and most indispensable of elements. To the landscape photographer it is an equally indispensable source of creative image making. Water enhances a landscape; it defines its character, determines its mood, shapes it and gives it an identity. Together with light, water is one of the raw materials on which we photographers are totally and inescapably dependent.

Used together, water and light can produce visions of unsurpassed beauty. Look for reflections on the mirror-like surface of a calm lake, or sunlight filtering through a dawn mist or, if fortune favours, you might capture a rainbow as it bursts into colourful life fleetingly to adorn a cloud-filled, grey sky.

In its solid, frozen form, water also has much to offer the photographer. Ice patterns formed along the edge of a lake are themselves a worthy subject and can also provide a striking foreground for the wider view, as can frozen leaves, reeds and frost covered stones.

Moving water is another attraction and photography, perhaps more than any other art form, is the perfect medium for capturing the elegance of its flowing form. Look for rivers and waterfalls that have appealing combinations of tumbling waters and colourful rocks and boulders. The meeting points of fast flowing water and solid, immovable rock are a rich source of opportunity and should be eagerly sought.

LLYN GEIRIONYDD, SNOWDONIA, WALES
Repetition is the theme of this photograph. Divide it either horizontally or vertically and you have two virtually identical mirror images. The one exception to this symmetry is the group of rocks protruding through the lake's surface. They are not an intrusion; I feel they bring a variation and a necessary hint of reality to the picture.

CAMERA **Tachihara 5x4in**
LENS **Super Angulon 90mm (Wideangle)**
FILM **Fuji Provia 100**
EXPOSURE **8sec at f22**
WAITING FOR THE LIGHT **45 minutes**

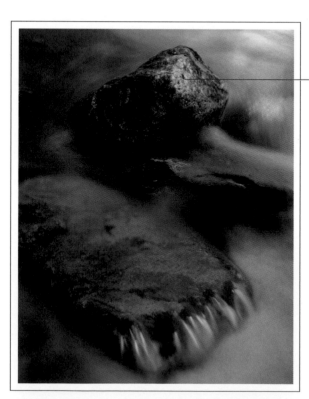

A Hidden Jewel

I can spend many a happy hour wandering through a forest, following the course of a winding river. To my mind, there is something utterly entrancing in a meandering, flowing stream. They seem to radiate a unique aura, a special quality which I find compelling. What I particularly like is the fact that no two rivers are ever the same. And not only are they individually unique, thanks to variations in rainfall, rivers and streams exist in a constant state of change. Miniature waterfalls and colourful rocks will miraculously appear, disappear, shrink and expand from one day to the next. This ongoing state of flux ensures there is always something new to discover.

I cannot recall the number of times I have strolled through Beddgelert Forest, along the banks of the River Colwyn (I say stroll but please be under no illusions, a photographer's stroll

along a riverbank invariably involves bouts of investigative stooping, peering, crouching, climbing and, if we are incredibly lucky, remaining upright). Despite my familiarity with the river I was, until my latest visit, completely unaware of this intricate microcosm of colour, shape and movement. It was, I must admit, a thrilling encounter. I knew as soon as I saw the gleaming rock that I had discovered a jewel. It must have remained hidden over the years because of the water level – this is the critical, and by far the most important, factor in this type of picture. The river must be just right, not too high, not too low, not too fast and not too slow. There is little tolerance in this, and it is difficult to predict what a river will look like. If you have a particular photograph in mind, you should make regular visits, monitor the appearance and then pounce when everything looks favourable.

Polarizer (fully polarized)

The polarizing filter has reduced the surface reflection of the wet rock and has also strengthened its colour. By absorbing the equivalent of two stops of light, the polarizer also enabled me to use a slow shutter speed to blur the movement of the water.

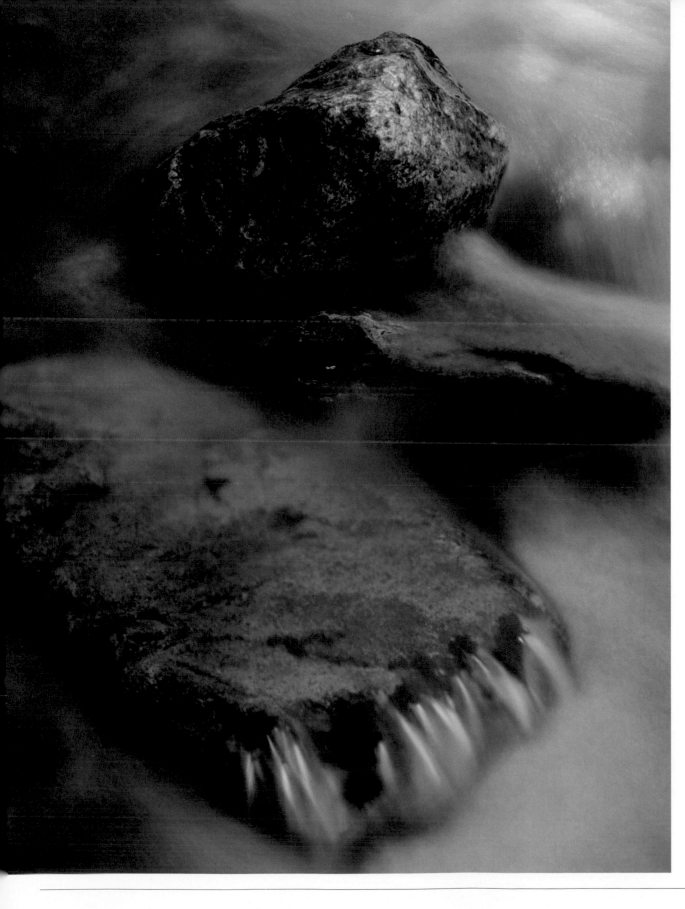

**AFON COLWYN, BEDDGELERT FOREST,
SNOWDONIA, WALES**
CAMERA Tachihara 5x4in
LENS Super Angulon 150mm (Standard)
FILM Fuji Provia 100
EXPOSURE 3sec at f22
WAITING FOR THE LIGHT Immediate

Time Embedded

I visited these falls during a severe drought and my expectations were as low as the water level. I was prepared for the worst - a barely trickling stream, stagnant pools and dry rocks - so you can imagine my surprise, and of course delight, when I was greeted by the sight of these cascading, flowing waters. I am only thankful that I caught them in a dry spell because there would surely be just too much water to photograph at any other time.

Like many photographers, I prefer to blur water in an image and I never tire of the creative challenge of transforming a splashing torrent into something defined and timeless. There is, to my eye, a beguiling elegance in the silken, flowing contours and curves, and also a magical quality when time is frozen and embedded into the heart of a waterfall. The technique involved in achieving such an effect is not difficult but you will need a sturdy and adaptable tripod, preferably one designed for landscape use. River beds and moss covered rocks are uneven and perilous surfaces and are hardly the perfect foundation for precision image making, so you must have a secure and solid support for your camera. A tripod which lacks flexibility in its movements can lead to the composition of a photograph being seriously compromised, it can also cause camera shake and - the ultimate of disasters - it could topple over, taking your camera along for the ride and testing its water resistance capabilities far more thoroughly than you would have ever wished for! I suggest, therefore, that along with waterproof boots, you pack a robust, adaptable tripod before venturing anywhere near a fast flowing river or waterfall.

To blur water an exposure of between 1/2 second to 2 seconds is usually required, depending on the water's speed and direction. In most cases a 1 second exposure will achieve the desired effect and is a good starting point.

A combination of white water, rocks and foliage will invariably lead to high levels of contrast and to minimize this it will be necessary to photograph under very flat, shadowless light.

The making of this image turned out to be somewhat demanding. It was taken from a position which was neither obvious nor easily accessible. It necessitated very careful placing of my tripod in the middle of falls and was only possible because of the tripod's rigidity and adaptability.

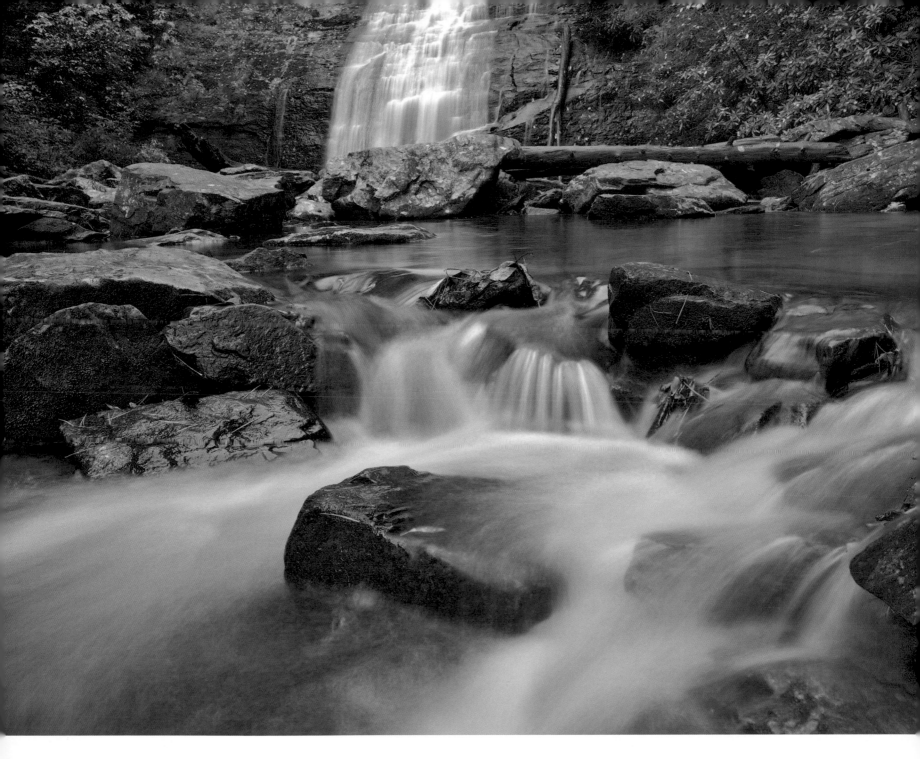

HELTON CREEK FALLS, GEORGIA, USA

CAMERA **Tachihara 5x4in**
LENS **Super Angulon 90mm (Wideangle)**
FILM **Fuji Provia 100**
EXPOSURE **1sec at f32**
WAITING FOR THE LIGHT **Immediate**

The Beauty of Symmetry

Uniformity and symmetry are bywords in my approach to composition. I am, I suppose, obsessive about them and have frequently dismissed a potential photograph because it lacked, in my view, a certain balance or harmony. I may have sometimes been pedantic over such matters, and it is possible that I could have squandered a number of opportunities by needlessly rejecting them. This, however, is conjecture on my part because there are of course no photographs from such occasions and, therefore, no evidence exists to either prove or disprove my profligacy. When looking at this picture of the Nantahala River, I am, however, inclined to think that the number of overzealous assessments I have been guilty of are relatively few. I say this because at the time of taking this photograph, I was unsure. It was a borderline decision and, after some protracted deliberation, I chose to make the image, but now I'm not sure it was the right choice.

The problem is that the nicely curving top row (or, rather, half row) of trees is, to me, an irritant. The trees should span the width of the picture but they are rudely interrupted by those bushes on the right which extend down the bank and across the stream. I waded up, down and across the river searching for an alternative viewpoint, but there was nothing to be found because of the need to include cascading waters in the foreground – and this limited my options. So, although unwanted, the ghastly bushes had to stay. If happier with the background I would have used a lower camera position. This would have accentuated the mini waterfall and also narrowed the middle stretch of river (which makes little contribution to the picture) and may have seemed to improve the photograph. Such a viewpoint would, however, have forced me to raise the angle of the camera, and that would have increased the mass of the background trees and bushes, which wasn't an appealing prospect. The result of my compromised approach is that the structure of the photograph is weak and lacking in impact. All this stems from my dislike for the asymmetrical background, and I do wonder if I was right to make the image. I am undecided, but what is in no doubt is that my appetite for balance and symmetry has been sharpened by this experience.

Polarizer (fully polarized)

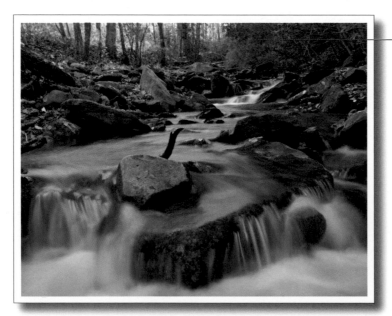

The crescent shaped leafy background should extend across the width of the picture but the overhanging bushes prevented this. Had they done so, I would have lowered the position of the camera and raised the angle to include more of the background trees.

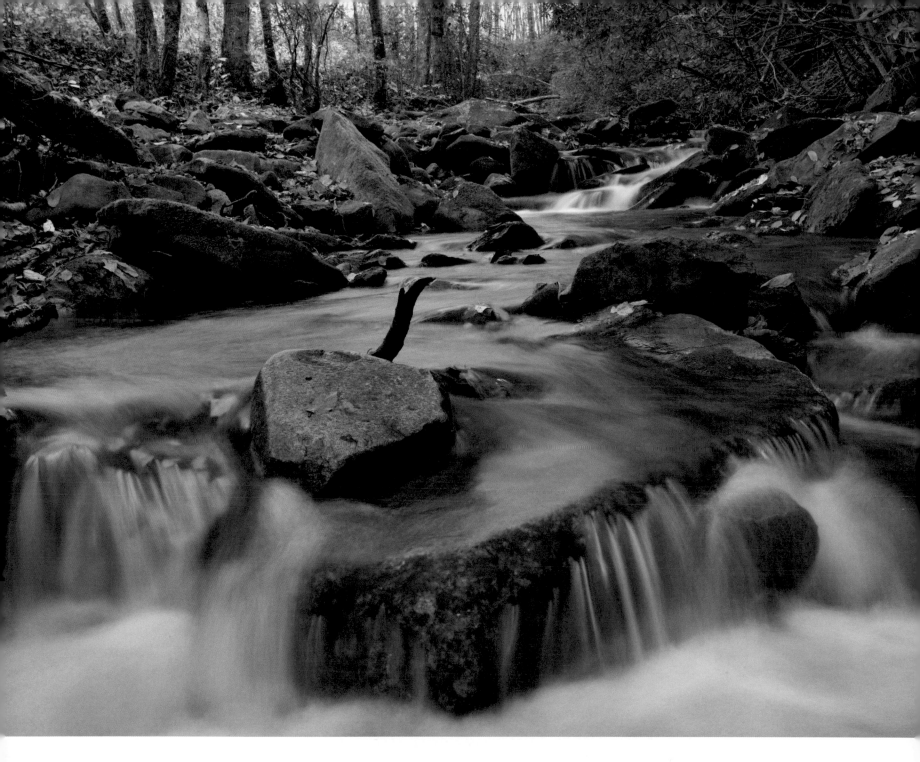

NANTAHALA RIVER, NORTH CAROLINA, USA

CAMERA **Tachihara 5x4in**
LENS **Super Angulon 90mm (Wideangle)**
FILM **Fuji Provia 100**
EXPOSURE **1sec at f22½**
WAITING FOR THE LIGHT **Immediate**

A Complete Picture

It is rare that I photograph a lake during a howling gale, but there was one occasion during a particularly stormy period in February, whilst driving past Buttermere, when I suddenly felt compelled to pull over and take a look. It was quite obvious the lake's surface would be choppy, but the sky was brimming over with moody magnificence and I couldn't let the moment pass me by. Bursts of sunlight were flashing across the trees and mountains and it all looked quite stunning. Taking it all in, I knew that my role as a mere spectator was going to be short lived.

Within minutes I was set up and keenly observing the billowing storm clouds. This image is as much a skyscape as a landscape because the lake, partly as a result of the lack of reflections, makes only a minimal contribution. I was, therefore, happy to devote the majority of the picture to the sky and place the horizon towards the bottom of the frame. But, for this to succeed,

it was important that what little there was of the landscape was lit in an interesting and appropriate manner. Bright, widely spread sunlight wasn't what I wanted; the light had to be in keeping with the character of the sky which meant piercing, strategically placed rays that carried with them a sense of drama.

Within twenty minutes of my arrival, a solitary beam broke through the cloud to spotlight a small patch of grass and an isolated tree. I couldn't have wished for better. It was the perfect answer to the storm clouds because it brought a balance to the sky and landscape. They are both now equals in terms of visual weight and together they form a complete picture.

The drama of a stormy sky can be heightened by the quality of light. A spotlit landscape with sharply contrasting light and shade can be particularly effective. Watch and wait for the key moment.

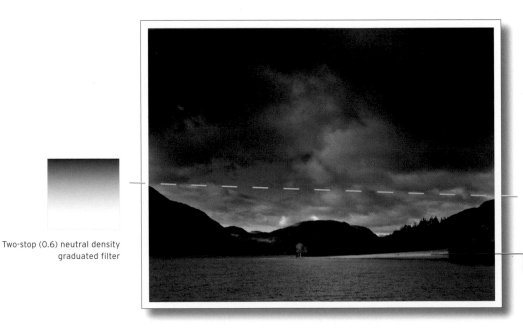

If a particular element is making little contribution in an image, reflect this in your choice of composition. Here the sky is much more interesting than the lake and I have therefore given it centre stage at the expense of the ruffled, non-reflective water.

Two-stop (0.6) neutral density graduated filter

A landscape does not need to be expansively lit to attract attention. A splash or two of light is often all that is required.

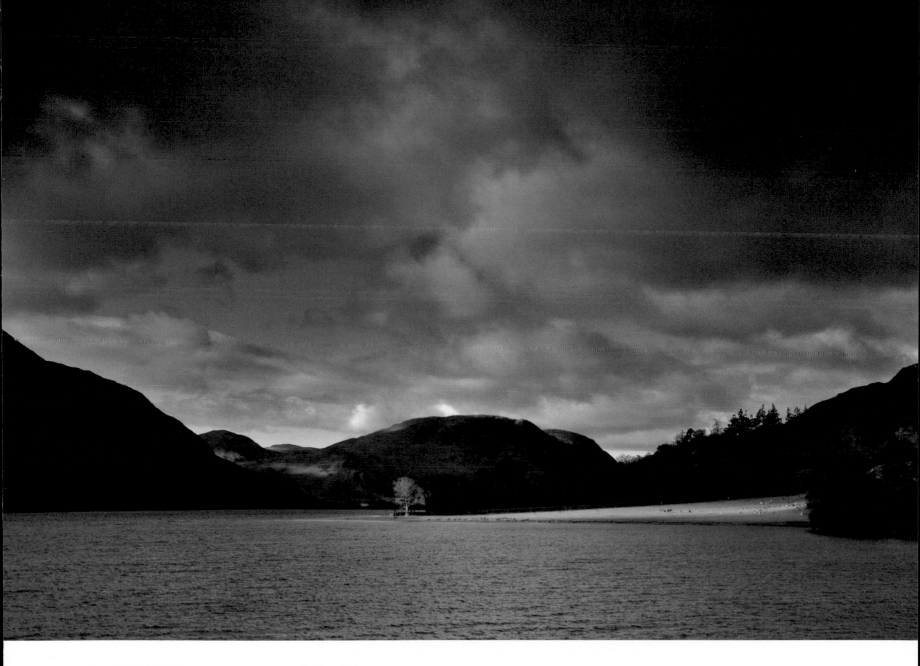

BUTTERMERE, CUMBRIA, ENGLAND

CAMERA **Tachihara 5x4in**
LENS **Super Angulon 150mm (Standard)**
FILM **Fuji Provia 100**
EXPOSURE **1/4sec at f22**
WAITING FOR THE LIGHT **20 minutes**

A Tree Beckons

The process of selecting the images for this book was not as simple as I had imagined it would be. Despite assuming that allocating each of my chosen photographs to its appropriate category would be a straightforward task, it wasn't that easy. With hindsight I should have anticipated the dilemmas awaiting me because a landscape image can often consist of a number of diverse elements and these can conspire to defy categorization. An example of this is this picture of a Highland lake, mountains and moors. Should I assign it to the lakes and rivers section or would mountains and wilderness be more appropriate? It was almost neither, in fact, because I also considered the image for the trees and woodland chapter, as it was the solitary tree on the edge of the lake which had encouraged me to take a closer look.

I think that subconsciously I must be constantly on 'tree alert' because I had spotted it from the road and of course I had to stop and investigate. Often such chance encounters come to nothing but here everything seemed to fall into place quite naturally, with the tiny, leafless tree acting as the link between the foreground and background. The image would, I think, still succeed without the tree but there is no doubt in my mind that its presence strengthens the photograph because it helps to give the picture depth and scale.

At the time of my arrival, the lake and surrounding moors were bathed in harsh sunlight, which wasn't to my liking, but I wasn't concerned because a blanket of cloud was approaching and it was simply a matter of biding my time. When photographing an open, distant view, I like to use light as sparingly as possible; if the foreground is colourful I prefer to have it subdued, with splashes of light in specific parts of just the middle and far distance. Restricting the light to strategic points helps to delineate shape and perspective and improves visual impact. I was therefore happy to wait for the arrival of the cloud and capture the moment when there was only reflected light on the surface of the lake and broken sunlight on the distant snow covered mountains.

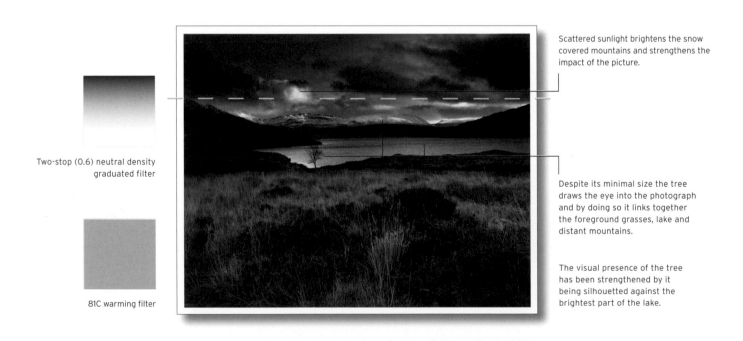

Two-stop (0.6) neutral density graduated filter

81C warming filter

Scattered sunlight brightens the snow covered mountains and strengthens the impact of the picture.

Despite its minimal size the tree draws the eye into the photograph and by doing so it links together the foreground grasses, lake and distant mountains.

The visual presence of the tree has been strengthened by it being silhouetted against the brightest part of the lake.

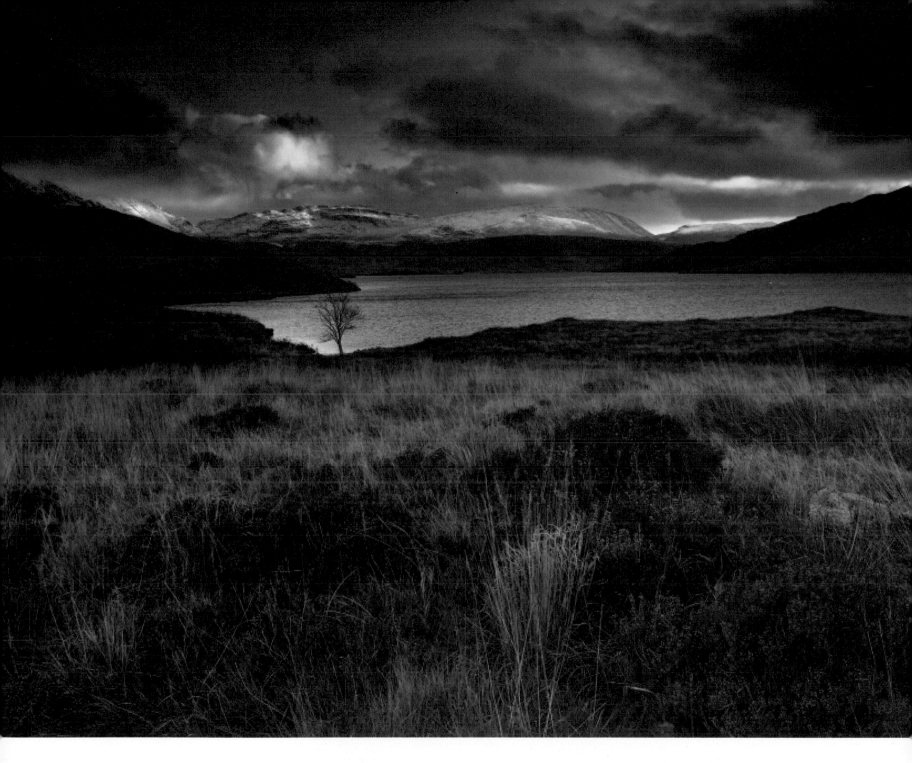

LOCH ASSYNT, SUTHERLAND, SCOTLAND

CAMERA **Tachihara 5x4in**
LENS **Rodenstock 120mm (Semi Wideangle)**
FILM **Fuji Provia 100**
EXPOSURE **1sec at f32**
WAITING FOR THE LIGHT **1¼ hours**

Seeking Equilibrium

I must confess to having a weakness for lakes. I simply cannot resist taking a look at any inland expanse of water, from the tiny, remote tarn to the larger, much celebrated tourist destination. Size, location and reputation are immaterial – if there's water, I want to stand in front of it, admire it and gaze over its rippled surface. My favourite season for lake spotting is winter; I like the light at that time of year and the tranquillity, and also the colours and reflections, which seem to be softer, more understated.

Ennerdale Water was exuding all these qualities when I stopped by late one February afternoon. It was blissfully quiet – although I didn't have the lake entirely to myself because another photographer was already in situ at the head of the main stretch of water, with camera mounted, at eye level, on tripod. It was the obvious vantage point but there seemed to be nothing for the viewer to dwell upon, particularly if the foreground was lost by photographing from a position 5 or 6 feet (1.5 or 1.8 metres) above ground level. It wasn't for me, so I walked the length of the lake to an enclosed corner that had the attraction of a uniform

ring of trees, a scattering of good sized, nicely shaped foreground rocks as well as shallow, dappled water. A low camera position enabled me to create a balanced arrangement of rocks, water, trees and sky. Dominance of one element over another was to be avoided; I wanted each of the four components to blend seamlessly together and make an equal contribution. Photographing at head height would not have produced such equilibrium.

An important feature of this image is the gentle sunlight. This is winter light at its best: low, angled, warm and fairly soft. The light has also been filtered and dappled by the leafless trees, which is another benefit of winter photography. This picture couldn't be made during the summer months because there would be too much shadow and contrast.

I am, you will gather, happy with the outcome of my visit to this charming lake and I hope that the photographer who shared the occasion with me is also satisfied. It's not my concern but I do wonder about that high camera position...

Polarizer (fully polarized)

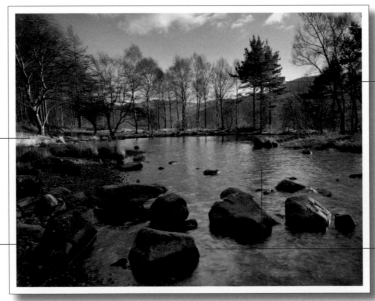

I like to use a combination of a shaded foreground and a more brightly lit background. This type of light helps to balance the elements and gives a photograph depth.

The choice of camera position, particularly its height, will have a significant effect on the relationship between the foreground, middle distance and background; the lower the position, the greater the foreground emphasis.

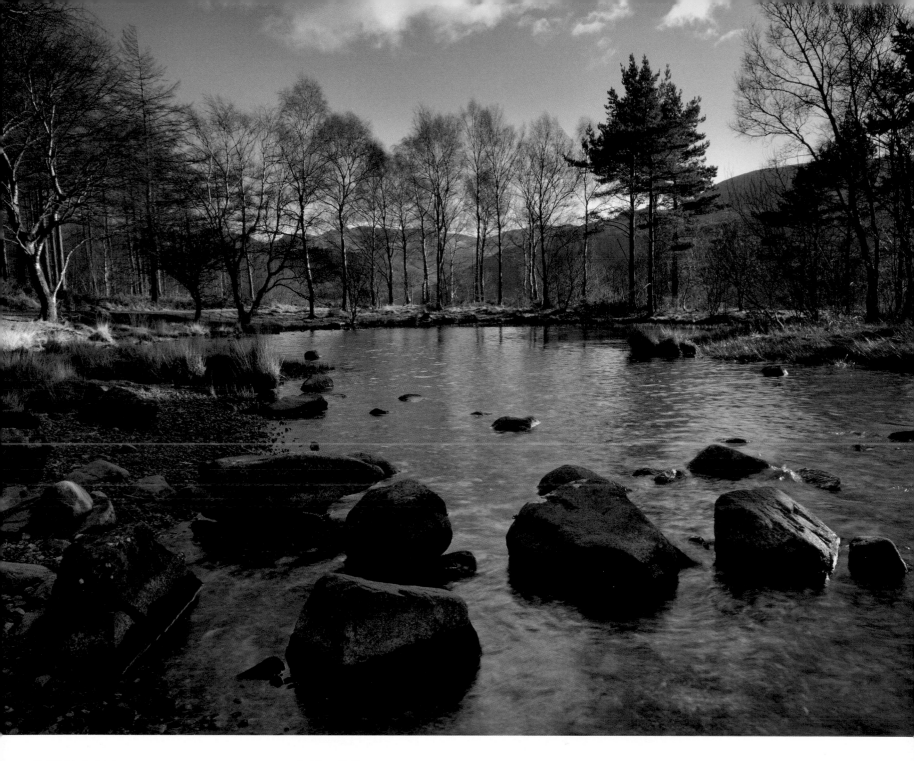

ENNERDALE WATER, CUMBRIA, ENGLAND

CAMERA **Tachihara 5x4in**
LENS **Super Angulon 90mm (Wideangle)**
FILM **Fuji Provia 100**
EXPOSURE **1/2sec at f32**
WAITING FOR THE LIGHT **40 minutes**

A Balanced Arrangement

I had driven 15 meandering miles through the Chattahoochee Forest to reach the Horse Trough Falls but, sadly, when I arrived they were a disappointment. The drought had taken its toll and the falls were looking decidedly sorry for themselves. I was of course a little deflated but not entirely surprised so, having made the circuitous journey, I embarked on a rock-by-rock search of the nearby streams for another image. The lack of water restricted my options and I was fortunate that, after spending two hours making a forensic-like examination of the river, I discovered two images lurking in the depths of the forest.

The first picture, opposite, appealed to me because it has such a perfectly balanced arrangement (my obsession with symmetry again) but it is regrettable that the perfection has not extended to the flow of the river. The problem isn't the low water level – in this instance it actually improves matters – it is the river bed, which is too smooth and free of rocks. Because of this there is no cascading water and the river is restricted to playing a passive role. It still makes a contribution and is the main focal point but there is no doubt that the image would have benefited from the presence of a more dynamic and rugged river with tumbling white water.

I initially used a relatively fast shutter speed of 1/2 second – in an attempt to sharpen the definition of the stream – but it wasn't successful. The resulting jagged appearance served only to emphasize the paucity of water and I eventually settled on a 3 second exposure. This is longer than I would normally use but this time it produced the best result.

When visiting a waterfall always check the surrounding rivers and tributaries for alternative images. More interesting pictures can often be found up or downstream, away from the main cascade. These small scale mini waterfalls are largely ignored and are rarely photographed, but once found they provide the opportunity for originality and creativity and frequently make the better photograph.

The river is surrounded by a group of naturally balanced elements which recede step by step into the distance. It was this symmetry which led to my making the photograph.

The picture suffers because of the smoothness of the river bed. The river lacks interest and the presence of a scattering of rocks and boulders would have improved its appearance.

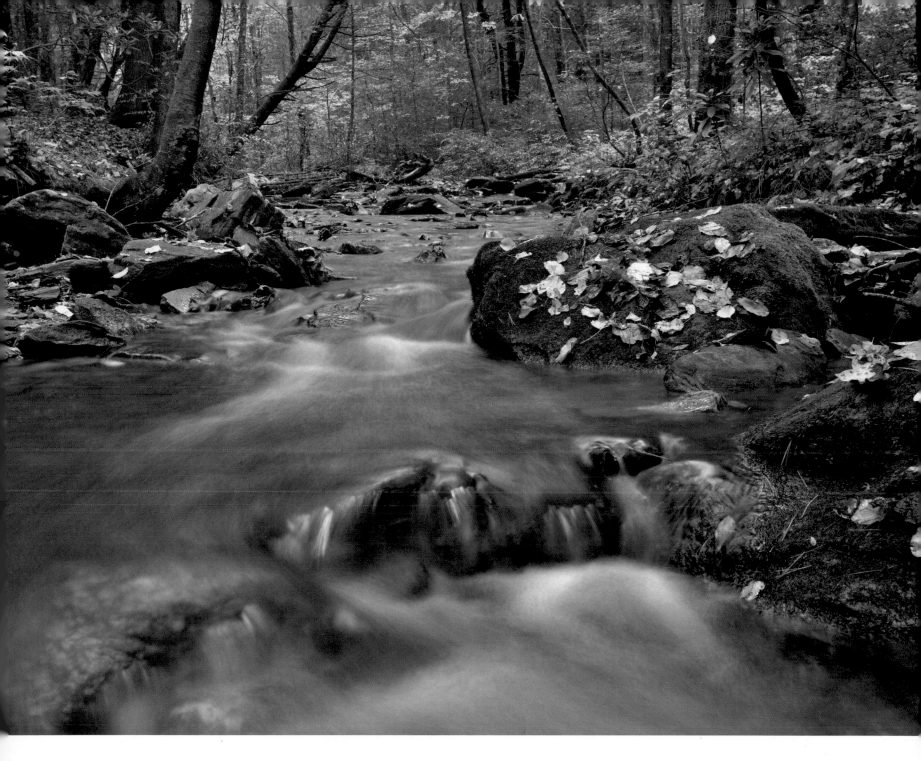

HORSE TROUGH FALLS, GEORGIA, USA

CAMERA **Tachihara 5x4in**
LENS **Super Angulon 90mm (Wideangle)**
FILM **Fuji Provia 100**
EXPOSURE **3sec at f32**
WAITING FOR THE LIGHT **Immediate**

Defying Gravity

Finding and photographing this miniature, transient waterfall was – I have to say – a most enjoyable and satisfying experience. It is, however, regrettable that the opportunity to make it arose as a direct result of the severe water shortage in the area. Although I have no desire to profit from another's misfortune, having stumbled upon this marvellous miniature world of glowing, glistening colour I was compelled to capture it in all its glory. I should imagine that this delightful rocky formation normally languishes under several feet of raging torrent and rarely sees the light of day; it was, I felt, therefore incumbent on me to make a faithful record of the memorable occasion.

Having made the discovery the hard work was, essentially, over – or so I thought. What should have been the relatively simple task of composing the picture and positioning my tripod developed into a mammoth struggle against the forces of nature and gravity. The problem was the extremely wet and slippery, and abruptly sloping, surface. The steep incline, flowing water and saturated moss combined to deadly effect to defy my attempts to find a secure footing for my tripod. It was treacherous, so I eventually resorted to scraping away much of the moss and building a support with boulders. I had to be certain it was secure because the camera I was using had been lent to me and I had visions of it crashing headlong into the muddy river! That was not something I relished explaining to my benefactor.

Having finally set everything up I fitted a polarizing filter before making an exposure using a 2 second shutter speed. It was important that I added the polarizer because the wet rocks were acting as a very efficient reflecting surface. The filter has absorbed much of the reflection and has strengthened colour. Helpfully it also absorbed the equivalent of two stops of light which enabled me to use a slow shutter speed.

Image taken and tripod support carefully dismantled, one very wet photographer and one very dry camera set off happily on the journey home through the labyrinth of Chattahoochee Forest.

81C warming filter

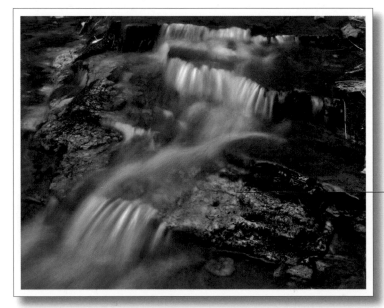

Polarizer (fully polarized)

You don't need a torrent of water to make an image. When river levels are low look for close-ups of miniature waterfalls and colourful rocks. These might normally be submerged and hidden from view.

Colour rendition, particularly on a wet surface, will be improved by the use of a polarizing filter.

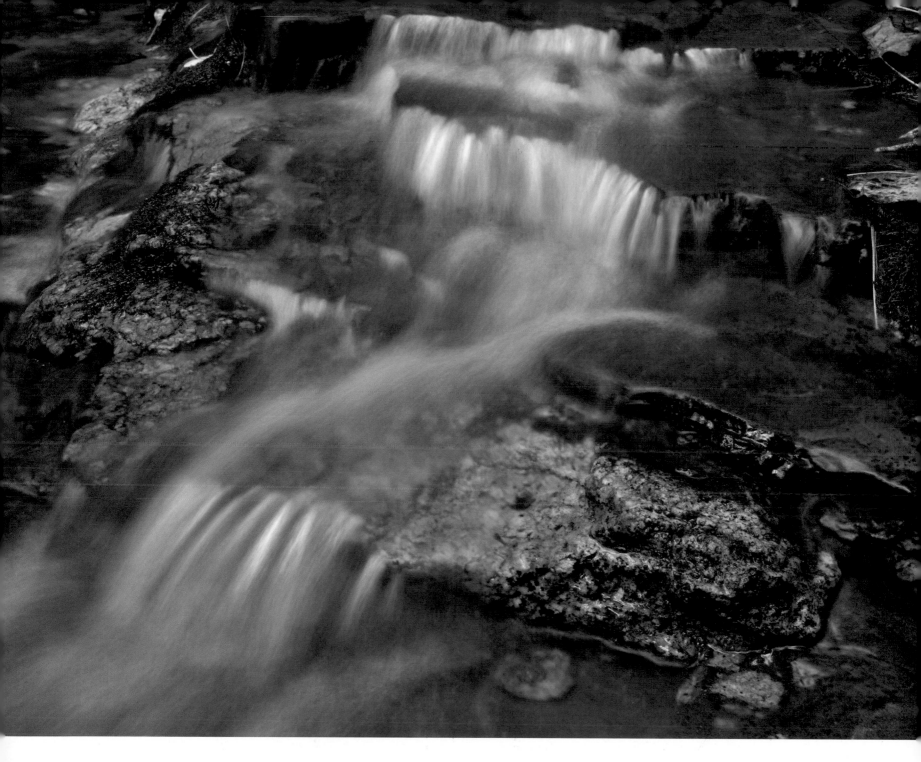

HORSE TROUGH FALLS, GEORGIA, USA

CAMERA **Mamiya 645ZD**
LENS **Mamiya 80mm (Standard)**
FILM **Image Sensor**
EXPOSURE **2sec at f22**
WAITING FOR THE LIGHT **Immediate**

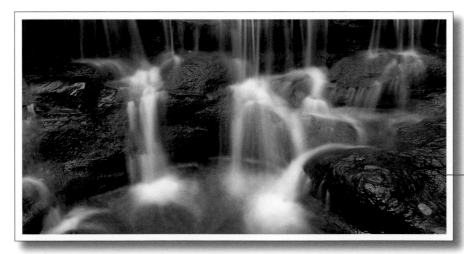

A Flawed Image

I like to make repeat visits to waterfalls and rivers because rainfall, and indeed the lack of it, can have a dramatic effect on their appearance. One day there may be nothing to photograph then, after a period of heavy rain (or drought), a previously unseen picture may suddenly present itself. What matters is the level of the river because the ratio of water to rocks is a finely balanced factor and it is this which will determine the aesthetic appeal and success of a photograph.

My first visit to the falls had been during a period of heavy rain and, while I was able to make an image, I felt there was slightly too much gushing water. Now, two weeks later, after a dry spell, I was looking at a transformation. Richly coloured, coarsely textured rocks had emerged from the deluge to create a waterfall panorama. It was tailor made for my Fuji 617 and I was soon back, camera in hand, to capture the picture. I chose not to use a polarizer because without their highlights, the glistening rocks looked a little dull. There is no hard and fast rule to this issue;

sometimes appearance is improved by the presence of wet reflections, sometimes it is diminished. It is a subjective decision which you can only make at the time by viewing the scene through the polarizer as you rotate it and choosing between full, half or no polarization.

I did, however, add an 81C warm filter in order to compensate for the cool, overcast daylight. Had it been left unfiltered the light would have given the photograph a blue tinge, which I was keen to avoid. Overall, I am satisfied with this picture but unfortunately there is a flaw in it, which you may have already noticed. It is the fallen leaf in the bottom right corner. It sticks out like a sore thumb and I now regret not removing it. I didn't think it important at the time but now I can see that it detracts from the purity of the image. There is a lesson to be learned from this: unless there is a good reason for the inclusion of stray elements always remove them.

81C warming filter

The warming filter has removed the blue cast which can be present in diffuse light and has enabled the true colour of the rocks to be revealed.

On this occasion I wanted to retain the shining reflections on the surface of the rocks and therefore chose not to use a polarizing filter.

KATOOMBA FALLS, NSW, AUSTRALIA

CAMERA **Fuji GX617**
LENS **Fujinon 105mm (Standard)**
FILM **Fuji Provia 100**
EXPOSURE **1sec at f22**
WAITING FOR THE LIGHT **Immediate**

A Miraculous Moment

It is better not to dwell upon frustrations and disappointments because I know that, over a period of time, I will be favoured with good fortune and the balance will be redressed. If I ever need reminding of this, I look at this photograph of Lake Emory. If divine intervention was ever responsible for the making of an image, then this was surely the occasion.

It was curiosity which took me to the lake and I was expecting to do no more than stroll around its perimeter. This proved impossible because there was no footpath and virtually no access to any part of it. But, not wanting to be defeated, I eventually found a gap through the overgrown reeds and bushes, and waded to the water's edge. The lake was attractive but there was little prospect of making a photograph because the conditions that day were poor. It was cloudy, windy and generally pretty dismal - except for a few miraculous, heaven sent moments.

I was preparing to leave when I noticed a small break in the clouds in the distance. The opening appeared to be heading in my direction and as it did so the sky began to change, the monotonous dull grey was gradually being replaced by bright blue and white. It failed to raise my hopes, however, because the wind remained strong, but I set up in preparation - just in case.

It is an understatement to say that good fortune then landed squarely in my lap. The sky continued to improve and, as a perfectly formed cloud floated into view, the wind suddenly and completely dropped. There was, for perhaps 30 seconds at the most, absolute stillness. A crystal clear reflection of the cloud appeared in the middle of the lake, I made two exposures before the gusts returned and the sky deteriorated. The moment had passed as quickly as it had arrived and I just stood in awe, frozen to the spot. Had I dreamt it? The answer was an unequivocal 'no'.

Polarizer (fully polarized)

The cloud and reflections are as important as the trees. On their own the trees and lake would have not have filled the frame and the photograph would have lacked interest.

The tree group is, I think, past its autumn peak. The leafless bushes detract from the image. A greener, fleshier lakeside would, I imagine, have looked superior.

LAKE EMORY, FRANKLIN, NORTH CAROLINA, USA

CAMERA **Tachihara 5x4in**
LENS **Super Angulon 90mm (Wideangle)**
FILM **Fuji Provia 100**
EXPOSURE **1/4sec at f16**
WAITING FOR THE LIGHT **30 minutes**

Braving the Elements

Compare the photograph opposite with the picture on page 107 and you will see that they have little in common. They are both of Llyn Mymbyr but were taken at different times of year and from separate viewpoints. Although the vantage point was a factor, it was the weather (and, I should add, the temperature!) which had the profound effect on the lake's appearance. These images demonstrate, I believe, the importance of the 'when' rather than 'what' principle which is discussed elsewhere in the book.

This photograph was taken in late December towards the end of the afternoon. It was several degrees below freezing and the combination of ice and mist has transformed one of the less spectacular parts of the lake into a brooding, frozen world, heavy with atmosphere and unrecognizable from its more usual, everyday appearance. There is no warmth to this image; this is a vision of a cold, inhospitable landscape, a place where in normal circumstances you wouldn't want to dwell. This is, or at least appears to be, a most hostile environment, and this impression has been reinforced by the dark, unwelcoming foreground. Lacking in detail, the black stones add to the raw bleakness of the scene and they also provide an essential contrast to the pale landscape and sky.

It really was as cold as the picture suggests. Freezing mist was forming on the camera lens and filter and it was necessary for me to continually wipe away droplets of moisture. I made three exposures as quickly as the weather allowed, packed away my equipment and set off on the two-hour return journey as the temperature dropped further and the fog thickened. Driving conditions were poor but I eventually arrived home, threw a log on the fire and, having forced myself to brave the elements, felt a warm glow of satisfaction wash over me.

One-stop (0.3) neutral density graduated filter

No warming filter was used because the theme of this picture is harsh, winter weather and the only hint of warmth is, intentionally, the reflection in the frozen lake.

The abrupt transition from foreground to lake is not completely to my liking. I would have preferred to have had a deeper scattering of rocks but they would have interfered with the reflection and I was unwilling to make this compromise.

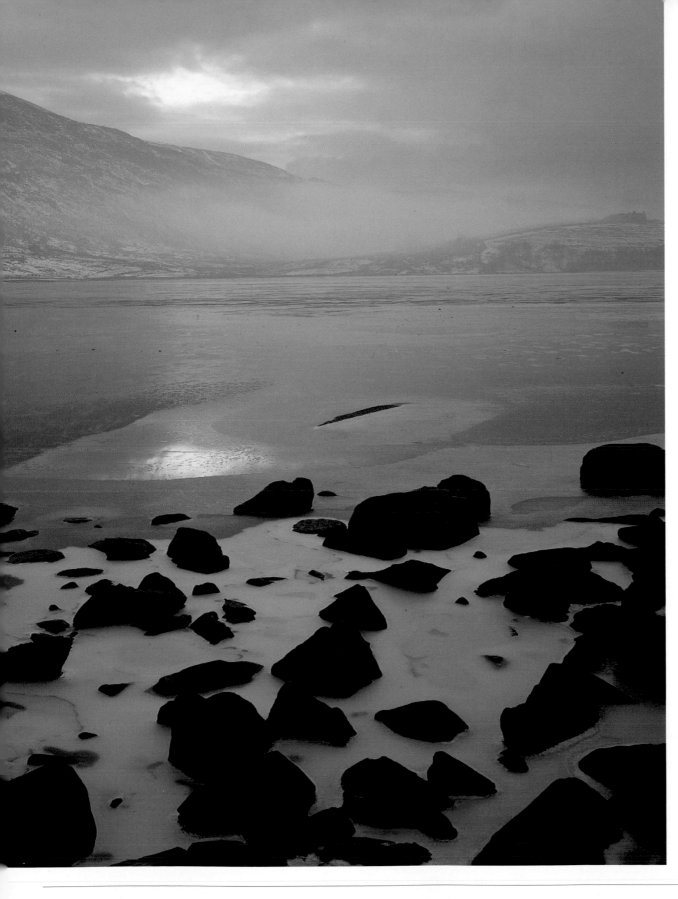

LLYN MYMBYR, SNOWDONIA, WALES
CAMERA **Tachihara 5x4in**
LENS **Super Angulon 150mm (Standard)**
FILM **Fuji Provia 100**
EXPOSURE **1/2sec at f32**
WAITING FOR THE LIGHT **30 minutes**

Reflected Foreground

Snowdon from Llyn Mymbyr is one of the classic Snowdonia views and is therefore one of the most commonly photographed scenes in Wales, but I am rarely drawn to such places because I like to be original and there is no shortage of subject matter in Snowdonia – so why sing somebody else's song when you can write your own music? There are, of course, always exceptions and on this occasion I was tempted to take an interest because of the absolute stillness of the lake. The view of Snowdon from this location is always impressive but when you have the bonus of a near perfect mirror image it can be quite breathtaking. So, weak-willed photographer that I am, I broke my rule and trekked down to the water's edge to capture the moment.

Llyn Mymbyr is in fact two lakes that are joined by a narrow channel. Both parts are accessible and offer good views of the Snowdonia Mountains. The edges of the lakes are also strewn with large, weathered rocks and protruding boulders which provide a strong foreground. I was tempted to move in close and use a wideangle lens but decided against this because a large and dominant foreground would have cut into, and partially obscured, the splendid reflection.

The sun was setting and a misty orange glow was beginning to emanate from the lake's calm surface. It was looking promising until the attractive cloud structure, with devilish timing, began to dissipate and lose appeal. But all was not lost because the still water redeemed the situation and, having dispensed with the rocky foreground, I was able to use a low camera angle to include more of the reflected sky at the expense of the sky itself. The reflected clouds became, in essence, the foreground.

You will see that at the time of my making the exposure a rippled texture has developed in the centre of the lake. I was not unhappy with this because it has brought a sparkle to the image and helps to draw the eye towards the mountains. I also like to have a hint of imperfection in a reflection because this can introduce a new dimension to a photograph.

81C warming filter

A warming filter will, in most cases, improve a sunset. Here it has enhanced the evening light but not to the extent that the image looks manipulated.

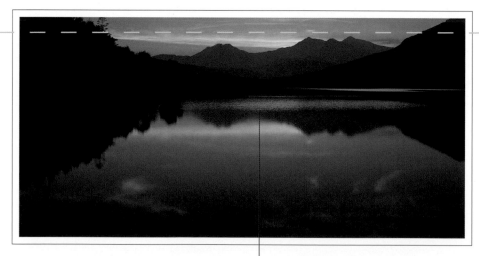

One-stop (0.3) neutral density graduated filter

The ruffled surface brings a shimmer and a degree of detail to the dark stretch of water. Crucially the ripples haven't cut into the outline of the mountain reflection. Had they done so it would undoubtedly have been to the detriment of the photograph.

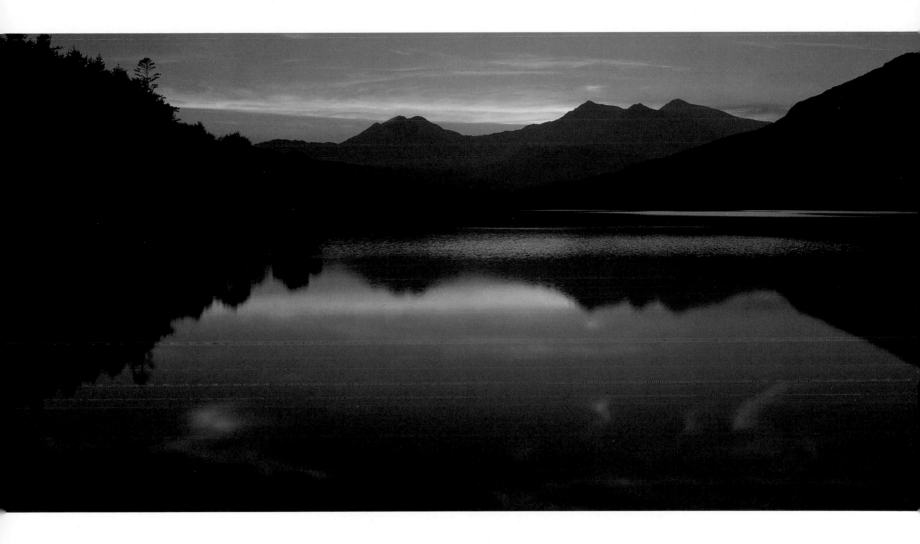

SNOWDON FROM LLYN MYMBYR, SNOWDONIA, WALES

CAMERA Tachihara 5x4in (12x6cm format back)
LENS Super Angulon 90mm (Wideangle)
FILM Fuji Provia 100
EXPOSURE 1/2sec at f22
WAITING FOR THE LIGHT 15 minutes

Quality, not Quantity

I feel fortunate to live within a relatively short distance of the Snowdonia National Park. During autumn and winter, if I am not photographing away from home, I follow the weather forecasts avidly and, if conditions are promising, will often be on the road before dawn to visit one of several places that I have become so familiar with over the years. I can do this because I am a full time photographer. My life revolves around landscape photography which means it can be given priority and within reason I can, at the drop of a hat, head off and home in on one of my shortlisted locations. I appreciate that many people are not in such a fortunate position (did I say fortunate, well, sometimes perhaps!) and can understand that it must be frustrating to hear me extolling the virtues of making return visits time and time again to a particular place because for many people this is not a practical proposition; but do not despair, all is not lost.

Before becoming a full time photographer, I was restricted to photographing during weekends, evenings and, if lucky, one or two weeks a year. The results of my efforts were generally disappointing and it gradually dawned on me that I was casting my net too wide. I changed my approach and reduced my locations to just a small number that held real potential, and were within a maximum of one hour's drive from home. I spent 12 months visiting only those shortlisted places and, slowly but surely, began to achieve some acceptable results. Once satisfied with these photographs, I moved onto another set of locations.

In terms of quantity, my approach wasn't particularly productive, but it still isn't even today. It is quality not quantity that matters and, even with limited availability of time, quality images can still be produced. My advice, therefore, is to work towards objectives that are achievable in the time you have available. Choose a small number of locations and concentrate on quality. I cannot think of a landscape photographer whose reputation has been built solely on the number of images they have produced so, surely, one outstanding photograph must be worth any number of unexceptional, forgettable images?

Polarizer (half polarized)

The early light of a winter morning has given a textured finish to the frozen lake. It was also the low sunlight, not a cloud, which has cast the welcome shadow on the first mountain.

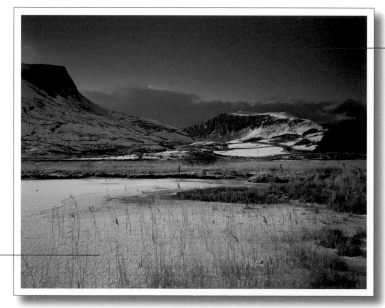

Be careful when using a polarizer in a snow covered landscape. There is likely to be little difference in the light values of the land and sky and full polarization can easily lead to an over-darkened blue sky. Here I have restricted the filter to half-polarization.

Being familiar with the location, I was able to take up my position in advance of the sun rising – and before the inevitable thaw in the sun-bathed lake.

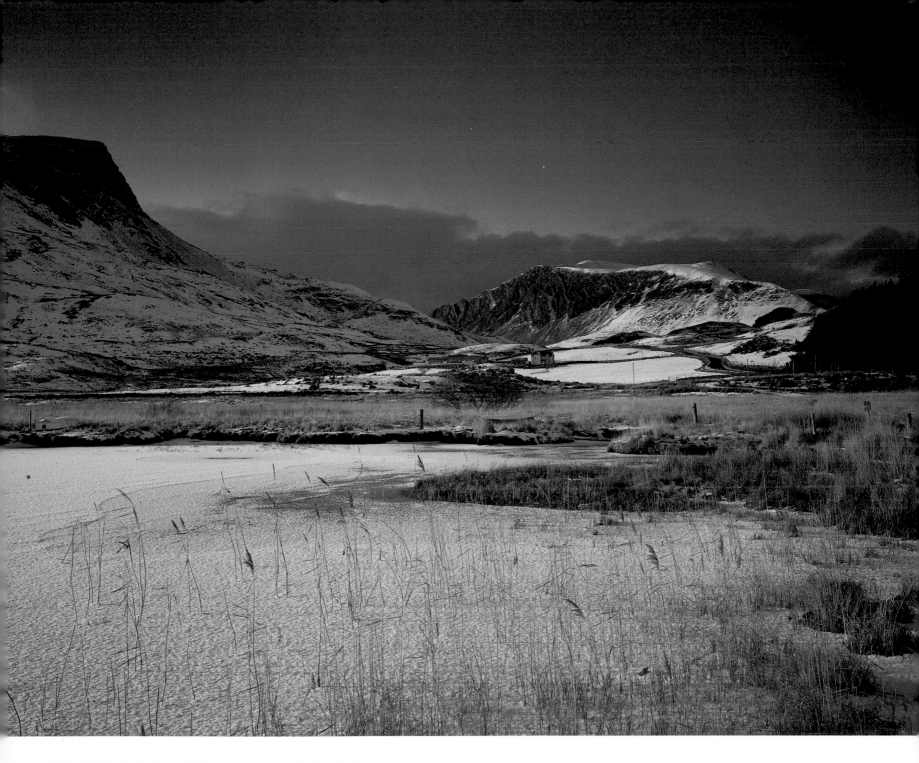

LLYN Y GADER, SNOWDONIA, WALES

CAMERA **Tachihara 5x4in**
LENS **Super Angulon 90mm (Wideangle)**
FILM **Fuji Provia 100**
EXPOSURE **1/2sec at f32**
WAITING FOR THE LIGHT **45 minutes**

The Grand Finale

I seem to have gone through a spate of photographing water in periods of drought because, once again, this image was made during an untypically dry spell, this time in the Lake District. I was, however, fortunate because the day after I took this picture the deluge started and those depth-creating stones – which are so important to the image – were soon completely submerged. This photograph was, in fact, the last I was able to make for several days because the rain continued relentlessly and (thankfully) I at least have this one.

Capturing a sunset is, for me, an exciting event. There is the anticipation, and the waiting with bated breath for the peak moment. Will it develop? Will it be spectacular? It is impossible to predict so the solution is to be set up, poised and ready to release the shutter, and then watch and wait. Often a promising sky will come to nothing, which is always disappointing, but there are also

occasions when, from humble beginnings, a fine cloud structure will emerge then gradually begin to glow with ever increasing intensity in a breathtaking display of pink, red and orange. Every sunset is unique and it pays to be prepared and ready for the unexpected. It is also important to wait; stay until it is dark because the afterglow can often be the high point of the finale and this can be several minutes after the sun has disappeared.

If it is possible, I like to include an expanse of water because its presence will give the image an added dimension. Silken surface reflections and finely detailed repetitive patterns bring a picture alive and will double the impact of a colourful sky.

A one or two stop graduated neutral density filter placed over the sky will balance the brightness of both sky and water and will enable detail and saturated colour to be retained throughout.

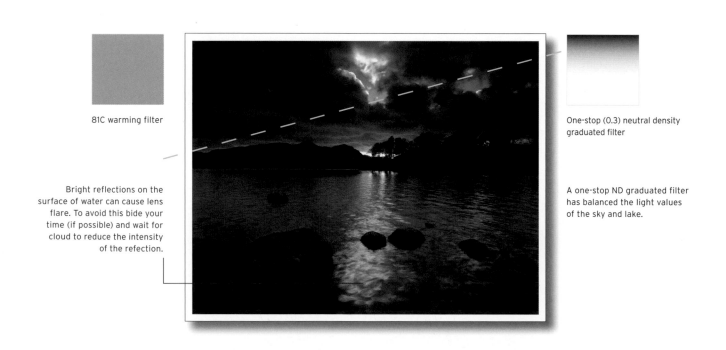

81C warming filter

Bright reflections on the surface of water can cause lens flare. To avoid this bide your time (if possible) and wait for cloud to reduce the intensity of the refection.

One-stop (0.3) neutral density graduated filter

A one-stop ND graduated filter has balanced the light values of the sky and lake.

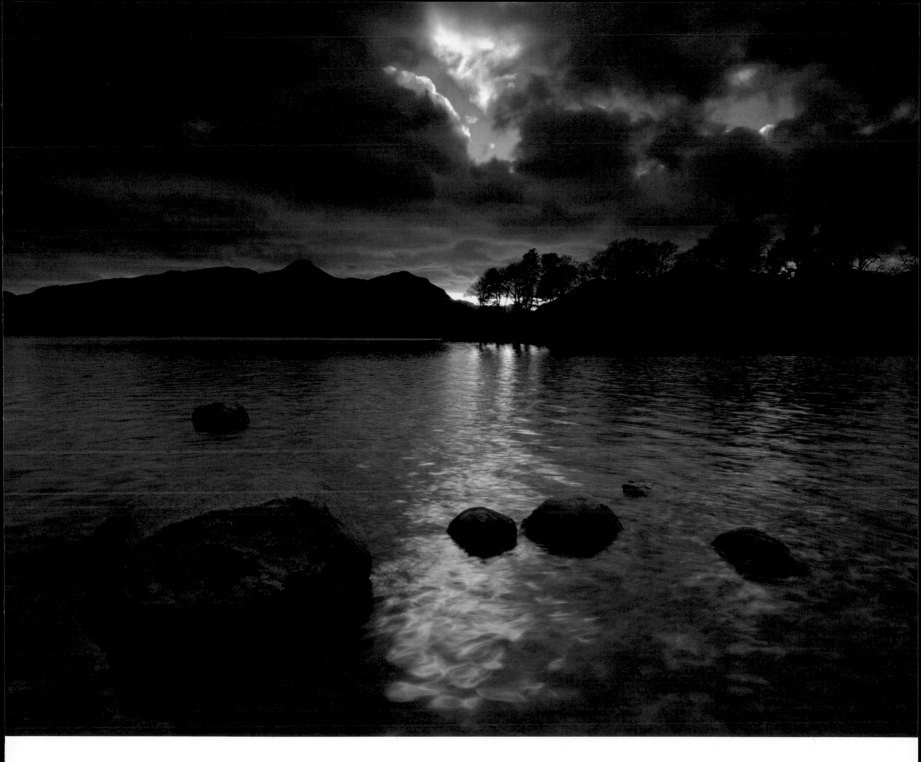

DERWENT WATER, CUMBRIA, ENGLAND

CAMERA **Tachihara 5x4in**
LENS **Super Angulon 90mm (Wideangle)**
FILM **Fuji Provia 100**
EXPOSURE **1/2sec at f22**
WAITING FOR THE LIGHT **1 hour**

Capture the mist

Dawn is the time when the air, and therefore the surface of a lake, is most likely to be still. When the sky is clear or reasonably cloud-free visit a lake at first light to capture mirror-like reflections with, quite often, the added bonus of a layer of ethereal mist hovering above the silken water. As the sun rises attempt to use backlighting to bring a golden glow to the misty scene. Calculating exposure can be difficult in such conditions and bracketing in steps of half a stop is, therefore, a sensible precaution. A number of visits could be necessary before you catch the lake at its best but there might be a magical moment and your patience and perseverance will be well rewarded. To increase your chances of success, research and visit your location in advance. Look for a vantage point close to the water's edge that provides a view of the rising sun. Look also for the presence of reeds or rocks as these will add foreground interest and enhance the image.

Follow the course of a woodland river

A twisting stream can hold many images. Slowly follow the course of a forest-clad river and look carefully at the many different permutations of water, rocks and foliage. Look for a balanced arrangement where each element makes an equal contribution. Attempt to build an image that is free of dead space, such as a composition consisting of cascading water in the foreground, rocks in the middle distance and a uniform background of trees. The sky should be excluded because the only highlights should be the splashing water. This exercise can involve more than a little scrambling around and should, I suggest, be undertaken at a leisurely pace. Give yourself time to absorb and contemplate your surroundings. In the right location, there is always a photograph hidden somewhere; the challenge is to find it.

Experiment with time

Flowing water is fascinating to photograph. No other subject provides the photographer with so many options for individual and creative interpretation. Time, of course, is the basis of the creativity and it is the combination of the speed and direction of water and the length of exposure that determines the success or failure of the photograph. No two waterfalls are identical and there is therefore no specific shutter speed which can be universally used. Assuming you wish to blur the water (I always do, but some photographers prefer not to), I would suggest you use exposures of 1/8, 1/4, 1/2, 1, 2, 4 and 8 seconds. By experimenting and comparing the results, you will become familiar with the effect of time on flowing water and will be able to anticipate the appearance of the final image.

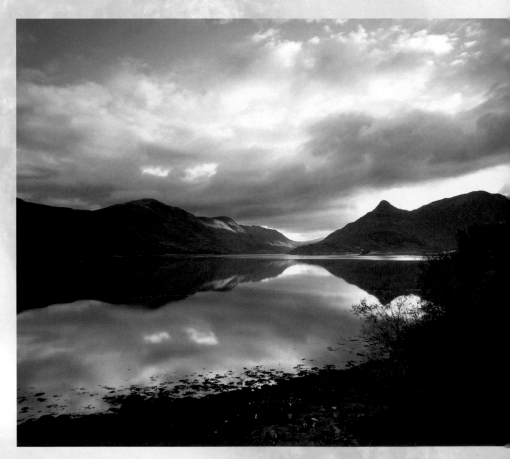

LOCH LEVEN, GLENCOE, SCOTLAND
The magic of dawn is often a fleeting event. This image was taken within 20 minutes of sunrise. Half an hour later the colour had disappeared from the sky and a stiff breeze had developed removing of course any hint of reflection in the water. Arrive at your location in good time to ensure you don't miss the spectacular moment.

DESOTO FALLS, CHATTAHOOCHEE FOREST, GEORGIA, USA RIGHT
The twists and turns of flowing rivers provide many creative opportunities. This image was one of several I made, all of which had different combinations of water, rocks and background foliage.

NANTAHALA LAKE, NORTH CAROLINA, USA BELOW LEFT
This balanced arrangement of water, rocks, colour and texture was hidden away in a small stream at the side of the lake. Careful inspection of locations is necessary if you are to avoid missing image making opportunities.

WARWOMAN WMA, GEORGIA, USA BELOW RIGHT
This miniature waterfall was covered by dense foliage overhead and the light was so poor that an exposure of 12 seconds was required. This is normally too long to retain definition in flowing water and this is apparent in this image. Ideally, I would have preferred to use an exposure of no more than 4 or 5 seconds but this would have required a wide aperture with a resulting reduction in depth of field, which I was reluctant to accept.

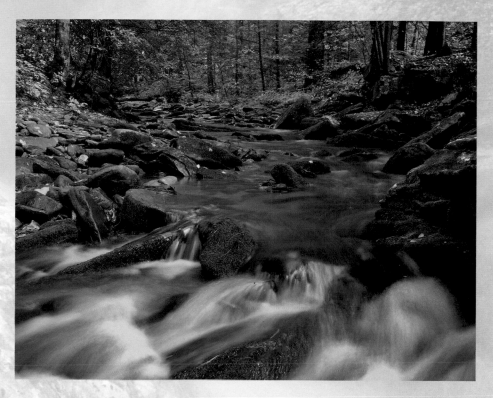

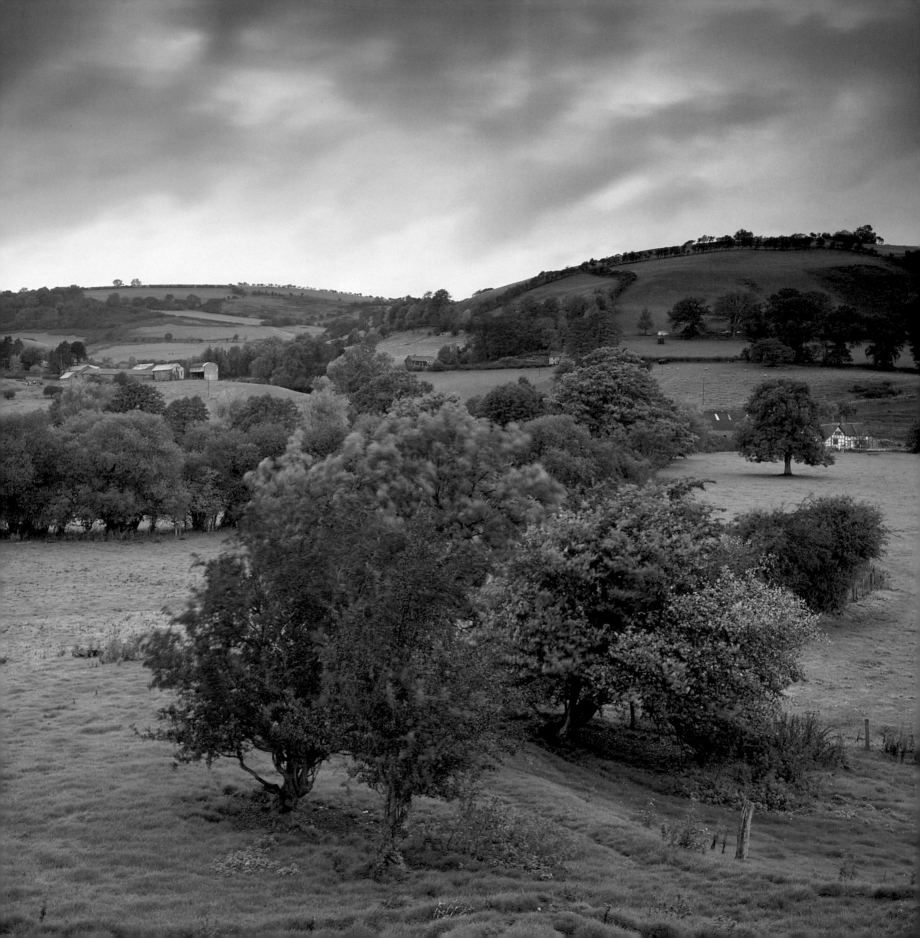

CHAPTER FOUR
Urban & rural landscapes

Perfection is a rare commodity in the landscape. All too often the imposing view that towers before you is flawed; a rogue telegraph pole, pylons, caravans, an abandoned vehicle, an untidy patch of land, litter, graffiti – the list is endless and unsightly blemishes of one description or another are frequently encountered. It falls to the photographer to overcome these obstacles and this, fundamentally, is at the core of landscape photography.

The landscape is always out there, always available, but not always looking its best and not, perhaps, as cooperative as we would like it to be. It is, therefore, the role of the photographer to arrange, edit, embellish and light the landscape in an appropriate and aesthetically pleasing manner. The actual making of the photograph – the focusing and exposure – is merely the culmination of the creative process, a process that, for some pictures, may have been in progress for many months.

Inhabited regions are particularly challenging. They can be a minefield of man-made obstacles; even sparsely populated areas will display the handiwork of man, but rarely does the hand of man work with the photographer in mind. However, with fastidious research, planning, patience and careful timing, it is possible to capture the beauty and character of towns and countryside. And there is of course the added bonus of the convenience of these locations, because no long expeditions into the wilderness are necessary in order to find a variety of original and interesting subjects.

That said, it is not in fact the subject per se that is important, what matters is shape, colour, form, pattern, repetitive qualities, atmosphere and, when the whole is photographed, the overall impact. To the creative eye the local environment can, with keen observation, yield many strong rural and urban images and it should be remembered that these can often be found in the unlikeliest of places.

NEAR NEWCASTLE, SHROPSHIRE, ENGLAND
The light was rapidly fading as the day drew to a close. I was forced to use a 3 second shutter speed, which worried me at the time, but I underestimated the improvement the long exposure would bring to the sky. It has given the image an added dimension and has introduced a vibrant quality to the serene landscape.

CAMERA **Tachihara 5x4in**
LENS **Super Angulon 90mm (Wideangle)**
FILM **Fuji Provia 100**
EXPOSURE **3sec at f16**
WAITING FOR THE LIGHT **30 minutes**

A Splash of Colour

Wild nature recognizes no rules. Untamed and unmanaged, it will flourish in an abundance of dazzling, chaotic beauty, but photograph the chaos and it will look anything but beautiful. For aesthetic qualities to be successfully portrayed, they need to be edited down, arranged and organized. Intervention is required because in order to make the transition to art, nature needs the hand of the photographer.

I whooped with delight when I saw this enticing patch of flourishing, freely growing colour but I knew that I would have to tread carefully. Attractive as it was, it was by no means a ready-made photograph. There was colour but no cohesion, depth but no pattern. For the image to succeed, it needed to have a sense of order and symmetry and, after pacing the width of the field and examining every combination of flora, field, tree and sky, I eventually decided on the arrangement you see here.

My choice of composition was determined by the distant field and surrounding trees. Fortunately, I was able to add a symmetrical horizon to the loosely defined colour dominating the picture. The horizon is key – holding the image down and providing orderliness which, in reality, was barely evident.

Having settled on the composition, it was then important that I had the right quality of light. You will see that it is slightly diffused in the foreground, with stronger sunshine falling on the trees. Bright colours should, generally speaking, be photographed under a soft light. Passing, hazy cloud is useful in this respect because it will take the edge off sunlight and give you the opportunity to use variegated light across a wide view. Here the combination of fairly flat light falling across the field, with highlights and shadows in the distance, helps to balance the foreground/background relationship and this also contributes to the picture's symmetry.

One-stop (0.3) neutral density graduated filter

Brighter sunlight in the distance has helped to balance foreground and background.

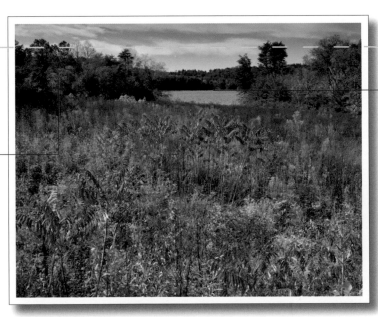

The sequence of trees/field/trees brings orderliness to the horizon which mollifies the jumbled nature of the field.

Polarizer (fully polarized)

Using diffused or semi-diffused light will improve colour saturation and will also enable intricate patterns and form to be recorded.

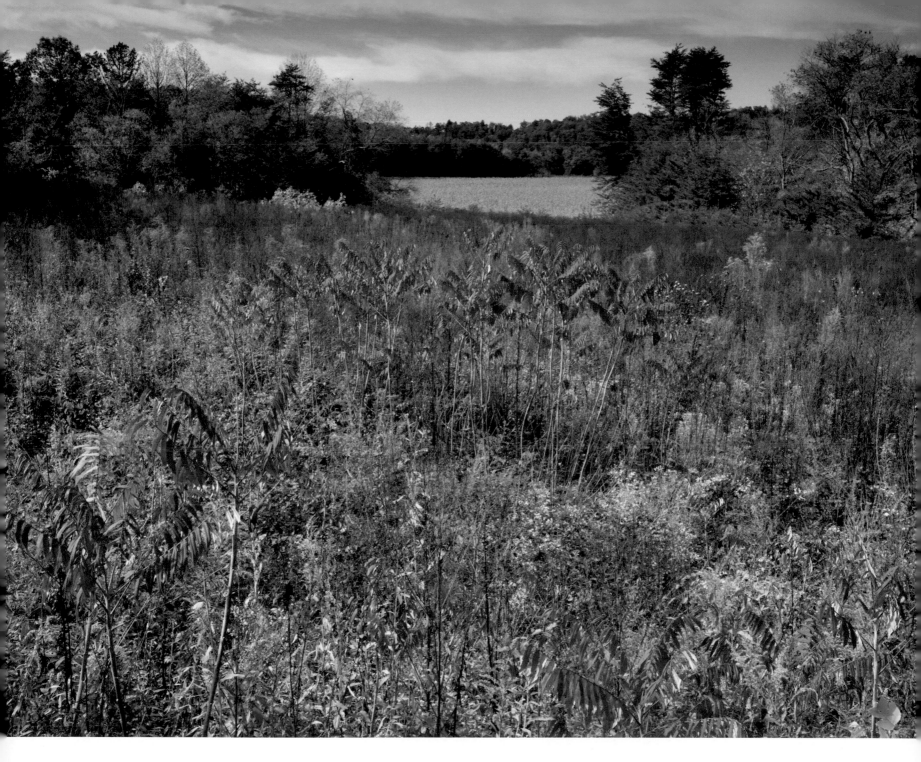

COOPER CREEK, GEORGIA, USA

CAMERA **Tachihara 5x4in**
LENS **Super Angulon 90mm (Wideangle)**
FILM **Fuji Provia 100**
EXPOSURE **1/2sec at f32**
WAITING FOR THE LIGHT **1 hour**

Wild Nature

I am always drawn to old buildings. They are, on their own, a worthy subject but, photographed in a wider environment, they also have an important role to play. They act as a focal point, a magnet for the eye, and give a sense of scale to an image. It is for these reasons that, if a building is to be included in a picture, its relationship with the landscape has to be carefully considered.

Imagine the picture opposite without the ramshackle old barn. There would be no point to it, it would lose all interest and there would be nothing to photograph. The building is, of course, the main subject but, attractive as it is, it needs to be depicted in a wider setting because, photographically speaking, it won't stand up on its own. The theme of the picture is wild, chaotic nature and in order to convey this, both the forest and barn are required. One without the other would not have succeeded on any level.

There are, however, occasions when it can be preferable to concentrate exclusively on a building, particularly one in graceful decay. Colour and texture can abound in such structures and close-up arrangements can work well. I examined every square inch of this barn but, interesting as it was, there was nothing that, in isolation to the bigger picture, made a sufficiently strong image. In this instance it was the wider view that was the obvious – and, indeed, only – choice.

A weathered building in an attractive location can yield a number of quite different images. Examine the structure carefully – look at it from a distance and different angles as well as taking the location into account. If the surroundings are interesting and appropriate to the nature of the building, consider a wider view.

Beware of including unwanted elements. Here the barn was surrounded by debris which I have attempted to hide by photographing from a low position and using the long grass to conceal it. It wasn't a total success because some of it is still visible but fortunately it isn't a great distraction.

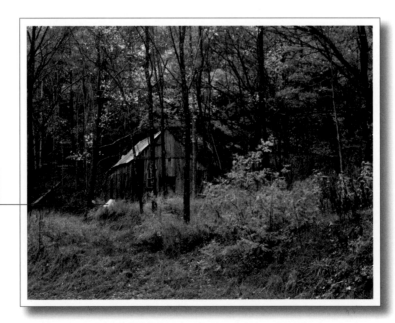

Polarizer (fully polarized)

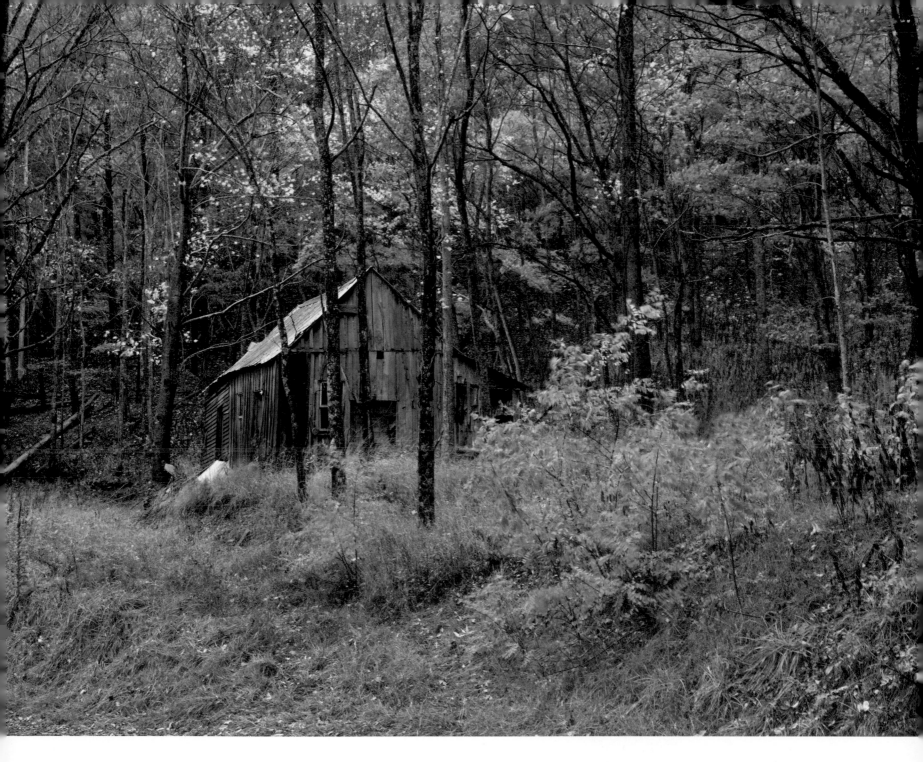

NEAR HIAWASSEE, GEORGIA, USA

CAMERA **Tachihara 5x4in**
LENS **Super Angulon 150mm (Standard)**
FILM **Fuji Provia 100**
EXPOSURE **1sec at f32**
WAITING FOR THE LIGHT **Immediate**

A Sight to Behold

When I am away photographing, whether it be somewhere familiar or an unknown territory, I make a point of having with me a map, usually a 1:50,000 OS Landranger. These are ideal because of the wealth of detailed information they include, but even large scale maps can't tell you everything. They cannot for example predict which fields will be in flower at any given time; for this kind of information I turn to local knowledge. I, therefore, never hesitate to seek out the assistance of a friendly farmer or resident but am always a little circumspect in following their advice too implicitly. While it can be helpful it can also lead you up a blind alley. I once spent the better part of two days searching for a poppy field, which I had been assured was a renowned annual spectacle, only eventually to discover that it hadn't flowered for five years!

I am, however, indebted to the local farmer who pointed me in the direction of this delightful meadow, glowing and resplendent in its full bloom. It was a sight to behold and I was privileged to be there at its peak. My timing also coincided with a spell of fine weather and, fortuitously, I was able to take the photograph within a couple of hours of my arrival. There was a slight breeze, but it didn't deter me from using a polarizing filter in order to darken the blue sky and strengthen the colours of the meadow. The shutter speed (1/4 second) necessitated by the filter forced me to wait for a lull in the virtually continuous swaying of the flower heads but it wasn't an arduous task. A blossom of wildflowers is not, after all, an unpleasant sight to dwell upon on a perfectly sunny afternoon.

Polarizer (fully polarized)

My viewpoint was determined by my desire to counterbalance the sloping line of trees by including an equal and opposite diagonal line on the left side of the image to create a v-shaped symmetry.

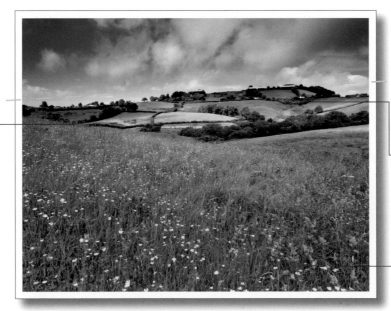

One-stop (0.3) neutral density graduated filter

A field of wildflowers can be frustrating to photograph. To obtain front to back sharpness, you will need to focus carefully and use a small aperture but this will necessitate a fairly slow shutter speed. Unfortunately long stemmed flowers are susceptible to the slightest breeze and patience may be required to capture perfect stillness.

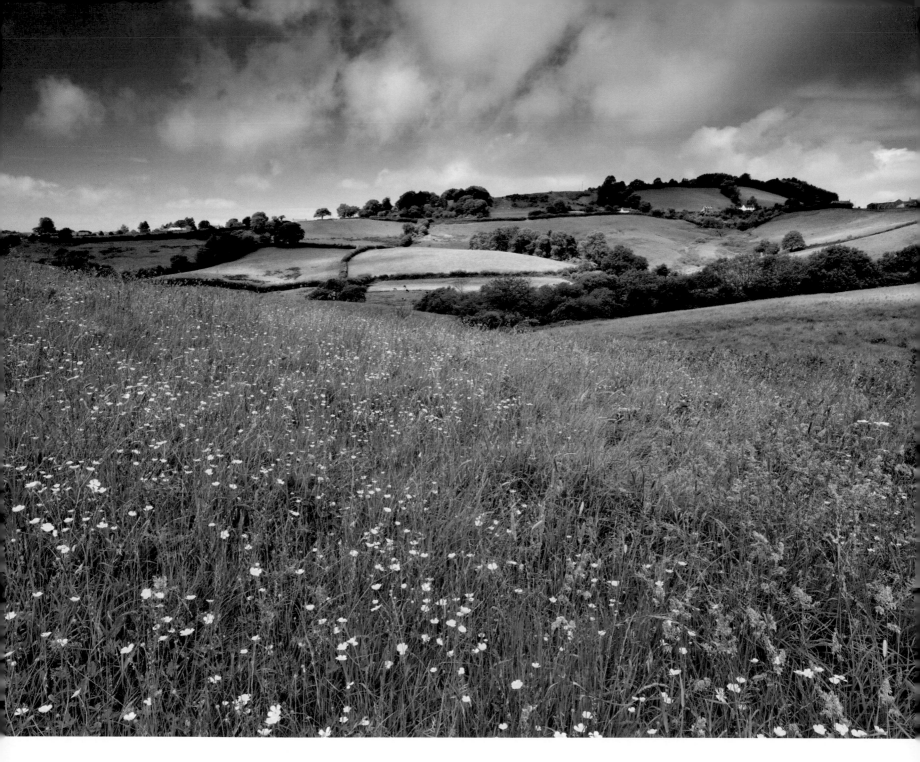

BIRDSMOORGATE, DORSET, ENGLAND

CAMERA **Tachihara 5x4in**
LENS **Super Angulon 90mm (Wideangle)**
FILM **Fuji Provia 100**
EXPOSURE **1/4sec at f22½**
WAITING FOR THE LIGHT **1 hour**

A Landscape Transformed

What a difference a few short weeks can make! Three months after my earlier trip I spent another week in Dorset revisiting some of the places I had previously photographed. I returned to the fertile, rolling hills at Birdsmoorgate and to a landscape transformed. Gone were the wild flowers which were in such abundance (pictured on the previous page) and now, September, there was the faintest hint that summer was ending. It was, of course, a perfect opportunity to create an image different from my earlier picture but still recognisably the same place.

In theory, the photograph was straightforward. I moved a few metres to the right in order to have a clear view of the bottom row of trees and then waited for a desirable sky and light. But when I say waited, this is an understatement because it took me three visits and periods of intensive sky watching before I had

what I wanted. This was because I needed a specific angle of light which meant that the sun had to be at 90 degrees in relation to my viewpoint. There was a small tolerance either side of this but even allowing for this the sun was in the required position for just one hour per day (similar in fact to the situation I encountered in the Rhinog Mountains, see page 37). I also wanted the contours of the hilly terrain to be accentuated by an appropriate combination of light and shadow.

Taking these requirements into account, I was fortunate to be able to capture the image as quickly as I did. It could have been much, much longer and I am not complaining about a mere three attempts. Indeed, one photograph every three days is highly productive for me. I hope it isn't the start of a trend; the pursuit and challenge is what makes it so rewarding.

One-stop (0.3) neutral density graduated filter

Polarizer (fully polarized)

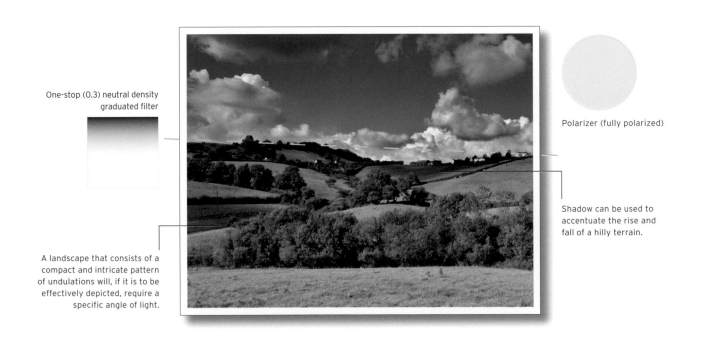

A landscape that consists of a compact and intricate pattern of undulations will, if it is to be effectively depicted, require a specific angle of light.

Shadow can be used to accentuate the rise and fall of a hilly terrain.

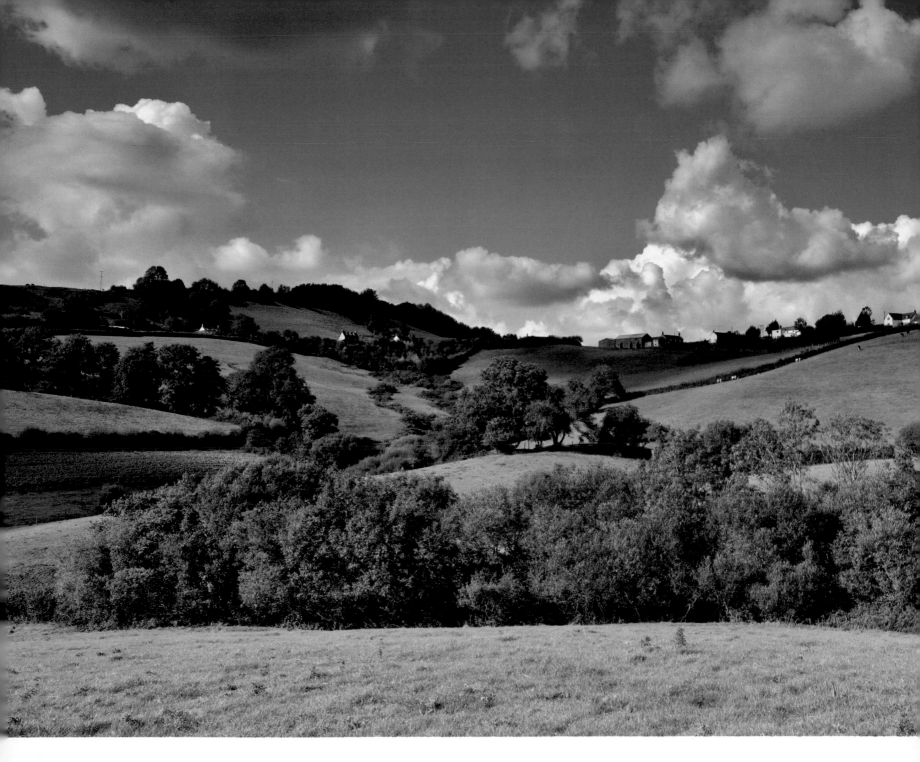

BIRDSMOORGATE, DORSET, ENGLAND

CAMERA **Tachihara 5x4in**
LENS **Rodenstock 120mm (Semi Wideangle)**
FILM **Fuji Provia 100**
EXPOSURE **1/2sec at f32**
WAITING FOR THE LIGHT **3 days**

An Endless Quest

As I have previously mentioned, old buildings seem to beckon to me. I can't ignore them. If I pass one I'll stop and take a closer look and, rather worryingly, if I see one in the distance and have to make a detour to check it out I will do just that. Friends and family tease me about it, but my quest will continue because to me a ramshackle building can, in addition to acting as the focal point in an expansive landscape, be a treasure trove of colour, pattern, repetition and texture. Photographs can lie hidden in every nook and cranny, just waiting to be teased out under the keen eye of the observant photographer.

My journey to this engaging little house involved no detour because I passed it as I was driving to the Chattahoochee Forest. I stopped on the way back and, approaching, realized that the building had long been unoccupied. Everything, house included, had gone to seed, but this of course only added to the attraction. The building, background trees and what I assume was once the garden made a complete picture and I felt a surge of excitement

realizing that there was an image to be made here. These are the moments photographers crave; the thrill and the realization that for the time being the search is over. All the frustrations and disappointments are instantly forgotten as the matter in hand - the creation of a photograph - occupies the mind to the exclusion of all other peripheral thoughts.

To the bemusement of passing motorists, I began to pace back and forth across the length and width of the surrounding land searching for the strongest vantage point. I felt it was important to show the cabin in its environment and there was only one position which allowed me to do this. I would have preferred to be closer, but this would have necessitated the exclusion of some of the trees and that was a sacrifice I was reluctant to make. So, with compositional matters settled and the sky and light to my liking, the picture was soon taken. And that was it; another dilapidated building discovered and another photograph captured. Now, where's the next one...

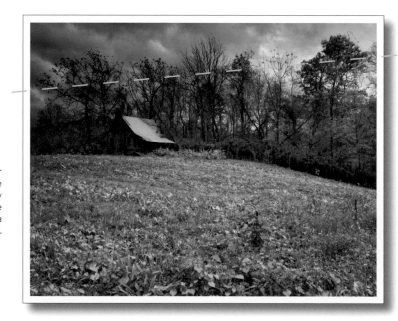

The one-stop ND graduated filter was positioned across both the trees and sky. Being a relatively mild filter, it has darkened the sky sufficiently but has not had a noticeable effect on the trees.

One-stop (0.3) neutral density graduated filter

The picture suffers from a lack of detail and visual interest in the expanse of green field. At the time of making the photograph, I was caught in two minds. A closer viewpoint would have made more of the building but this would have been at the expense of a large portion of the trees. With hindsight I wish I had taken a second image closer to the cabin and then compared the results.

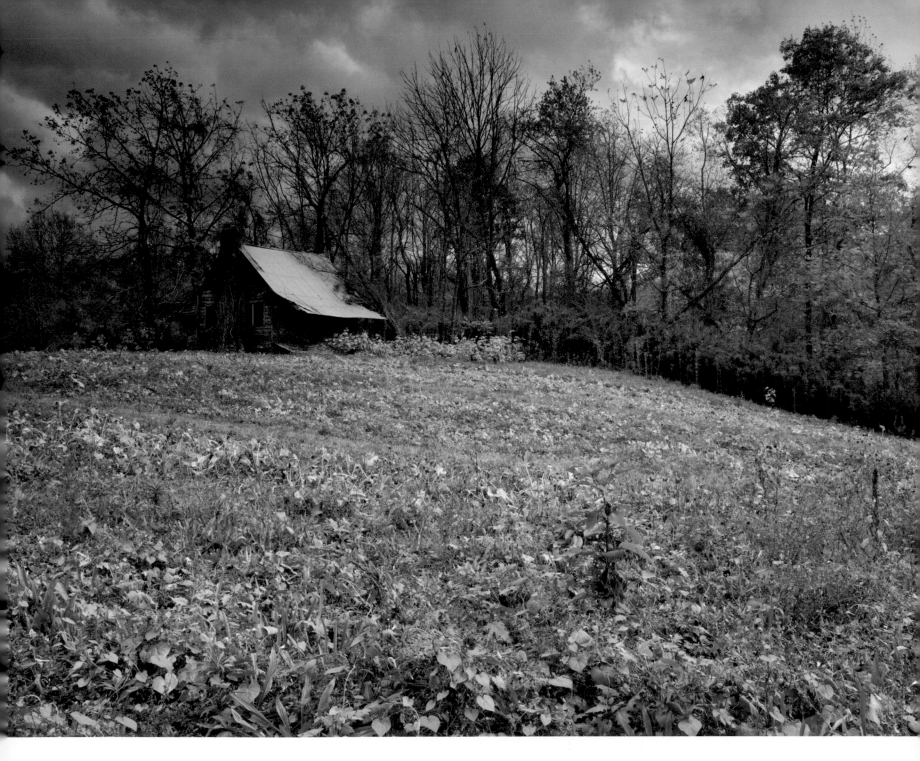

TOWN CREEK, GEORGIA, USA

CAMERA **Tachihara 5x4in**
LENS **Rodenstock 120mm (Semi Wideangle)**
FILM **Fuji Provia 100**
EXPOSURE **1/2sec at f22**
WAITING FOR THE LIGHT **10 minutes**

Journeys of Discovery

My Landranger map indicated a bridge, river and footpath. This is a promising combination and was worth checking out so I set off in the hope of finding something of interest. But you can never be certain because a map can do no more than point you in the right direction. What you will find when you get there is, from the photographer's point of view, impossible to predict. Such excursions are exploratory, no more than a speculative investigation, but they can be a journey of discovery and I never tire of following my map and instincts deep into a rural hinterland.

You can imagine how I felt when, having taken the riverside path, I crossed the bridge to discover this delectable potpourri of vibrant, unfettered nature. It was beauty to lift the heart. It is moments such as this that remind me how fortunate I am to be a landscape photographer. Those unexpected chance encounters, the sudden realization that a picture making opportunity has arisen, make the pursuit so very worthwhile and it is immensely satisfying and rewarding.

Having regained composure and then gathering my thoughts, I considered how best to capture the prolific display. The aspect of the view was southerly, which was ideal because I wanted soft, delicate sidelighting which, given it was the middle of the afternoon in late September, I hoped I would have in just a couple of hours, weather permitting. I took the opportunity to spend the remainder of the afternoon exploring the length of the river in case there were any more gems hidden along its banks. Pleasant as it was, there was nothing to equal my earlier discovery and I returned in good time to set up, take in the view and wait for the sun gradually to sink into position.

The sky was largely cloud-free but for once I was happy with its blue simplicity. A heavy, brooding sky somehow seemed to be inappropriate and with no obstacles to impede me the image was soon made. I kissed my map, packed it away and returned to my rented cabin in a state of deep contentment. There were still two hours to sunset but my day was over – it had already reached its glorious climax.

Polarizer (half polarized)

One-stop (0.3) neutral density graduated filter

Consider carefully the qualities of the landscape you are photographing and use the type of light appropriate for those qualities. Here the subtle tonal variations – which are such an important part of this picture – are largely a result of the delicate, warm sidelighting.

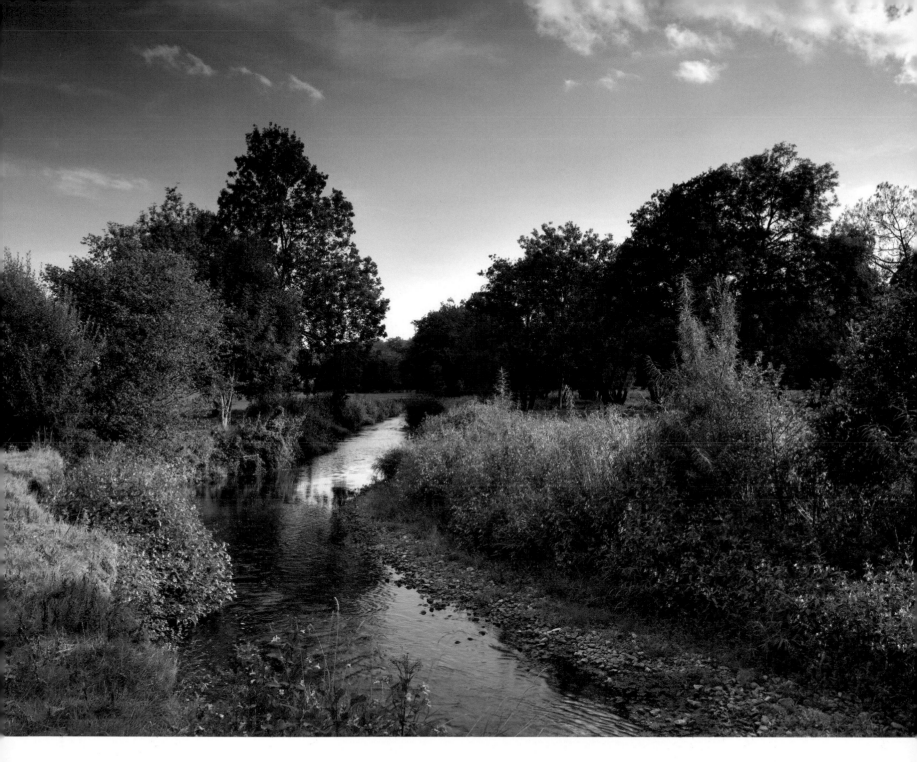

THE RIVER YARTY, DEVON, ENGLAND

CAMERA **Tachihara 5x4in**
LENS **Super Angulon 150mm (Standard)**
FILM **Fuji Provia 100**
EXPOSURE **1/2sec at f22**
WAITING FOR THE LIGHT **2½ hours**

Creating Depth and Definition

The 'Gateway to the Cheviots' is the proud claim of the historic Northumbrian town of Wooler. Although justified, this assertion does not, I believe, tell the whole story because in addition to the Cheviots, the town is also well placed for forays into a much wider, and most appealing, landscape. A few miles to the north, close to the English/Scottish border (in fact spanning the border), are the villages of Kirk Yetholm and Kirknewton. Here rolling hills and mountains mingle with fertile fields and pleasant agricultural land and this is where I discovered this impressive display of crops.

Conditions were, predictably, not quite right on my first visit. While the light was attractive (fairly soft, hazy sunshine and ideal for this particular landscape), I wasn't happy with the sky. It was neither here nor there and it was all rather bland. I returned later in the day but there was no improvement. However I could see that the position of the sun during late afternoon/early evening

would create low backlighting and this would give the crops a measure of depth and definition. Fired with enthusiasm I returned to the field on the following three afternoons but it was to no avail. Finally, on my last day, I was able to capture the image you see here. It is by no means perfect because the sky is still weak. I used a two-stop ND graduated filter which has brought some improvement to its colour but filters are no panacea for a lack of intrinsic quality in an image. They cannot, for example, do anything to help an insipid cloud structure. It is fortunate that the warm backlighting has, to a degree, redeemed this picture.

Arable farmland is rich in graphic detail and repeating lines and shapes. Use gentle backlighting to accentuate the detail and reinforce the repetition.

The sky is very poor and spoils the image. There is no way to rectify this and the only solution is to return on another occasion. Sadly I was unable to do this.

The backlighting has revealed depth and form in the crops and this has been helped by the rolling undulation of the field. The sunlight, if anything, is perhaps a little harsh. A slightly softer light might, I feel, have improved colour saturation.

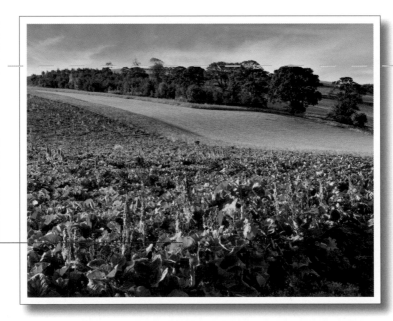

Two-stop (0.6) neutral density graduated filter

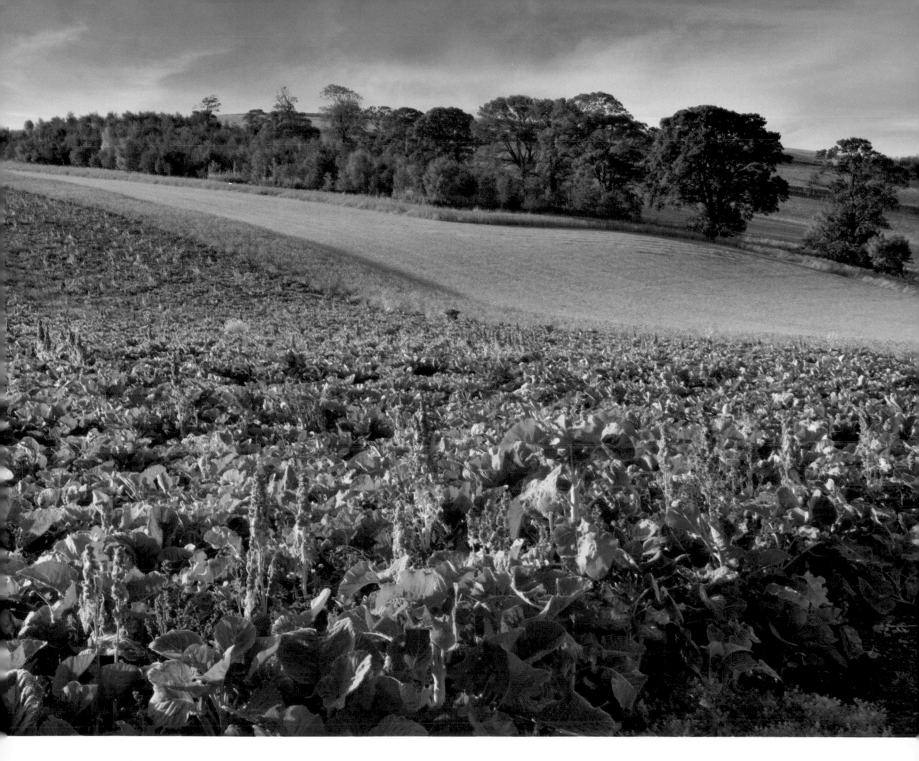

NEAR KIRK YETHOLM, THE SCOTTISH BORDERS

CAMERA **Tachihara 5x4in**
LENS **Super Angulon 90mm (Wideangle)**
FILM **Fuji Provia 100**
EXPOSURE **1/2sec at f32**
WAITING FOR THE LIGHT **5 days**

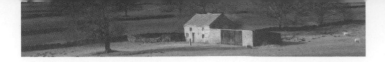

Compressed Distance

I am not, as mentioned before, a prolific user of the telephoto lens. My style of photography is more suited to wideangle and standard lenses but occasionally the magnification and narrow field of view of a longer focal length can open up opportunities which would otherwise be impossible. It is for this reason that I permanently carry such a lens in my case.

I was photographing in the Appalachian Mountains and, encouraged by the softening evening light, I climbed high above the tree-filled landscape to enjoy the view and the warm, still air. I contemplated photographing the sprawling scene and considered my options, but there were very few. The mountains were distant; they looked small and they would have to be magnified and compressed if they were to be photographed successfully. I then remembered that I had with me a 210mm lens for my borrowed camera. It was time to make another digital image.

The sky was almost featureless and I felt that the photograph would suit a panoramic format. I decided to crop the image after exposure. It is something I rarely do but on this occasion I felt it was the most acceptable solution. Other than this cropping, the picture was relatively simple to take. I added a polarizing filter to darken the blue sky and enrich the landscape and then, as the sun sank towards the horizon and the shadows lengthened, made two exposures. An average meter reading of the landscape was required and on this occasion I was happy to rely on the camera to determine this but, not trusting digital entirely, I used the aperture-priority mode to ensure I had control over both aperture and shutter speed.

Distant mountain ranges can respond particularly well to the use of a telephoto lens. The magnification, narrow angle of view and compressed perspective will emphasize distance and give an image impact.

Polarizer (fully polarized)

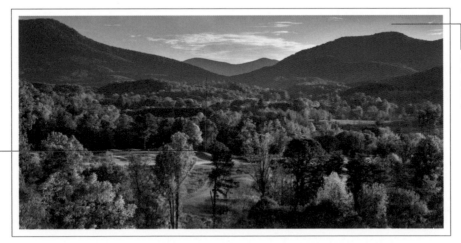

Avoid including the sky simply because it's there. A photograph can often be improved by excluding, or cropping, a weak sky.

Some photographers don't like to see haze in a landscape but I am normally happy to include it as I think it accentuates distance.

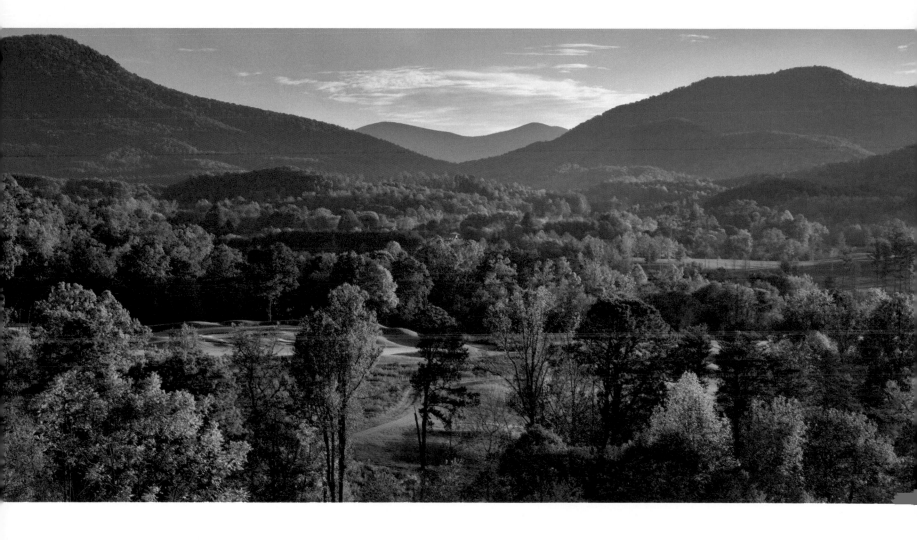

NEAR YOUNG HARRIS, GEORGIA, USA

CAMERA **Mamiya 645ZD**
LENS **Mamiya 210mm (Short Telephoto)**
FILM **Image Sensor**
EXPOSURE **1/4sec at f22**
WAITING FOR THE LIGHT **30 minutes**

A Gentle Rhythm

The map of Lake Chatuge was intriguing; it seemed to be a series of intricate coves and inlets with a shoreline in excess of 130 miles so, of course, I was there like a shot to feast on the profusion of photographs that undoubtedly lay cheek by jowl along the lake's extensive perimeter. I would be spoiled for choice, wouldn't know where to start. It would be like stepping into a goldmine, a photographer's paradise. Surely it would, wouldn't it?

The reality of course was different. While the lake was undoubtedly attractive there was nothing I could use as a focal point. The first stumbling block was the water's edge. There were no features to soften the transition from land to water and as a result no foreground on which to build a photograph. It also seemed to be permanently breezy which didn't help matters, but all was not lost, because adjoining the lake were tree-lined fields and wooded areas that were wavering between summer and autumn. The attractions of both seasons appeared to have been frozen in time and my thoughts of the lake quickly vanished as

I contemplated the exciting prospect of photographing a mixture of colourful autumn-tinged trees and flora-filled fields.

I wanted to produce an image that not only reflected the diversity and character of the area but also captured the essence of the moment. After an hour of searching and experimenting with different arrangements, I found a viewpoint encompassing all of the desired elements. There is a pleasant colour combination and a gentle rhythm to the image which I find appealing. I like to include flowing lines in a picture and was initially attracted by the subtle curves along the horizon of trees, which I have endeavoured to repeat in the foreground with the yellow and green flowering grasses. The softly sweeping lines also appear along the edge of the field at the meeting point with the base of the trees and it was this collection of curves, together with the summer and autumn seasonal colour, which drew me towards this vantage point.

One-stop (0.3) neutral density graduated filter

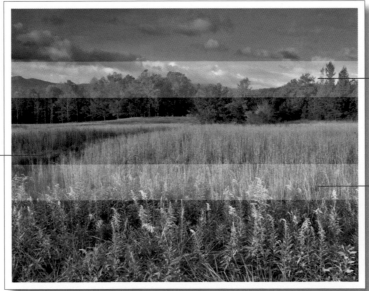

The break in the long grass helps to give the photograph depth and leads the eye to the distant trees.

When choosing a viewpoint, look for repetition or symmetrical features. Here the two lines of similar curves give the image a subliminal, but important, symmetry.

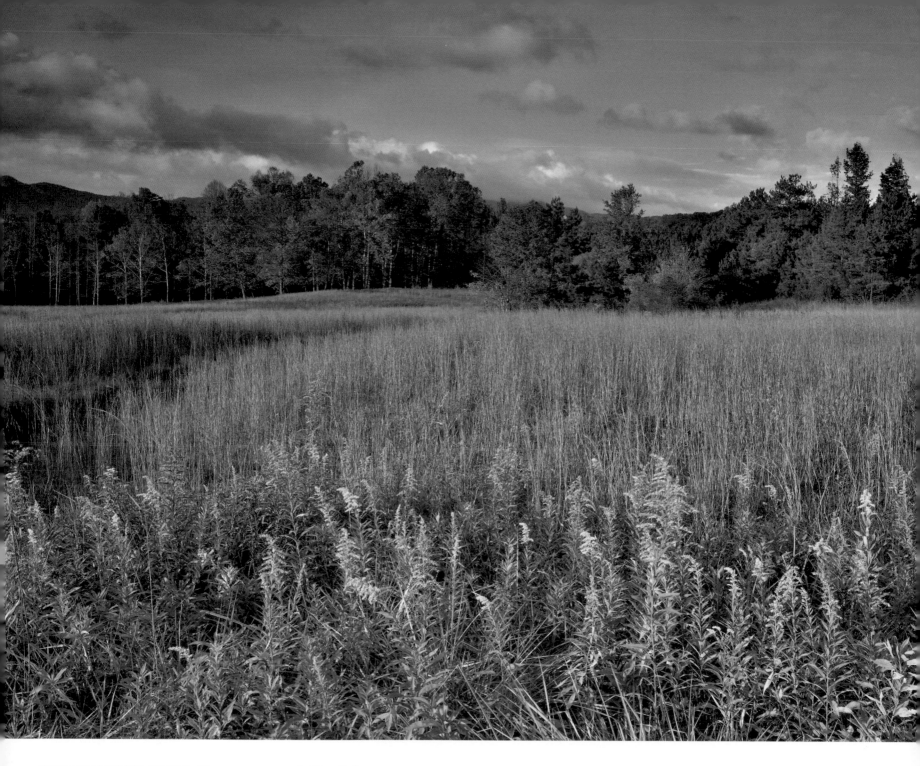

NEAR LAKE CHATUGE, GEORGIA, USA

CAMERA Tachihara 5x4in
LENS Super Angulon 90mm (Wideangle)
FILM Fuji Provia 100
EXPOSURE 1/2sec at f22½
WAITING FOR THE LIGHT 20 minutes

A Painted Photograph

Simplicity in an image is to be applauded. Whittled down to its bare essentials a single picture will convey an emotion or theme far more effectively than any number of cluttered, information-laden images. Colour, in particular, if it is to be central to the theme of a photograph, should be portrayed as clearly and simply as possible. It should be shown as well-defined shapes or blocks, not as a kaleidoscope or a wide-ranging spectrum which can be confusing to the observer. The colour range is best restricted to a small number which are appropriate to the theme. Colours which are bold and contrasting will give an image impact and a dynamic quality while softer, harmonious hues will create feelings of restfulness and tranquillity. Brighter colours tend to attract the eye and the presence of a colourful object in a landscape can often disrupt its balance. To maintain the integrity of a picture's composition, vivid hues are therefore either best avoided (unless of course there is a specific reason for their inclusion) or at least used with caution.

Restriction of colour and simplicity of shape were essential in the making of this image of a barn wall. Colour is the theme of the photograph and it is the combination of the contrasting red and green together with a neutral, textured back-ground that conveys this to the viewer. The message is unambiguous because there is nothing else in the picture to cause confusion. There is no extraneous information, just clearly defined content and because of this, there is no weakening of the theme.

I had passed this barn many times but had never stopped because the door had, for several years, been a rather uninspiring pale grey. I can't imagine the farmer had a photograph in mind when he painted it, but I am grateful he did so. The colours are a bold and eye-catching combination and it certainly brightened my day when I saw the newly painted door from a distance. I was reminded that photography and painting are, indeed, more closely connected than many people realise.

Polarizer (fully polarized)

The polarizer has saturated the colour and has strengthened the contrast of the vibrant red and green.

The neutral stone wall provides the perfect background for two bright, contrasting colours.

If colour is the theme of an image, the composition and content should be kept as simple as possible. A myriad of colour will look confusing and will lack impact.

**NEAR BETHESDA,
SNOWDONIA, WALES**
CAMERA **Tachihara 5x4in**
LENS **Super Angulon 150mm (Standard)**
FILM **Fuji Provia 100**
EXPOSURE **1sec at f32**
WAITING FOR THE LIGHT **Immediate**

A Single Image

If ancient towns and architecture interest you, then Italy is the land of plenty. The Liguria district in particular is rich in such delights. Here, hidden in the mountains, are remote villages untouched by the hand of time, and it is an unbridled pleasure to wander through the narrow streets and alleyways poring over every last untarnished detail.

Pigna is an especially fine example of medieval Italy and, out of season, the town is blissfully quiet (if, that is, you ignore the ubiquitous, free-roaming cats that seem to thrive in these parts). I was tempted to make a number of images, but it would have been too many, so I forced myself to exercise a degree of self control and resisted the urge to virtually shoot on sight. It is easy to become overawed by the atmosphere and history of these old towns and this has, I have to admit, happened to me before. In my early days I have ended up with several images of one location, all variations on a theme, but it has been a narrow theme and the pictures have all been too similar. The six or seven photographs

regularly taken could, and should, have been reduced to just two or at the most three. My approach now is to make a short list of potential subjects, then refine this by a process of elimination. I use a handheld viewfinder to compose, frame and evaluate each image before setting up my camera. Working this way enables me to discard many photographs before, not after, taking them.

This narrow, arched alley survived my scrutiny because it seemed to reflect the character of the town so perfectly. The walkway through the arch gives the image depth and I was also won over by the ancient stone wall, worn and weathered over the centuries but standing solid as a rock. And, to top it all, we have those two superb blocks of colour which are the perfect foil for the grey stonework.

This was in fact the only exposure I made that day. This single image said it all and I now wonder if even as few as two photographs of a subject are on some occasions perhaps one too many?

Highlights and shadow tend to obscure subtle tonal variations. Diffused light is therefore preferable if this is the theme of your photograph.

Avoid tilting the camera up when photographing a building. The result of this will be distortion and converging parallel lines. If you are close to the building consider, instead, using an ultra wideangle lens and cropping the image afterwards.

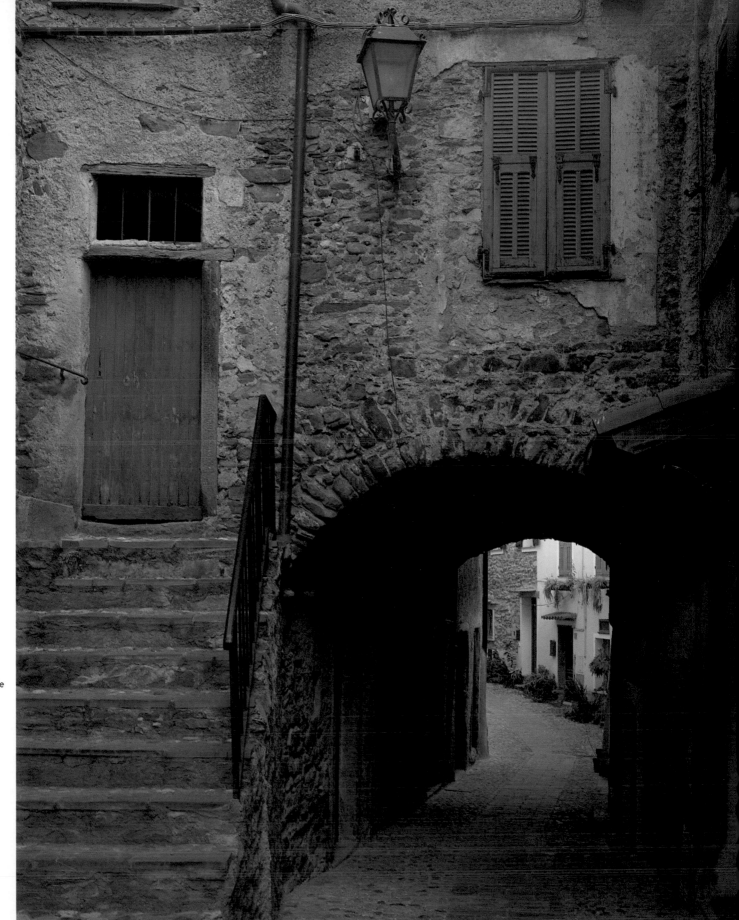

PIGNA, LIGURIA, ITALY
CAMERA Tachihara 5x4in
LENS Super Angulon 150mm
 (Standard)
FILM Fuji Provia 100
EXPOSURE 2secs at f32
WAITING FOR THE LIGHT Immediate

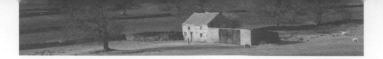

A Surreptitious Peek

I had spent the day photographing the rugged coast near Achill Island and was heading back to my base in the small town of Castlebar. It had been a day of mixed fortunes and I was feeling a little frustrated when, suddenly, emerging from a bend in the road I was greeted by the sight of a gloriously dilapidated thatch roofed cottage. I say thatch but the roof was mainly grass because the years had taken their toll and the dwelling was now overrun with weeds and moss. The light was beginning to fade so bright and early the next day I returned, brimming over with enthusiasm and anticipation. But I was wary as I approached the crumbling ruin because although it looked uninhabited you can never be sure. I've been caught out before and there has been more than one occasion when I've been peering through a grimy window only to recoil in shock as my gaze has been returned from the other side. Several close encounters have taught me that, when it comes to dwelling places, age and condition are unreliable indicators of occupancy. My advice therefore is to tread carefully!

However, on this occasion the cottage had been well and truly abandoned and I was able to give it a thorough examination. Unfortunately, as is often the case, the building didn't quite live up to its earlier promise. The problem was that it was so overgrown with weeds and overhanging trees that there was barely anything left to photograph. The only solution was to move in close so, flattening down the long grass and copious weeds, I concentrated on just one window. It was a sunny morning but sunlight wasn't what I wanted; the delicate colours and roughly textured surfaces were crying out for soft, shadowless light. With everything set up and ready I waited for passing clouds to flatten the light. Cloud always seems to be notable for its absence when you most need it but after an hour or so the relentless sunlight was briefly interrupted and I was able make the exposure. I wasn't convinced at the time but the picture has since grown on me. It is of course no more than a morsel, a surreptitious peek into rural Ireland, but I have nevertheless become quite fond of it.

Polarizer (fully polarized)

A building's true character can often be depicted by concentrating on one specific feature.

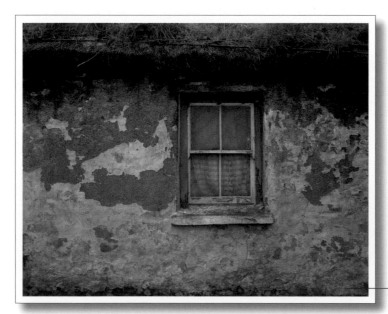

This part of the wall was hidden by overgrown grass and weeds. The removal of the overgrowth has undoubtedly improved the photograph.

NEAR CASTLEBAR, CO. MAYO, IRELAND

CAMERA **Tachihara 5x4in**
LENS **Super Angulon 150mm (Standard)**
FILM **Fuji Provia 100**
EXPOSURE **1sec at f45**
WAITING FOR THE LIGHT **1 hour**

Time-ravaged Beauty

I couldn't resist stopping when catching a fleeting glimpse of this old mill house hidden away down a narrow, little used lane. Decaying buildings can, as previously discussed, be a rich source of colours, textures and patterns and for that reason they are always worth investigating. Past their prime and no longer functioning as originally intended, these ageing structures enter a period of transformation. They evolve from their beginnings as a productive or habitable unit to something that is little more than an ancient folly and perhaps now only of curiosity value. But some of these buildings are more than that. To my eye, many of them are art objects, a collage of time-ravaged materials of an intricate and maturing beauty. Sadly they will not survive forever and their state of impermanence compels me to capture them whenever an opportunity arises. This is not, I should add, by any means an onerous task, because I find it fascinating to absorb and scoop up every last intricate detail, and long may that continue.

Only flat light would suit the mill's richly coloured surfaces and the perfect, overcast sky guaranteed there would be no waiting or return trips involved in the making of this photograph. It was in fact rather dark which, taking into account the polarizing filter I had attached, meant that an exposure of five seconds was required. Fortunately there was no wind and therefore no risk of blurred foliage and the image was quickly taken. A mere five seconds – surely a worthwhile investment of time to ensure the existence of a record of a unique and quite charming piece of history?

When photographing the front of a building, it is important to ensure that your camera is perfectly parallel with the building's facing wall, both vertically and horizontally. A spirit level is essential unless you have an unerring eye for straight lines.

81B warming filter

Polarizer (fully polarized)

The mild warming filter has improved the fading colour of the painted stone wall but has not tainted the green foliage.

Damp leaves can be very reflective. Although I used a polarizer there are still unwanted highlights which could not be avoided.

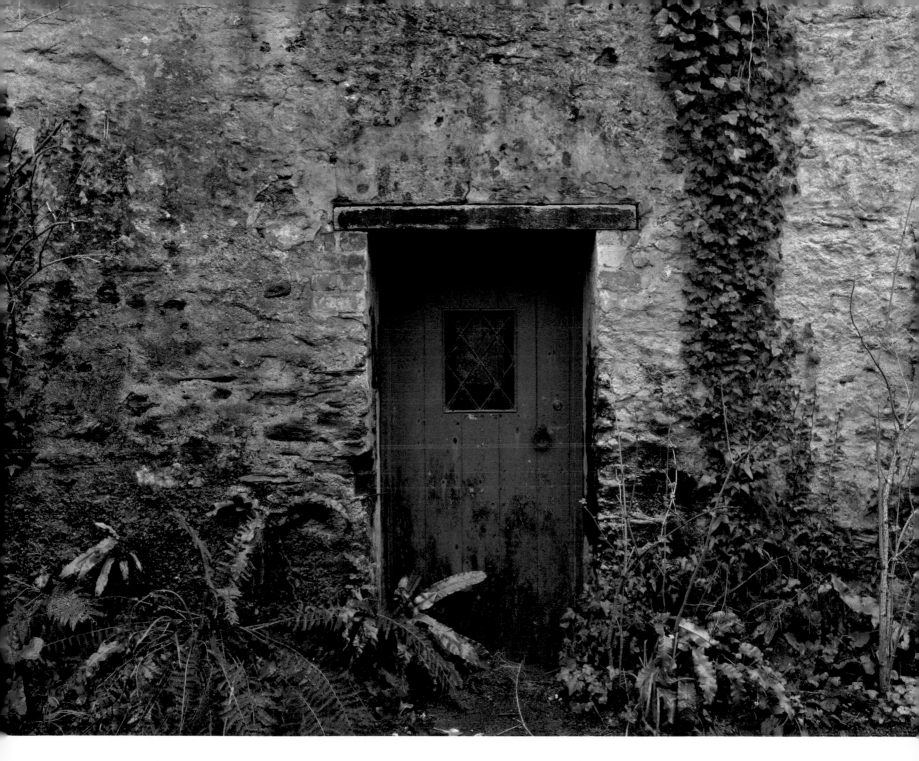

NEAR SOUTH ALLINGTON, DEVON, ENGLAND

CAMERA **Tachihara 5x4in**
LENS **Super Angulon 90mm (Wideangle)**
FILM **Fuji Provia 100**
EXPOSURE **5secs at f32**
WAITING FOR THE LIGHT **Immediate**

Under the Spotlight

Searching for suitable locations is a time consuming, but essential, part of the process of producing landscape photographs. However, important as it is, I do not believe it is the most critical factor in achieving success. I have always found that it is 'when' rather than 'what' I photograph that matters most because, with the right quality of light and sky, the most mundane subjects can be transformed and can transcend their humble origins to briefly become the source of many original and distinguished images.

The farmland in the picture opposite lies in one of the less spectacular parts of the Peak District. Being somewhat remote the area receives few visitors and, I should imagine, even fewer photographers – and that suits me perfectly. This is because I like to be original; preferring to photograph the unphotographed and, whenever possible, trying to use the raw materials of light and cloud to bring an added dimension to what would otherwise be an unremarkable landscape.

The barn and surrounding trees certainly looked unremarkable when I first discovered them. This was no doubt due to the fact that it was misty and raining, with a blanket of lifeless, grey cloud hanging ominously overhead. But the potential shone through and I returned the following day to make a more thorough assessment. It didn't take me long to make up my mind.

Within minutes of my arrival, beams of sunlight had sliced through the blustery sky to sweep a searchlight across the open fields. Gone was the gloom from the previous day, I was looking at a landscape transformed. The light show continued as I frantically unpacked, set up, composed, focused and took spot meter readings of the highlights. Then suddenly it was all over. The light faded and the landscape returned to its winter hibernation – but not before I'd been able to make two exposures as the barn fell fleetingly under the glare of the spotlight!

A landscape image consists of transient elements. It is the timing of the capture of those elements that determines a picture's success.

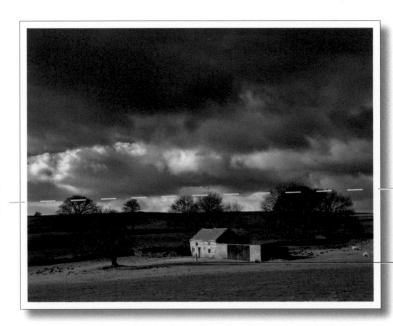

A spotlit landscape is always worth photographing. In the right conditions – for example bursts of sunlight breaking through a stormy sky – dramatic images can be made. Watch the light and be ready to release the shutter at the right moment.

When using spotlighting, exposure should be based on the highlights, not the shaded areas.

Two-stop (0.6) neutral density graduated filter

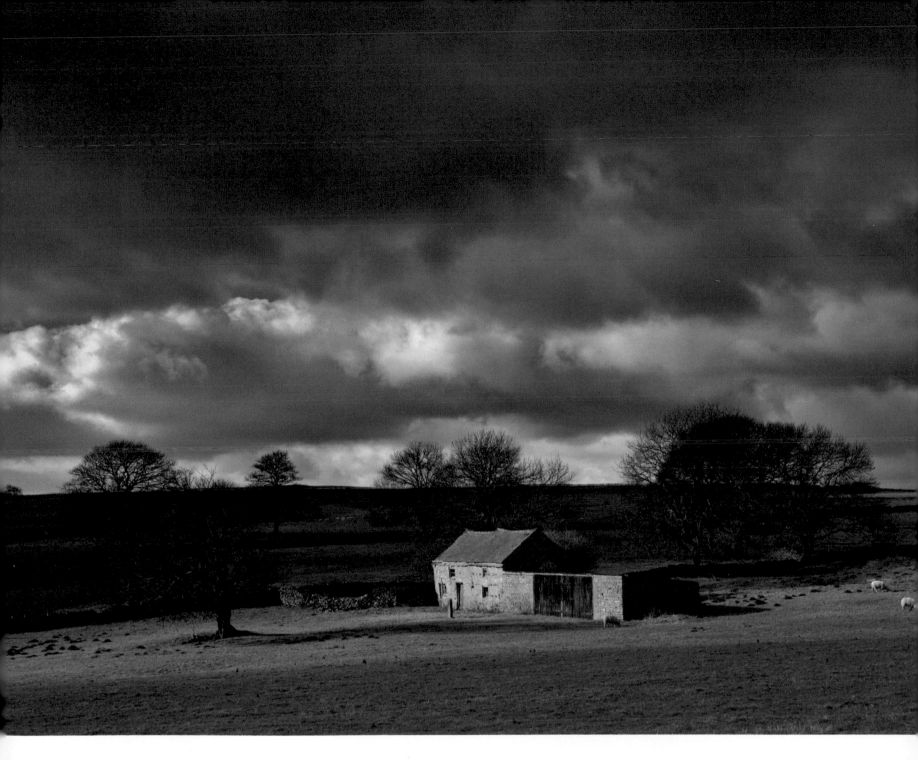

NEAR FLAGG, THE PEAK DISTRICT, ENGLAND

CAMERA **Tachihara 5x4in**
LENS **Super Angulon 150mm (Standard)**
FILM **Fuji Provia 100**
EXPOSURE **1/4sec at f32**
WAITING FOR THE LIGHT **Immediate**

A Restrained Grandeur

Hog Pen Gap? Where is it? What is it? Why go there? Yes I have to admit these are reasonable questions. It is hardly a major tourist destination; devoid of canyons, gorges and mountains. Hog Pen Gap is a hinterland of restrained grandeur. Here more subtle features of the landscape create the magnificence and with it the photographic opportunities, and of course an added attraction of such locations is that they have rarely, if ever, been photographed. Discovering places like this is a joyful and fulfilling experience and time invested in seeking them out is never time wasted.

Discovery is of course only the initial step, because one aspect shared by all landscapes is that the seeing and photographing of them are two separate, distinct acts. Sometimes they may be minutes apart but often it can be hours, days, weeks, or much longer before the sight you first encounter is actually captured. It's not unusual to have to visit a location several times before the light, sky and landscape combine together in a favourable manner.

Hog Pen Gap was no exception and I finally got this photograph after several futile attempts. In Britain the problem is usually persistent cloud but in sunny Georgia it was just the opposite. Clear blue skies were dominant and, if it continues for several days, too little cloud can become just as frustrating as too much.

The weather did, as you can see, eventually change and I was able to watch as the billowing cloud caused light to play across the fields and trees. I waited for the moment when the foreground was in shade and broken sunlight illuminated the middle and far distance. This type of variegated light gives an image depth and accentuates detail and contours and is ideal when photographing an open landscape. So, after several days of waiting, there was the perfect light for what I consider to be a most entrancing and perfect piece of landscape. And, you never know, this might just put Hog Pen Gap on the map!

Two-stop (0.6) neutral density graduated filter

The ND graduated filter has enabled the detailed cloud structure to be correctly exposed and accurately recorded.

A softly shaded foreground with brighter light in the distance will draw the eye into the landscape and will help to give a photograph a three dimensional appearance.

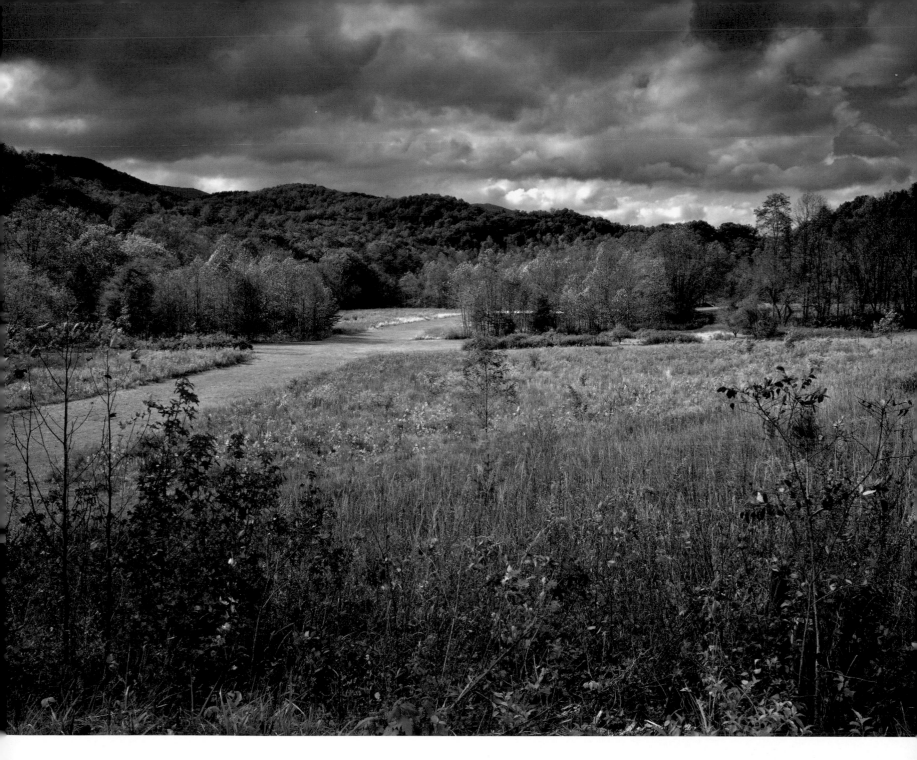

HOG PEN GAP, GEORGIA, USA

CAMERA **Tachihara 5x4in**
LENS **Super Angulon 90mm (Wideangle)**
FILM **Fuji Provia 100**
EXPOSURE **1/8sec at f22½**
WAITING FOR THE LIGHT **40 minutes**

Derelict buildings and land

Industrial areas, particularly derelict buildings and land, can yield many intriguing images. Look for weathered painted surfaces and the rich, jagged fabric of worn stone and brick. Colourful weeds and wild plants thrive in the unlikeliest of places and can embellish and transform the shabbiest of buildings. When photographed, this combination of wild, prolific nature growing freely amidst a decaying man-made environment can be an arresting vision. The photographer should not neglect the neglected urban landscapes; they can provide the opportunity for creative and original image making and should be investigated.

Coastal resorts

During the winter months, coastal towns and villages are free of crowds and the unattractive signs of commercialism. This is when they reveal their true character and a walk through their quiet streets and harbours can be a rewarding experience. Look for old, original buildings and artifacts of abandoned trades and activities. Fishing boats, nets, jetties and the remains of piers are all worth investigating. There is no shortage of material and photographs can always be found with observation and creative interpretation.

BIRKENHEAD DOCKS, WIRRAL, MERSEYSIDE, ENGLAND LEFT
Pockets of fertile ground can be found in industrial landscapes and they can often be sandwiched between old and dilapidated buildings. Look for combinations of colour and texture and contrasts between natural and man-made materials.

NEAR TOLLER PORCORUM, DORSET ABOVE
The broken cloud softened the sunlight and created the perfect light to capture the colours in this flowering meadow. Note also the depth and scale in the image which has been enhanced by the presence of the farmhouse.

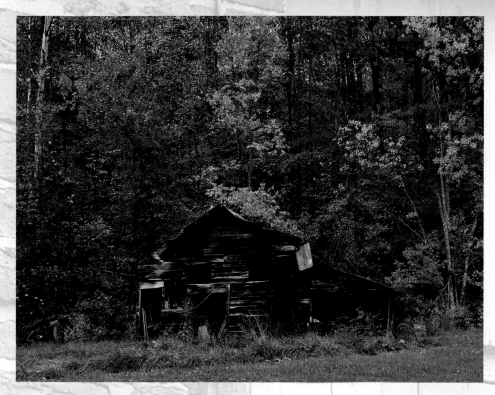

Farmland and buildings

During the growing season, arable farmland abounds with repetition, patterns and graphic lines of an elemental, but beautiful, simplicity. Look for fields planted with rows of crops and use a telephoto lens to isolate and emphasize the symmetry. Exclude the sky and any extraneous features. The rule to remember is – the simpler the image, the better the image.

Flower-rich meadows can be found in grassland and fields which have been set aside. Visit these during late spring and early/midsummer to catch them at their peak. Use soft sunlight to capture the colourful display and, if possible, use a polarizing filter (be wary of using long exposures however, particularly if it is breezy). As well as taking images of the entire meadow look for perfectly formed, unblemished examples of individual flowers. These can photographed as a close-up and can look attractive when depicted against a simple, uncluttered background.

Agricultural barns and sheds are often fine examples of innovative, cost-effective maintenance techniques, and the array of building materials used in their repair can be interesting to photograph. If located in a picturesque setting, consider placing the building as a focal point in the wider landscape. Alternatively, images of a single part of the building, for example a single wall, a window or a specific feature, can often be successful. Look for a theme based on an abstract or semi-abstract arrangement or a bold or unusual colour combination.

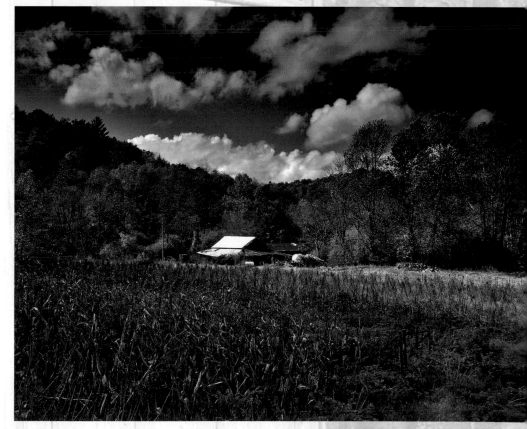

CHAPTER FIVE
Coastal landscapes

There are some eminent landscape photographers who, almost exclusively, practise their art along the coastline, and it's not difficult to see why they choose to do so because nowhere else do you find such a rich tapestry of shapes, patterns, colour and texture together with the most sublime light. This is more than just low level light, this is sea level light; the exquisite first or last light of day that floats across the ocean surface gently to probe every nook, every cranny and every ripple in the sand. Combine this special quality of light with the strong elemental features of the coast and you have the most fertile photographic ground to be found anywhere.

The coastline also plays host to some of the most volatile weather conditions. From the tranquil to the frighteningly ferocious, conditions can suddenly lurch from one extreme to another. To the attentive eye compelling images will arrive in all their glory on the passing wind and there is no better place to spend a few hours sky and weather watching; you can almost guarantee that, at some point, you will be presented with a dramatic seascape or cloudscape.

You never know what to expect at the coast; that's the beauty – it is invigorating, intriguing and often inspiring. Leave the landscape behind, take a few steps to the water's edge and you will enter another world. There is nowhere quite like it. Spend some time there and you will discover that in all seasons and in all weathers, the coast has something unique and quite splendid to offer.

NEAR PORTLAND, MAINE, USA
I had arrived at the coast early in the hope of capturing a spectacular sunrise. It wasn't to be but discovering this delightful group of shells more than compensated for my disappointment. I couldn't have asked for, or indeed arranged, anything better. My only contribution was to remove a strand of seaweed and blow away some surplus sand. As is often the case with still life images, it was the seeing, not the taking, which was the crucial factor in the making of the photograph.

CAMERA **Tachihara 5x4in**
LENS **Super Angulon 150mm (Standard)**
FILM **Fuji Provia 100**
EXPOSURE **1/2sec at f22**
WAITING FOR THE LIGHT **Immediate**

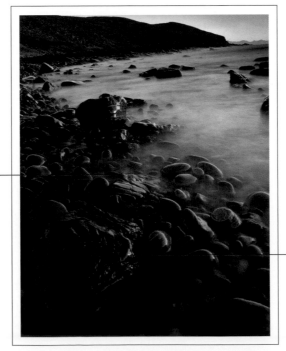

A Rare Occasion

I am by nature a minimalist. Instinctively, I prefer quality to quantity and this is possibly why I favour photographing in winter rather than during the summer months. The short hours of daylight will, with any luck, provide exceptional light throughout the entire day, from dawn until dusk. This doesn't occur at other times of the year so for me there is no better time than those short days of winter to venture out and capture the unique quality of light.

Towards the northern tip of Scotland, along the west coast north of Lochinver, there are a number of coves and inlets that are in some respects similar to Cornwall. However, the coastline here has its own distinctive character and each bay along this stretch has something different to offer. I was spoilt for choice but have to admit that, during my stay in this part of Scotland, I did grow particularly fond of the diminutive Balchladich Bay.

There is certainly a minimalist quality to the landscape here, to the extent that the bay is enclosed, isolated and not particularly expansive. This is, however, its strength because it has a beguiling combination of gently sloping beach, shallow crystal clear water and a plethora of protruding rocks and boulders. Add to this clean sand and a south-western aspect – which is tailor made for winter photography – and you have all the ingredients necessary for the making of outstanding images.

It was mid afternoon when I arrived at the bay but already the sun was heading rapidly for the cloud-free horizon. As the sun sank lower, I was able to position my tripod in the shallow waters and take images facing north and south, following the direction of the coastline, with the sun, hovering just above the ocean, at a right angle to my viewpoint. The gentle sidelighting this created was perfect for capturing the surface detail and textured colour of the rock covered foreground. It was one of those memorable, and sadly all too rare, occasions when not only was the light perfect but there was also more to photograph than I could manage in the time available. The pictures were literally queuing up in front of me and I was able to enjoy an hour of non-stop photography before darkness brought an unwelcome end to proceedings.

Polarizer (fully polarized)

The contrasting colours of the water and rocks are an attractive feature. I didn't want to tamper with the finely balanced combination of cool and warm tones and therefore chose not to use a warming filter.

A specific angle of light will be needed if surface detail is to be depicted. Here the sun was slightly in front of the camera and it is the combination of side and semi-backlighting which has revealed the intricate outline of the boulder.

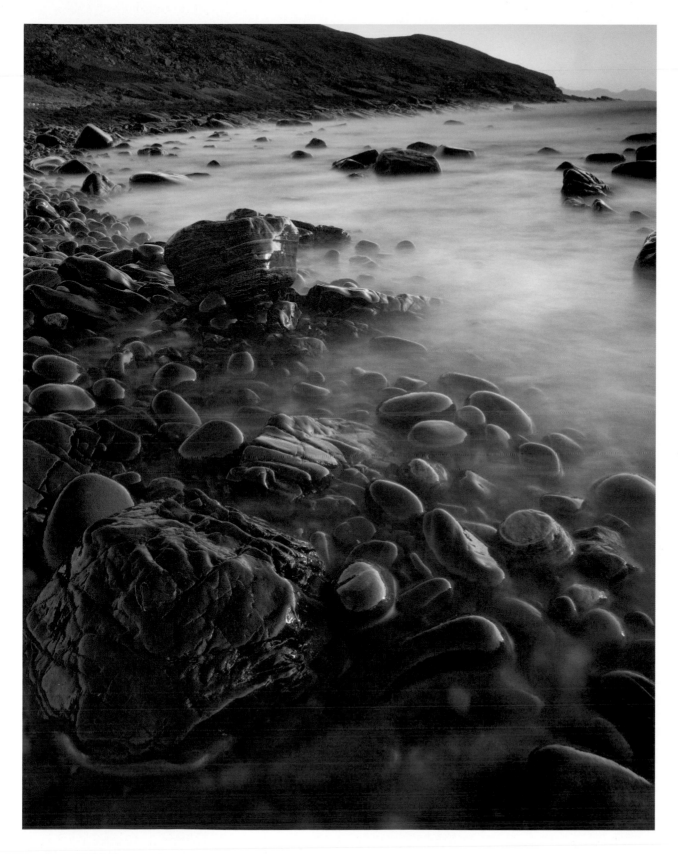

**BALCHLADICH BAY,
SUTHERLAND, SCOTLAND**

CAMERA **Tachihara 5x4in**
LENS **Super Angulon 90mm (Wideangle)**
FILM **Fuji Provia 100**
EXPOSURE **6sec at f32**
WAITING FOR THE LIGHT **Immediate**

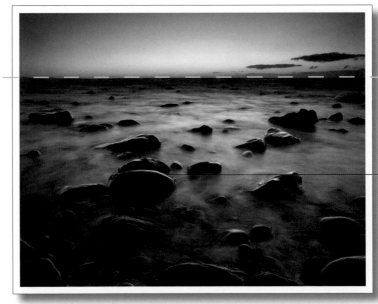

Entrancing Light

My visit to Balchladich reached its climax with this tranquil image of the frequently hostile Minch Atlantic channel. There was no hostility on this occasion, however, because the hour spent here had been calm and, had I not been working so intensely, it would have been a restful and relaxing experience. With the lapping of the waves the only sound breaking the silence, I could have been on a deserted tropical island (admittedly a slightly chilly one!). There was virtually no cloud to impede the light and this enabled me to study the changing appearance of the rocky shoreline.

As the final minutes of daylight approached, I turned my camera towards the horizon and the setting sun. When the sun disappeared, the clear twilight sky produced a strong afterglow which, with the right subject, is a captivating light. With no risk of lens flare I was able to shoot into the light and capture the warmth of the dusk sky which contrasted so well with the cool blue of the ocean. Pointing the camera in this direction also gave me

backlighting – which again can be an entrancing light in the right conditions – and this imparted a pleasant shimmer to the rocks that, to my mind, brings a necessary sparkle to the photograph.

To prevent the sky from being overexposed I used a two-stop ND graduated filter and positioned it carefully along the horizon line. A post-sunset sky can be surprisingly bright, particularly if there is no cloud present. The use of the filter has enabled colour to be retained throughout the image, from sky, to water, to foreground rocks.

Although somewhat remote, this part of northern Scotland should be on every photographer's map. Balchladich is just one of several bays along this stretch of coastline and I urge you to discover them for yourself – you will not be disappointed.

In the right conditions, the combination of lengthening shadows, softening light and incoming tide can produce a seemingly endless supply of quite different, but equally appealing, images.

Two-stop (0.6) neutral density graduated filter

A two-stop ND graduated filter has balanced the light values of the sky and water.

Backlighting has brightened the outline of the boulders and has prevented them from being reduced to flat silhouettes.

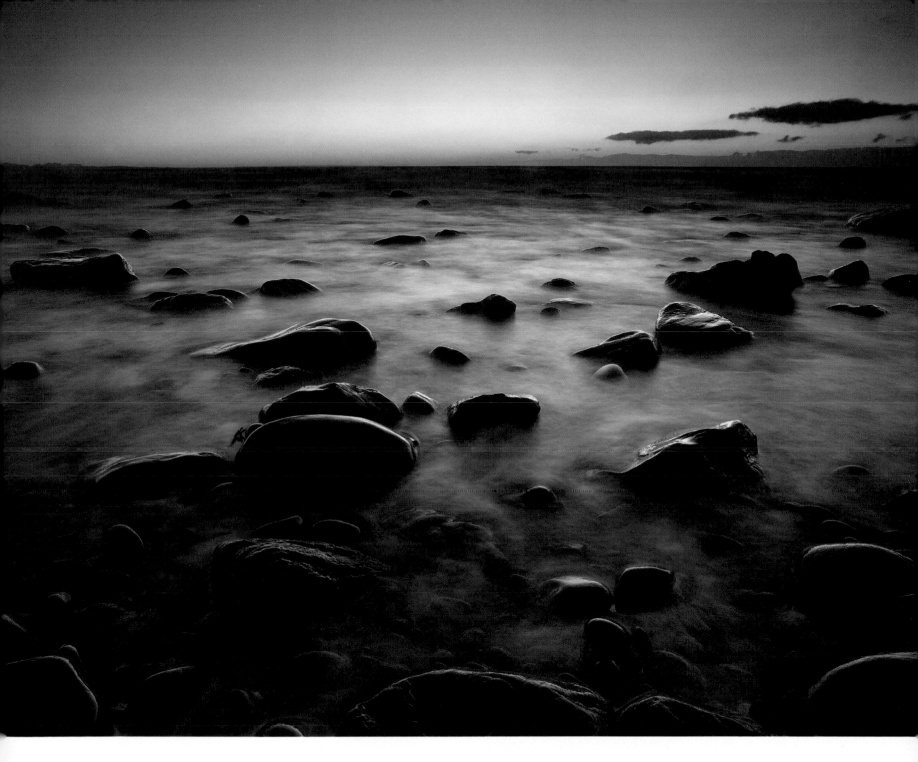

BALCHLADICH BAY, SUTHERLAND, SCOTLAND

CAMERA **Tachihara 5x4in**
LENS **Super Angulon 150mm (Standard)**
FILM **Fuji Provia 100**
EXPOSURE **10sec at f45**
WAITING FOR THE LIGHT **10 minutes**

An Engrossing Discovery

It was with a heavy heart that I made my way to the Northumbrian coast. I normally have a positive outlook but had good reason to feel pessimistic because the sky was a dismal, monotonous grey and a steady drizzle was dampening everything, including my spirits. Two photographer friends and I were staying in Northumberland for the week, so it was a case of making the best of it. We had planned to spend the day in the Cheviots but the bleak conditions had steered us towards the coast. I thought that, in spite of the weather, we could at least make good use of our time by exploring the coastline. The possibility of actually photographing anything had been completely dismissed from my thoughts; I was, however, about to be proved entirely wrong!

The rain continued as we parked and set out on our trek along the lengthy stretch of beach between Bamburgh and Seahouses. Any type of photography seemed out of the question, but we continued on. We eventually reached a rocky expanse and it was then that, out of the gloom, I felt a flicker of hope. The rocks and boulders were a fascinating combination of bold colours, rich textures and patterned, flowing lines. My companions and I hopped, like excited children, from one craggy crevice to another. There were photographs here for the taking and, with a newly found sense of purpose, we quickly retraced our steps, collected our equipment and returned to our engrossing discovery. And, wonder of wonders, at that very moment the rain stopped! Suddenly the day was looking decidedly bright.

The rocks were, of course wet, and therefore reflective, and it was necessary to use a polarizing filter to reduce the unwanted highlights. Otherwise it was straightforward and we spent an absorbing couple of hours experimenting with various compositions, colour themes and combinations of pattern and shape. Bleak as it initially was, I now have very fond memories of that day. All the photographs from that occasion are a reminder to me that, no matter how unpromising the conditions, we should never give up hope. With a positive approach, there is no doubt that creative landscape images can be made in all types of weather.

Polarizer (fully polarized)

On their own, colour and texture will not make a complete photograph. In order for an image to be satisfying aesthetically, the elements need to be aligned in a structured and cohesive manner. It was the finely balanced arrangement in these rocks, rather than their colour, that initially attracted me to them.

The picture benefits from the muted green rock at the top of the frame; this helps to keep the arrangement simple and prevents the picture from becoming overloaded with colour.

I liked the combination of the two contrasting rock faces and the row of stones which were sandwiched between them. They are supported by a nicely shaped curve and to make the most of this, I placed the stones slightly above the centre of the composition, which is a visually strong position.

NEAR BAMBURGH, NORTHUMBERLAND, ENGLAND

CAMERA Tachihara 5x4in
LENS Super Angulon 150mm (Standard)
FILM Fuji Provia 100
EXPOSURE 4secs at f32½
WAITING FOR THE LIGHT Immediate

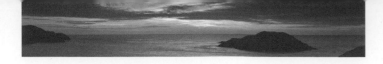

A Minimalist Approach

Simplicity in a photograph is a fine quality. When looking at a subject, be it a wide open vista or something on a much smaller scale, whenever possible I seek to reduce it to its most basic elemental form. Such an approach, however, has to be practised with restraint because there is a fine line between the simple and the bland. For minimalism to succeed, it is imperative that every minute detail in the picture engages the eye and satisfies the closest scrutiny. What the result will look like is not always easy to predict and there have been occasions in the past where I have, perhaps, been injudicious in my approach. The final image has been a big disappointment and my attempts to impose clarity on my subject have been a resounding failure. However, like most photographers I learn from my mistakes and caution, restraint and objectivity are now bywords in my approach to minimalism.

A clear sky is not as a rule to my liking but it can on occasion prove to be a blessing in disguise. I was once spending a week photographing along the south coast of Cornwall; it was mid February, cold, wet and windy and when saying I was photographing, this is an exaggeration. To be precise, I had taken the grand total of just one picture during the previous four days and was feeling a little sorry for myself. The weather then changed dramatically and the fifth day dawned bright and sunny, but that didn't improve my mood because I now had a completely cloudless sky to contend with. The fine weather conditions lasted throughout the day and for once the horizon was virtually clear with just a thin layer of misty cloud hovering above the ocean. This brought a hint of warmth to the sky and I began to realize that the day was going to end on a high note.

The cliffs, the setting sun and the distant rocks provided me with the opportunity to satisfy my minimalist inclinations. For once I was thankful that I had an almost clear sky because it provided the appropriate backdrop to a picture which demanded simplicity. This photograph was unplanned, unexpected but, in an otherwise frustrating and cloud-filled week, certainly not unwelcome.

If I am being critical, I have to say that while the sky is perfectly acceptable, it is not entirely to my liking. There should ideally be a small amount of cloud present on the left. This would have improved the balance of the image without compromising its simplicity.

One and a half-stop (0.45) neutral density graduated filter

The final moments of a sunset happen very quickly. The sun appears to gather speed as it approaches the horizon and unless you are set up and ready to make the exposure, you will miss the opportunity.

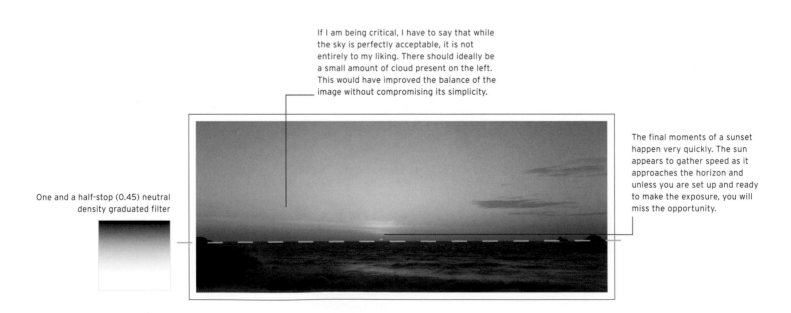

PORTH NANVEN, CORNWALL, ENGLAND

CAMERA **Fuji GX617**
LENS **Fujinon 105mm (Standard)**
FILM **Fuji Provia 100**
EXPOSURE **2sec at f45**
WAITING FOR THE LIGHT **2 hours**

Whirls, Loops and Curves

Squally showers were forecast and this encouraged me to spend the day along the exposed west Sutherland coast. The combination of windy, unpredictable weather and the constantly changing appearance of the ebbing and flowing tide would undoubtedly be a challenge and with any luck would create some picture making opportunities. So, looking forward to the day ahead, I arrived early at Clachtoll Bay during a passing shower which, two hours later, showed no signs of actually passing. It seemed that I would indeed have a challenging day ahead.

The weather did eventually improve and I was able to take up a position at the water's edge to capture the incoming waves as they broke against the jagged rocks which are scattered across the bay. Wave watching can be a rewarding experience as intriguing combinations of whirls, loops and curves fleetingly emerge from the impact of water against stone and they can be the basis of many fine and original images.

I was tempted to adopt a close position and concentrate on the patterns created around individual rocks but there was drama brewing in the sky and I preferred the bigger view. The group of coastal cottages (which are so essential to the scale and perspective of this image) were perfectly placed to enable me to photograph the bay in its entirety, water and waves included. The precise timing of the exposure was of critical importance and this dominated my thoughts. I took several images throughout the afternoon, all with varying arrangements of water and rocks. The appearance of rapidly flowing water is difficult to predict and the best approach is to make a number of exposures and then assess the results. I used a 1 second shutter speed but exposures over a wide range are possible, from say 1/20 second to 20 seconds or longer. All will give quite different results and it is interesting to experiment with different speeds and compare the effects they create.

When photographing on a wet beach, it is important to check for movement and possible sinking of your tripod because water flowing over sand will create an unstable surface. Keep checking that the horizon is level using a camera mounted spirit level.

Polarizer (fully polarized)

As well as improving the sky, the polarizer has also enhanced the colour of the clean, blue water.

One and a half-stop (0.45) neutral density graduated filter

When photographing waves, many different permutations of timing and length of exposure are possible. The final appearance is difficult to predict so I took several images to enable me to compare and select from a number of quite different results.

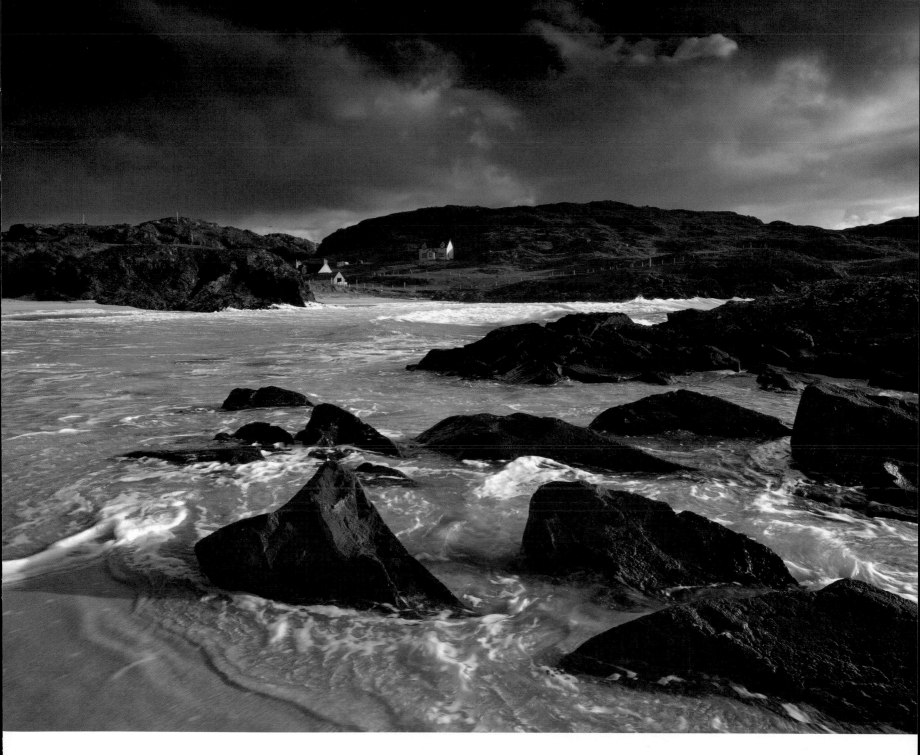

CLACHTOLL BAY, SUTHERLAND, SCOTLAND

CAMERA Tachihara 5x4in
LENS Rodenstock 120mm (Semi Wideangle)
FILM Fuji Provia 100
EXPOSURE 1sec at f45
WAITING FOR THE LIGHT 3 hours

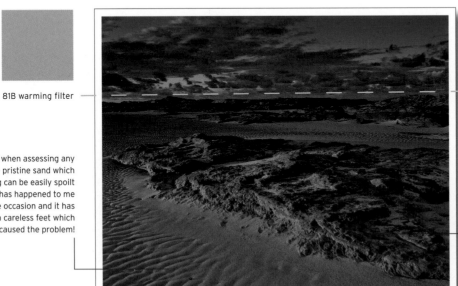

A New Gallery?

The Dee Estuary along the Wirral Peninsula is renowned for being one of Britain's premier bird watching sites but the area's coastline is not, in itself, dramatic. There are, however, some richly detailed rock formations and they photograph well in the revealing light of late afternoon and evening. I live on the peninsula and can therefore keep a watchful eye on the sky and make the short journey to the beach if it looks promising. Even though it is only a 15-minute drive, I have lost count of the number of times I've left the house in fine weather only to be greeted on my arrival at the coast by gathering storm clouds; just 15 minutes - 900 seconds! - a period of passing brevity on land, but apparently an aeon in the sky.

On this occasion, however, I was in luck. The fine cloud structure held and I was able to wait until the sun was almost level with the horizon, then, as the light began to soften slightly, I had time to make several exposures. I photographed in both landscape and portrait formats, at the time thinking that the vertical composition was the stronger. However, once I saw the results, I don't know why but I preferred the landscape images. Although the light had shifted towards the red end of the spectrum, I still added an 81B warming filter which I generally use when photographing sand as it has a marvellous effect on its colour. I also used a two-stop ND graduated filter to enable the detail in the sky to be properly recorded.

Whilst waiting for the light, I watched as a group of bird watchers and photographers made their way across the sand to the promenade. It occurred to me that to my knowledge there was no collective noun specifically for photographers so, with a little time on my hands, my thoughts began to wander. The best I could come up with (and you will now realize that I didn't dwell on the matter for long!) was gallery - a gallery of photographers. It seemed to roll off the tongue at the time but somehow I doubt the term will become commonly used. However, you never know (and if by chance it does, please remember - you saw it here first!).

81B warming filter

Tread carefully when assessing any beach scene. The pristine sand which you find so appealing can be easily spoilt by footprints. It has happened to me on more than one occasion and it has usually been my own careless feet which have caused the problem!

Two-stop (0.6) neutral density graduated filter

Warming filters should not, as a rule, be used when photographing large areas of grass. They can give a green landscape an unattractive yellow tinge as can be clearly seen here. Although the filter has improved the colour of the sand you can see the undesirable effect it has had on the moss.

HOYLAKE, WIRRAL, MERSEYSIDE, ENGLAND

CAMERA Tachihara 5x4in
LENS Super Angulon 90mm (Wideangle)
FILM Fuji Provia 100
EXPOSURE 1/2sec at f22
WAITING FOR THE LIGHT 20 minutes

A Smooth Transition

Foreground is, as I have said before, essential in an image where distance and scale are to be conveyed to the viewer. Without it there would be nothing to catch the eye and no starting point for the visual journey that you are asking the viewer to make. However, for foreground to fulfil its role effectively, it should be an integral part of the photograph and not simply bolted on as an afterthought. It should join seamlessly with more distant features, flow into the heart of the picture and be free of obstacles that interrupt or obscure the distant view.

The pebbled beach at Aberdesach provided me with an attractive and appropriate foreground in this photograph of the Lleyn Peninsula. On their own, however, the pebbles and rocks would have looked a little lost because there would have been no connection with the sea and mountains. But what a difference the incoming tide makes. An ethereal quality has been introduced by the effect of the water gently lapping over the stones and this has also created a gradual progression from heavy, solid rigidity to light, fluid mobility. There are no abrupt meeting points, just a smooth transition from the closest stone to the distant horizon.

To give water a transparent appearance careful timing and long exposures are necessary. I released the shutter at the moment the incoming waves hit the first row of pebbles and used an exposure of 10 seconds. This was one of several images I made because the strength and speed of each wave is a constant variable and will have a pronounced, but unpredictable, effect on the final result.

I must also comment on another element in this picture. When I arrived the lower part of the sky was cloudless and I was concerned that the photograph would look unbalanced due to the abrupt termination of the mountains halfway across the horizon. Fortunately, by the time I made the exposures, a line of cloud had developed which maintained the mountainous appearance across the width of the picture and this has prevented it from looking one-sided. Cloud can be helpful in this respect because its solid appearance can be used to balance other features.

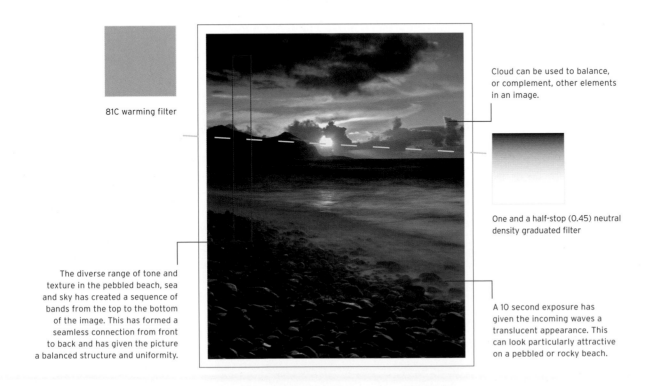

81C warming filter

Cloud can be used to balance, or complement, other elements in an image.

One and a half-stop (0.45) neutral density graduated filter

The diverse range of tone and texture in the pebbled beach, sea and sky has created a sequence of bands from the top to the bottom of the image. This has formed a seamless connection from front to back and has given the picture a balanced structure and uniformity.

A 10 second exposure has given the incoming waves a translucent appearance. This can look particularly attractive on a pebbled or rocky beach.

ABERDESACH, GWYNEDD, WALES

CAMERA **Tachihara 5x4in**
LENS **Super Angulon 150mm (Standard)**
FILM **Fuji Provia 100**
EXPOSURE **10secs at f45**
WAITING FOR THE LIGHT **1½ hours**

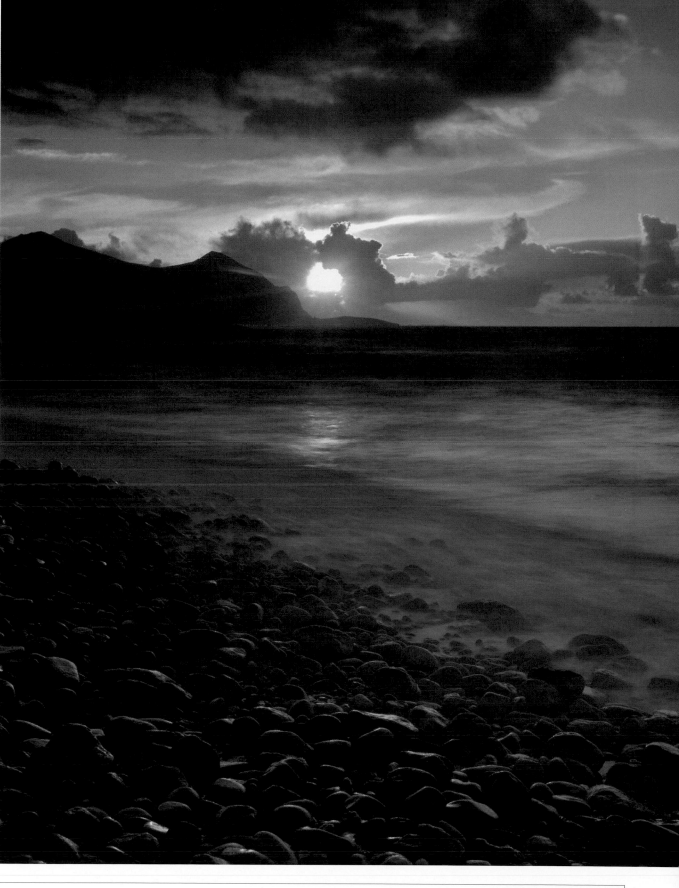

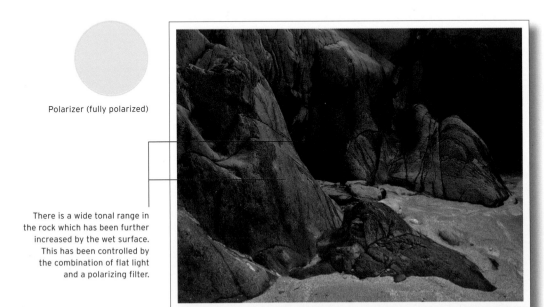

A Clean Sweep

I had spent the day with a good friend, who is also a photographer, exploring the Pembrokeshire coast and photographing a small number of locations which neither of us had previously visited. We were discussing our day over dinner and I began to reflect on an image taken at Caerfai Bay. I had photographed a particularly attractive part of the cliffs which encircle the bay but the more I thought about it, the unhappier I became about a particular decision. The base of the cliffs was covered by a thin layer of sand, which didn't unduly concern me at the time, but it was now preying on my mind. I was lamenting the fact that I had failed to clean the rocks (although how I would have done this I have no idea, because at the time I had no means of undertaking such a task) when my companion suggested that we return to the bay the following day and retake the picture, this time minus the sand.

I was more than happy to return to the scene of my crime and early the next morning we were back on the beach with cameras, tripods and, this time, sweeping brushes in tow. Taking care not to leave any footprints we removed every grain of unwanted sand and, for the second time, I photographed the strikingly beautiful sandstone cliffs. It was a race against time because the sky was clear and, under the glare of the morning sun, my shining rocks would soon be shining a little too brightly for my liking. Highlights and shadows had no role to play in my photograph; only flat, delicate light would suit the soft curves and the rounded, weathered rock face.

With minutes to spare the image was taken and I am thankful that I was able to rectify my error of judgement. Having now been able to compare both photographs, there is no doubt that the excess of sand in the first picture weakens its appeal and I should have realized this immediately. I have learned my lesson and with luck it will stand me in good stead in the future. I certainly hope it will, but have to admit that I am a little reluctant to add a sweeping brush to my already eclectic assortment of accessories!

Polarizer (fully polarized)

81C warming filter

There is a wide tonal range in the rock which has been further increased by the wet surface. This has been controlled by the combination of flat light and a polarizing filter.

Much of this rock was covered in sand when I first photographed it. There is no doubt that removing the sand has improved the picture.

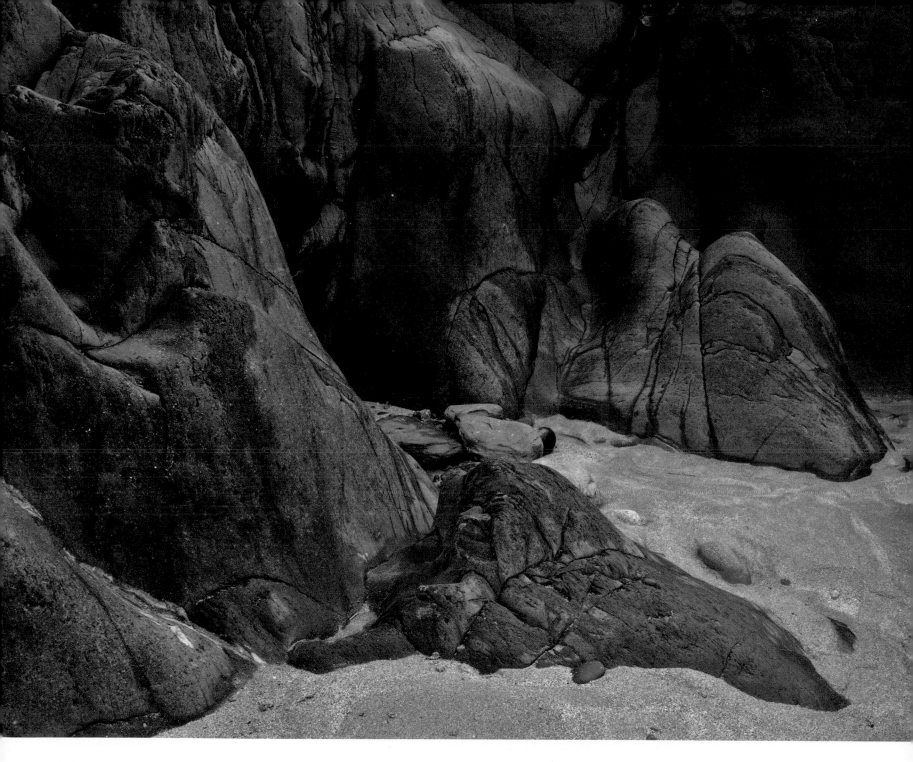

CAERFAI BAY, PEMBROKESHIRE, WALES

CAMERA **Tachihara 5x4in**
LENS **Rodenstock 120mm (Semi Wideangle)**
FILM **Fuji Provia 100**
EXPOSURE **3sec at f45**
WAITING FOR THE LIGHT **Immediate**

A Miniature World

The day had been a mixture of sun and showers and I was wandering around Westport Bay, on Ireland's west coast, hoping for a dry end to the afternoon and a fine sunset. While waiting for the grand finale, I noticed a discarded ship's rudder and I started to examine it more closely. It was the bold colours and rough texture that had caught my eye. Here was a miniature landscape, a tableau of weathered colour with a strong three dimensional quality. What I particularly liked was its depth; this was more than just a flat, painted piece of metal, there was a rich, tangible fabric to its surface. It was on a small scale but in photography scale is relative. Photograph something the right way and you can create your own landscape with its own depth and perspective.

I scrutinized every inch of the rudder through my handheld viewfinder. It had a large and variegated surface area which provided me with a number of options and, in fact, too much choice. Which format should be used? Portrait? Or perhaps landscape? Should I move to the left a little, or possibly use a slightly higher position? The image had a strong abstract quality but I preferred to retain a degree of reality by including part of the structure of the rudder, rather than just a loose expanse of colour. I settled on the composition you see here because this arrangement seemed to capture the essential qualities of the subject. Vibrant, varied colour, graphic depth and rugged texture, it's all here in this miniature man-made world.

Shielding the rudder from the sunlight, I used a standard lens with a polarizing filter attached and made two exposures. The sunset I was hoping for failed to materialize but I wasn't disappointed. I had got my grand finale, it just wasn't quite on the grand scale I'd been expecting.

Polarizer (fully polarizer)

Colour on its own rarely makes an interesting subject. What attracted me to the rudder was the rugged depth to its surface, which I have attempted to maximize by including a raised part of its structure.

WESTPORT BAY, CO MAYO, IRELAND

CAMERA **Tachihara 5x4in**
LENS **Super Angulon 150mm (Standard)**
FILM **Fuji Provia 100**
EXPOSURE **1sec at f32**
WAITING FOR THE LIGHT **Immediate**

A Change of Direction

I hadn't intended taking this image. I was hoping for a sunset and my camera was pointing in the direction of the setting sun but it was becoming frustrating because the sky was beginning to close in. I was about to give up for the day when a shaft of light suddenly emerged from the gathering cloud to clip a protruding edge of the cliffs at the side of the bay. Fortunately I was using my Fuji and it was a simple task to swivel it 90 degrees and capture the unexpected moment. I use the word moment but the light continued for several minutes and I was able to concentrate on the incoming waves and time my exposures to coincide with the appearance of ripples and speckles on the water's surface. These apparently minor details add interest to the foreground and give the lower portion of the picture a degree of weight and depth.

My spot meter readings indicated a difference of one stop in the light values of the sky and water. I therefore added a one-stop ND graduated filter to compensate for this, took a spot reading of the illuminated rock face and exposed for the highlights. An average meter reading would have produced a much brighter image and the spotlit rock – which is of course the whole point of the photograph – would have been grossly overexposed and its rich, glowing surface would have been reduced to an insignificant splash of pale yellow.

I considered using a warm filter but decided against it because I felt that the contrast between the warm, golden rock face and the cool, blue water and sky was an important feature. It helps to draw attention to the rock and there seemed to be little point in risking this by tinkering with the colour.

When watching a sunset keep a keen eye on all parts of the surrounding sky and landscape. Opportunities can arise in any direction and they can often surpass the main event.

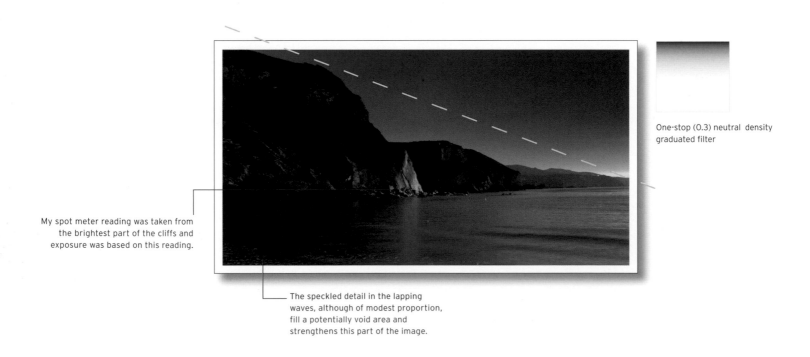

One-stop (0.3) neutral density graduated filter

My spot meter reading was taken from the brightest part of the cliffs and exposure was based on this reading.

The speckled detail in the lapping waves, although of modest proportion, fill a potentially void area and strengthens this part of the image.

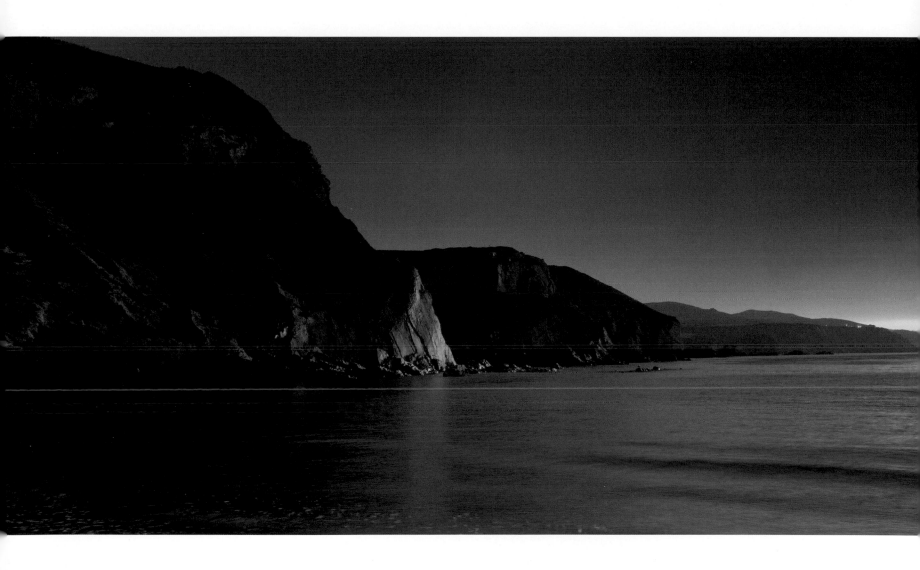

PWLLGWAELOD, PEMBROKESHIRE, WALES

CAMERA **Fuji GX617**
LENS **Fujinon 105mm (Standard)**
FILM **Fuji Provia 100**
EXPOSURE **2sec at f45**
WAITING FOR THE LIGHT **2 hours**

An Interesting Challenge

I live within 60 miles of the Yorkshire border but despite my relatively close proximity I have in the past tended to overlook the county, while the far flung parts of Britain such as Cornwall and the Scottish Highlands have received my full and undivided attention. I think my reticence was partly (and foolishly) due to its size and the number of options the county offers. It was because there was so much to choose from and consider that I often made the easy decision and chose to go somewhere else! But that was in the past and recently Yorkshire has become one of my more regular destinations.

I was thus spending a week along the North Yorkshire coast during an unusually warm and sunny September. Encouraged by the favourable weather forecast I arrived early at Saltwick Bay to watch dawn break behind the striking rock slab known as Black Nab. Unfortunately the day started inauspiciously and

I was beginning to think I had made a wasted journey, but there was a steady breeze and a hint of improvement in the sky. Thirty minutes later the sun made its belated appearance and I was able to make several exposures before the cloud thinned and the warmth in the sky evaporated.

Saltwick Bay is one of the more popular photographic locations and I have seen a number of fine images, taken from different viewpoints and at various times of day and year. It was curiosity which took me to the bay and I had hoped that, if I made a photograph, it would be as original as possible. This can be difficult when a subject has been heavily photographed over many years but it can be an interesting challenge to look for a new angle or an innovative composition. My picture is hardly innovative but I hope it is at least original. I would hate to think that my pre-dawn rise was merely to replicate an existing image.

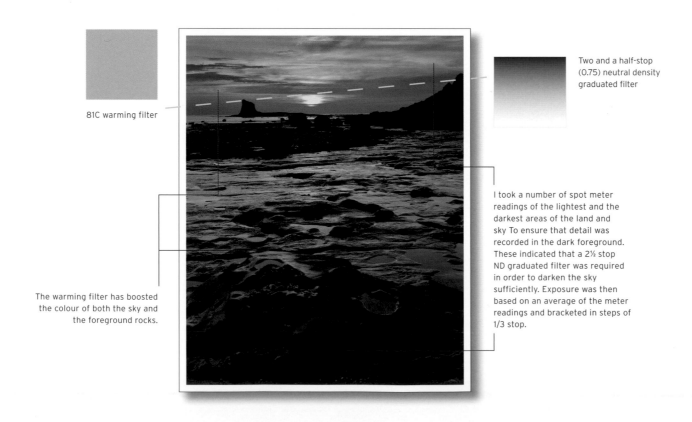

81C warming filter

Two and a half-stop (0.75) neutral density graduated filter

The warming filter has boosted the colour of both the sky and the foreground rocks.

I took a number of spot meter readings of the lightest and the darkest areas of the land and sky To ensure that detail was recorded in the dark foreground. These indicated that a 2½ stop ND graduated filter was required in order to darken the sky sufficiently. Exposure was then based on an average of the meter readings and bracketed in steps of 1/3 stop.

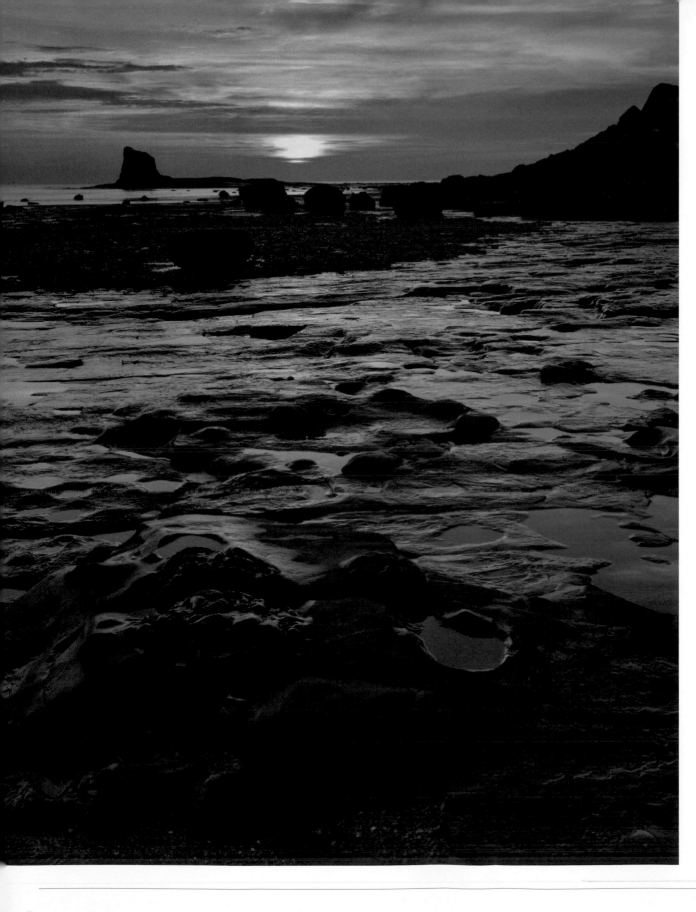

SALTWICK BAY,
NORTH YORKSHIRE, ENGLAND

CAMERA **Tachihara 5x4in**
LENS **Super Angulon 90mm (Wideangle)**
FILM **Fuji Provia 100**
EXPOSURE **5sec at f32**
WAITING FOR THE LIGHT **30 minutes**

A Simple Task

Waterfalls are not one of the coast's most ubiquitous features but they do exist and, when discovered, they often surpass those to be found further inland. This is because the presence of colourful boulders and stones can transform a waterfall and coastal rocks, free of moss and decomposing leaves, do not suffer from the discoloration which is a common problem in forest and woodland. Also, the constant weathering by tidal action ensures the rocks are generally unblemished and attractively shaped. The water also tends to be cleaner and it is for these reasons that coastal waterfalls are a fine subject for the camera and should, I suggest, be actively sought.

I didn't know what to expect when I first visited Bigbury Bay. It was new territory and, as far as I could determine from my map, it seemed to have potential, but there was no indication or even a hint of what I would actually find. In fact it didn't take a lot of finding because this magnificent waterfall was the first thing I saw as I stepped onto the beach. It was at the edge of the bay and was formed by an inland stream which was gushing down towards the sea. It was a captivating sight and I stood before it, mesmerized and taking in every last, glistening detail. It was in every sense perfect and I had the rudimentary and immensely pleasurable task of simply positioning my camera in the middle of the stream and capturing the spectacle.

At the time of making this image the sky was overcast which suits this type of subject. Bright sunlight should be avoided when photographing colourful stones and fast flowing water (either together or separately). The only highlights in the photograph should be those formed by the tumbling water, not the sun.

The river was very fast flowing and I therefore used a relatively short exposure of 1/2 second. A slower shutter speed would have led to a loss of tonal variation and definition in some parts of the water.

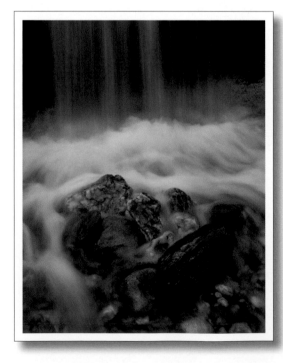

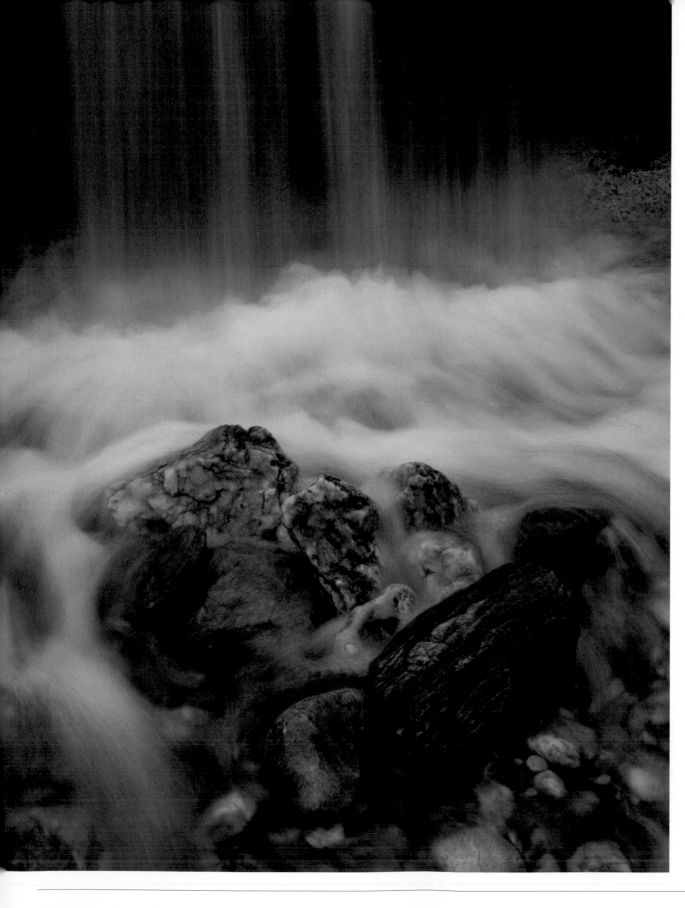

BIGBURY BAY, DEVON, ENGLAND

CAMERA Tachihara 5x4in
LENS Super Angulon 150mm (Standard)
FILM Fuji Provia 100
EXPOSURE 1/2sec at f22
WAITING FOR THE LIGHT Immediate

A Sharp Focus

I was nearing the end of my week in Devon and had managed to produce the grand total of just one photograph, the waterfall (previous page) being my only success. It had been a disappointing and frustrating few days but when it rains, there is little that can be done about it. I normally console myself with the thought that next time will be better and make the best of the situation. Inhospitable weather had prevailed and the week seemed destined to end on a gloomy note. I felt the raw, cold chill of failure run through my bones and, in an effort to raise my spirits, I decided to take a walk along the one part of the bay that I had yet to examine.

Without realizing it, I had unwittingly saved the best for last. This end of the beach was adorned with statuesque rocks and cliffs of a rich and vibrant colour. It was expansive and, weather permitting, I felt sure that there must be a photograph hidden away somewhere, waiting to be teased out from the imposing surroundings. In theory these images should be easy to find but in practice they almost never are. For an attractive rock formation to transfer successfully to film or sensor, there has to be a strong,

distinctive pattern and shape. Symmetry, balance and repetition are the key requirements. Without a discernible uniformity and pattern, the photograph will lack aesthetic quality and will fail to engage the viewer. Finding the right image requires critical observation and an objective assessment of every possible arrangement. There is no shortcut to this and it can be a time consuming but ultimately very rewarding process.

The rain eventually abated and coincided with my discovery of this fascinating piece of weathered, natural sculpture. It was well and truly hidden and took some finding; I could have easily overlooked it but I was concentrating on the search and letting nothing pass me by. Finding it was the result of a painstaking search and methodical assessment but it was, I should add, also my concentration and determination which led to its discovery and it is an inescapable fact that you have to be sharply focused - as sharply focused as your camera - if you are not to miss such opportunities.

81C warming filter

The rich and varied tonal range together with the slightly darker background (which creates discernable space behind the main formation) gives the image depth and realism.

It is essential that the pointed apex occupies a central position. This is the crowning glory of the formation and it has to be given centre stage. Composing the photograph in this manner also portrays a balanced uniformity and gives the eye something to dwell upon.

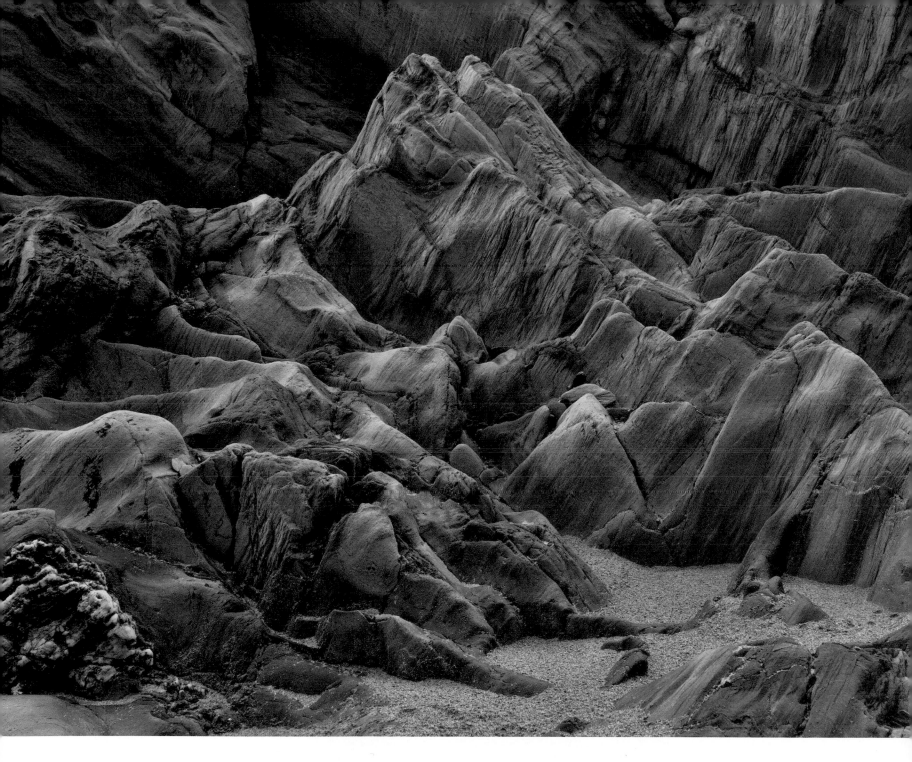

BIGBURY BAY, DEVON, ENGLAND

CAMERA **Tachihara 5x4in**
LENS **Super Angulon 90mm (Wideangle)**
FILM **Fuji Provia 100**
EXPOSURE **1/4sec at f32**
WAITING FOR THE LIGHT **Immediate**

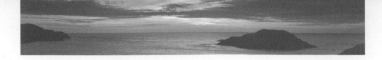

A Dedication

New Brighton is no longer the thriving seaside resort it was in its heyday. The Punch and Judy shows have long disappeared and the town is now mainly a residential suburb, but despite these changes some remnants of the Victorian era have survived the passage of time. One fine example is the old lighthouse which has been lovingly maintained and, standing in an elevated position on a rocky foundation, it is well placed to catch the winter light as the sun sets to the west.

I hadn't intended to take the picture opposite and had travelled to the coast with another photograph in mind, but the combination of the low tide and the fading sunlight drew me towards the lighthouse. The light, the foreground and the sky were all irresistible and I quickly set up and began all the preparations for capturing this exquisite scene. There was a high degree of contrast between the sky and rocks which I reduced by the use of a polarizing filter. I also added an 81C warm filter to improve the colour of both the rocks and sand and then waited for the glow in the clouds to intensify, which I felt sure it would.

It all seemed to be going perfectly to plan when, at the very moment I was poised, ready to make my first exposure, no fewer than three dogs suddenly appeared from behind the lighthouse. They were immediately followed by their owner and I could only watch in horror as the sky, with perfect mistiming, reached its peak. Then, quite miraculously, my unwelcome intruders disappeared as quickly as they had arrived. Once again they were hidden behind the lighthouse and I wasted not a second in taking two images before either they, or the rapidly fading light, brought proceedings to a close.

Overcome with relief I stood for a few moments as dusk descended. As I was packing my equipment away, the dogs returned, together with an elderly gentleman. 'Did you get your picture?' he asked. 'I saw you were taking a photograph and didn't think you'd want us in it. It was lucky this lot were on their lead!' He laughed, nodding towards his dogs. I thanked the man and shook his hand. My relief then turned to gratitude. Never before have I had such an experience and I dedicate this picture to the observant and considerate gentleman.

Polarizer (fully polarized)

81C warming filter

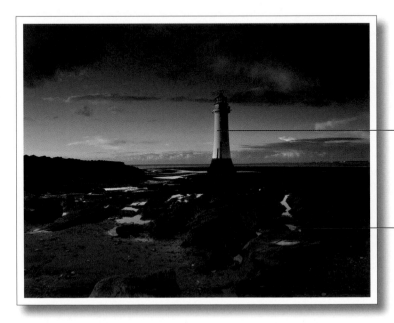

The presence of the lighthouse prevented me from using a ND graduated filter. The polarizer was however a good alternative because it has darkened the blue portion of the sky without affecting the clouds or lighthouse.

In addition to the rocks and sand, the lighthouse and clouds have also benefited from the use of the warming filter.

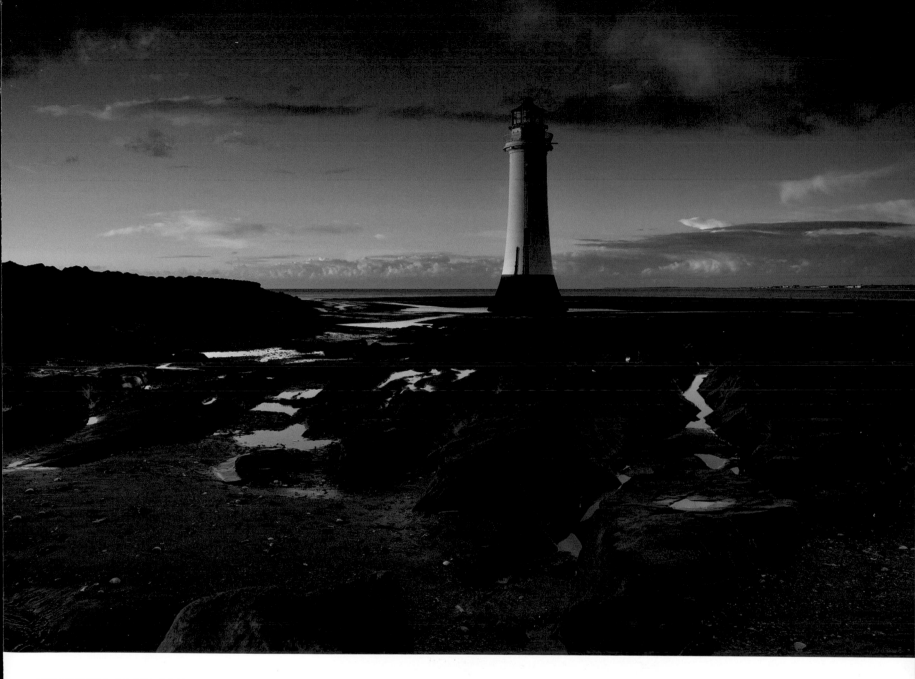

NEW BRIGHTON, WIRRAL, MERSEYSIDE, ENGLAND

CAMERA **Tachihara 5x4in**
LENS **Super Angulon 90mm (Wideangle)**
FILM **Fuji Provia 100**
EXPOSURE **5secs at f22**
WAITING FOR THE LIGHT **15 minutes**

Digging for Gold

Vast stretches of sandy beaches extend along the North Wales coastline from Barmouth all the way to the southern tip of the Lleyn peninsula. It is perhaps for this reason that Llandanwg, overshadowed by other supposedly bigger and better beaches, tends to be bypassed and as a result receives relatively few visitors. This was certainly the case when I spent a few days along this part of the coast early one February. It was a bitterly cold day, which was no doubt a contributory factor to my solitude, but otherwise the weather was agreeable with just a hint of a gentle breeze and a sky that promised a fine end to the day.

Part of the beach is strewn with boulders and I was soon paddling in the rock pools rummaging around for hidden gems. The rocks were an array of different shapes and sizes and I had plenty of choice, which was fortunate, because I am very particular about what I photograph. The stones must be smooth and weathered, colourful, not too big and not too small. They also have to be located on a clean, deserted beach, free of seaweed and be exposed to obliquely angled sunlight at either dawn or dusk.

And of course they have to be positioned in a particular way; ideally there will be a combination of a sprawling expanse and a few fine, individual specimens, distinct from yet still associated with the main group. It might all sound like a tall order but, in the right location and with a little research and careful scrutiny, I can, with luck, usually find what I'm looking for.

Within half an hour or so of arriving at Llandanwg I found, to my delight, what I was hoping to discover. A small rock group surrounded by clear, calm water – in effect a miniature island – was enticingly spotlit by the low winter sun. A warm vibrant glow emanated from the rocky cluster and I watched it intensify as the sun gradually bid its farewell. It was a satisfying moment because it was one of those occasions when no enhancement of colour was necessary and I was able to dispense with the use of a warming filter. That brightly lit slab of rock was quite delightful just as it was; solid gold in appearance, it was absolute pure gold to photograph.

The light has given prominence to the main group of boulders but I have also emphasized them by using a wideangle lens from a close position. This has had the effect of exaggerating their isolation from the surrounding rocks.

Two-stop (0.6) neutral density graduated filter

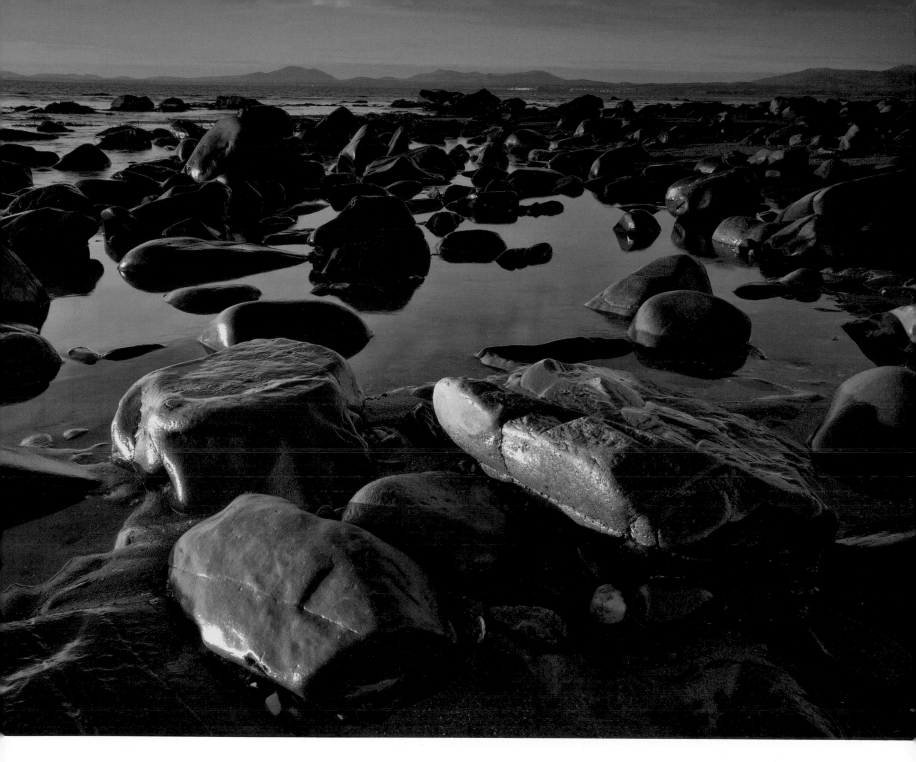

LLANDANWG, GWYNEDD, WALES

CAMERA **Tachihara 5x4in**
LENS **Super Angulon 75mm (Wideangle)**
FILM **Fuji Provia 100**
EXPOSURE **1/2sec at f22**
WAITING FOR THE LIGHT **10 minutes**

Sunrise and sunset

With a clear, uninterrupted view of the horizon, the coast is the perfect place to capture the glory of the rising or setting sun. To maximize the impact and spectacle of the event, choose a rock covered beach with either an easterly or westerly aspect and time your visit to coincide with, as close as possible, a high tide at either sunrise or sunset (as appropriate to the aspect of your location). Watch and wait for the sea to wash over a rocky part of the beach and, using a long exposure of several seconds, attempt to blur the incoming waves as they ripple over the rocks. This will give the water a silky, ethereal quality and will contrast well with the rock covered shoreline. If you then add to this the first or last light of day and a strong sky you will have the ingredients of a fine and distinctive image. A grey (neutral density) graduated filter, if positioned over the sky, will balance the light values between sky and land and will enable the entire image to be correctly exposed, with strong, saturated colour from top to bottom.

Success may at first seem elusive because all the elements have to be perfectly combined and you will be working within a limited time-frame. However, with perseverance, patience and a little luck, you should eventually reap the rewards of your endeavours.

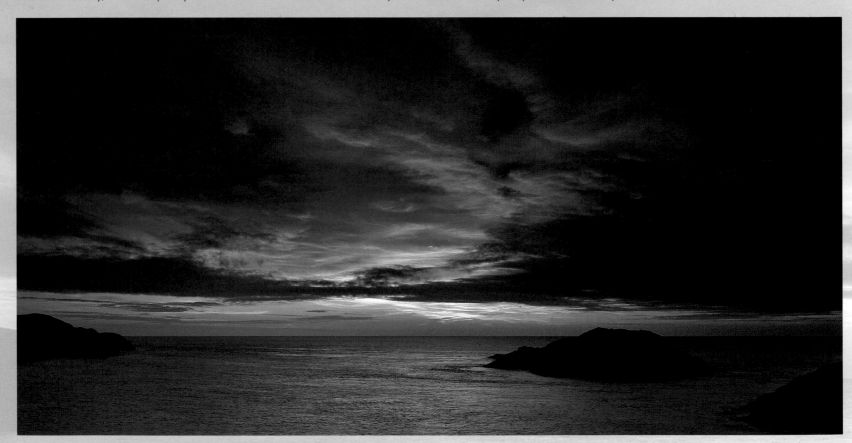

STRUMBLE HEAD, PEMBROKESHIRE, WALES
There was a difference of two stops in the light values of the sky and water. By positioning a two-stop ND graduated filter over the sky and bringing it level with the horizon, I was able to base exposure on the water without losing detail in the cloud structure.

Take a closer look

One of the coastline's most interesting features is its geology and eye catching close-up photographs can be found among the cliffs, rocks and boulders. Look for attractive combinations of colour, shapes, patterns and textures. Consider also themed images, for example subtle tonal variations of just a single colour.

These types of subject should be photographed under soft, diffused light. An overcast sky is therefore perfect which makes the process of capturing these images relatively simple – simple, that is, once they have been found because the real challenge lies in discovering them. A smorgasbord of shapes and colours might look impressive as you stand before it but it won't transfer to your camera. Look instead for clarity and repetition. It is often the case that the less that goes into a photograph, the more the viewer will receive from it and this is particularly the case with this type of arranged landscape. As a rule therefore I suggest you keep the composition and structure of the image simple and easy to comprehend. Success may not be achieved overnight but as with all types of subject your eye and instinct will develop over time with practice and experience, and of course a degree of trial and error.

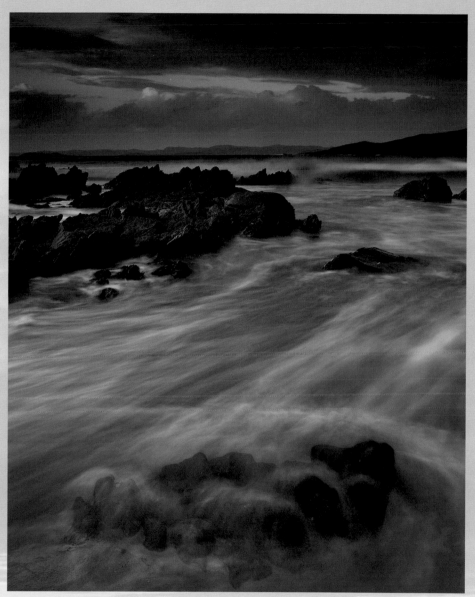

ACHNAHAIRD, ROSS AND CROMARTY, SCOTLAND ABOVE
The four second exposure has blurred and softened the incoming waves. I released the shutter as the waves approached the group of rocks to enable the swirling motion of the water to be captured. I made several exposures that day and they are all quite different in appearance because of variations I made in the timing and length of exposures.

NEAR PORTLAND, MAINE, USA LEFT
Coastal areas can be literally covered with intriguing combinations of colours, shapes and textures. Arrangements of pebbles and shells look attractive when photographed as close-up images with background details excluded from the composition.

Equipment

Cameras
Tachihara 5x4in view camera
Fuji GX617 panoramic
Mamiya RB67
Mamiya 645ZD

Lenses
Super Angulon 75mm, 90mm, 150mm, 210mm
Rodenstock 120mm
Fujinon 105mm, 300mm
Mamiya 50mm, 80mm, 210mm

Filters
Lee ND graduated from 0.3 to 0.75, polarizer, warm 81B and 81C,
soft focus

Exposure Meter
Sekonic spotmeter

Tripods
Uni-Loc Major 2300 and 1600

Viewfinder
Linhof 4x5 Multifocus Viewfinder

Other Facts
Number of days spent in the field: 359 (but not in one year!)
Time spent waiting for the light: 28 days, 8 hours, 42 minutes
Number of exposures made: 322

Useful resources

Camera manufacturers

Canon
www.canon.com

Fujifilm
www.fujifilm.com

Hasselblad
www.hasselblad.se

Kodak
www.kodak.com – Kodak USA
www.kodak.co.uk – Kodak UK

Konica and Minolta
www.konicaminolta.com

Leaf
www.leafamerica.com

Leica
www.leicacamera.com

Mamiya
www.mamiya.com – Mamiya USA
www.mamiya.co.uk – Mamiya UK

Nikon
www.nikon.com

Olympus
www.olympus.com

Pentax
www.pentax.com

Phase One
www.phaseone.com

Sigma
www.sigmaphoto.com – Sigma USA
www.sigma-imaging-uk.com – Sigma UK

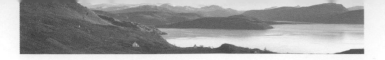

Large format camera manufacturers

Cambo
www.cambo.com

Canham
www.canhamcameras.com

Ebony
www.ebonycamera.com

Gandolfi
www.gandolficameras.com

Linhof
www.linhof.de

Silvestri
www.silvestricamera.com

Sinar
www.sinarcameras.com

Toyo
www.toyoview.com

Walker
www.walkercameras.com

Wisner
www.wisner.com

Wista
www.wista.co.jp

Others

www.adobe.com – software
www.billingham.co.uk – camera bags
www.cokin.com – filters
www.dalsa.com – digital sensor manufacturers
www.epson.com – printers, ink and paper
www.four-thirds.org – new digital standard
www.foveon.com – digital sensor manufacturers
www.gepe.com – slide mounts and related products
www.gossen-photo.com – lightmeters
www.leefilters.com – filters
www.lowepro.com – camera bags
www.lyson.com – inks and papers
www.manfrotto.com – tripods and heads
www.novoflex.com – accessories
www.optechusa.com – straps, pouches and accessories
www.patersonphotographic.com – accessories
www.permajet.com – inks and papers
www.piezography.com – monochrome printing system
www.schneideroptics.com – camera accessories
www.sekonic.co.uk – lightmeters
www.tamron.com – lenses
www.tetenal.com – inks, papers, chemicals
www.tokina-usa.com – lenses
www.vosonic.com – digital image storage and viewers
www.zeiss.com – Carl Zeiss lenses

Maps

For safety reasons, it is a good idea to familiarize yourself with an area before you visit, therefore maps are invaluable. Topographic maps and geographical information are available from:

USA
www.mapsofworld.com/usa
www.usgs.gov
www.themapshop.co.uk

Australia
Geoscience Australia,
www.ga.gov.au

Ireland
www.maps-warehouse.co.uk
www.themapshop.co.uk

Italy
www.mapsworldwide.com
www.italy-weather-and-maps.com

UK
www.ordnancesurvey.co.uk

Tides

If photographing by the coast, make sure you have a timetable for the tide. Worldwide tide information is available from:

The United Kingdom Hydrographic Office
www.ukho.gov.uk

Weather

Check the following websites for weather information:

USA
www.americasweather.com

Australia
www.bom.gov.au

Ireland
www.met.ie

Italy
www.italy-weather-and-maps.com

UK
www.metoffice.gov.uk

Glossary

Angle of incidence The angle between the incident light falling on the subject and the reflected light entering the camera lens.

Angle of view The angle seen by a given lens. The shorter the focal, the wider the angle of view. Together with the subject-to-camera distance, this determines the field of view.

Aperture The hole or opening formed by the leaf diaphragm inside the lens through which light passes to expose the film or sensor. The size of the aperture relative to the focal length is denoted by f-numbers (stops).

Aperture priority Automatic in-camera metering of exposure based on a pre-selected aperture. Exposure is therefore adjusted by changing the shutter speed.

Aspect ratio The ratio of the width to the height of a frame.

Autoexposure (AE) The ability of a camera to recommend the correct exposure for a particular scene.

Autofocus (AF) An in-camera system for automatically focusing the image.

Backlighting Light coming from behind the subject shining towards the camera.

Bracketing Making a series of exposures of the same subject at different exposure settings, typically in steps of ⅓ or ½ stops.

Centre-weighted metering Type of metering system that takes the majority of its reading from the central portion of the frame. Suitable for portraits or scenes where subjects fill the centre of the frame.

Colour cast A variation of the colour of light which causes a distortion in the colour of a photograph.

Colour correction filter A filter that is used to compensate for a colour cast, the most common example being the 81 series of warming filters. *See* ***Warm filter***.

Colour temperature The colour of light is described as having a colour temperature. This depends on a number of factors including its source and the time of day. The colour temperature is measured on the Kelvin scale – lower temperatures produce warmer colours and vice versa.

Contrast The range between the highlight and shadow areas of a negative, print, transparency or digital image. Also refers to the difference in illumination between adjacent areas.

Converging parallels The distortion of parallel lines which appear as converging angled lines. This commonly occurs when a building is photographed with the camera pointing at an upwards angle.

Cropping Printing only part of the available image from the negative, transparency or digital image, usually to improve composition.

Definition The clarity of an image in terms of both its sharpness and its contrast.

Depth of field The zone of acceptable sharpness in front of and behind the point at which the lens is focused. In other words, the amount of the image that appears in focus from foreground to background. This is controlled by three elements: aperture – the smaller the aperture, the greater the depth of field; the camera-to-subject distance – the further away the subject the greater the depth of field; the focal length, the shorter the focal length the greater the depth of field.

Diffuse lighting Lighting that is low or moderate in contrast, such as the light on an overcast day.

Exposure The amount of light reaching the film or sensor. This is controlled by a combination of aperture and shutter speed. Alternatively, the act of taking a photograph as in 'making an exposure'.

Exposure compensation A level of adjustment given to auto-exposure settings. Generally used to compensate for known inadequacies in the way a meter takes readings - for example, positive compensation in situations where the meter will usually recommend a reading that may result in underexposure, such as snow scenes.

Exposure latitude The extent to which exposure can be increased or reduced without causing an unacceptable under or overexposure of the image.

Exposure meter A device either built into the camera or separate with a light-sensitive cell used for measuring light levels, used as an aid for selecting the exposure setting.

Exposure value A single value given for a measurement of light that indicates an overall value that can be reached by a combination of shutter speed and aperture for a particular ISO rating.

Field of view The actual dimensions of the scene that can be captured on film or sensor. This depends on the film/sensor format, the angle of the lens and the camera-to-subject distance.

Flare Non-image forming light reflected inside a lens or camera in an unwanted fashion. It can create multicoloured circles or loss in contrast and can be reduced by multiple lens coatings, low-dispersion lens elements or a lens hood.

Focal length The distance between the film or sensor and optical centre of the lens when focused at infinity.

F-numbers A series of numbers on the lens aperture ring and/or the camera's LCD panel that indicate the size of the lens aperture relative to its focal length. The higher the number, the smaller the aperture.

Frontal lighting Light shining on the surface of the subject facing the camera.

Highlights The brightest part of an image.

Histogram A digital graph indicating the light values of an image.

Hyperfocal distance The closest distance at which a lens records details sharply when focused at infinity. Focusing on the hyperfocal distance produces maximum depth of field which extends from half the hyperfocal distance to infinity.

Incident light Light falling on a surface, as opposed to light reflected from that surface. An incident light meter measures the light before it reaches the surface. Compare with *Reflected light*.

Image sensor The digital equivalent of film. The sensor converts an optical image to an electrical charge which is captured and stored.

ISO rating Measures the degree of sensitivity to light of a film or sensor as determined by the International Standards Organisation. As the ISO number doubles, the amount of light required to correctly expose the film/sensor is halved.

Large format A camera which uses sheet film of 5x4in or larger.

Law of reciprocity A change in one exposure setting can be compensated for by an equal and opposite change in the other. For example, the exposure setting of 1/60sec at f/11 produces exactly the same exposure as value as 1/30sec at f/16. See *Reciprocity failure*.

Medium format Refers to cameras using rollfilm (normally 120 or 220 film), or a digital sensor of equivalent size, that measures approximately 2½in (6cm) wide.

Neutral-density(ND) filter A filter that reduces the brightness of an image without affecting its colour.

Neutral-density graduated filter A neutral density filter that is graduated to allow different amounts of light to pass through it at different parts. These filters are used to even up naturally occurring bright and dark tones. In landscape photography they are commonly used to balance the exposure values of sky and landscape.

Panoramic camera A camera with a frame of which the aspect ratio of width to height is greater than 3:2.

Polarizing filter A filter that absorbs light vibrating in a single plane while transmitting light vibrating in multiple planes. When placed in front of a camera lens, it can eliminate undesirable reflections from a subject such as water, glass or other objects with a shiny surface, except metal. It is also used to saturate colours.

Prime lens A lens that has a fixed focal length.

Reciprocity failure At shutter speeds slower than one second the law of reciprocity begins to fall because the sensitivity of film reduces as the length of exposure increases. This affects different films to different extents, but means that the exposure will need to be increased slightly to compensate.

Reflected light Light reflected from the surface of a subject. The type of light that is read by through-the-lens meters and hand-held reflected-light meters such as spot meters.

Resolution The amount of detail in an image. The higher the resolution the larger the negative, transparency or digital image will be when printed.

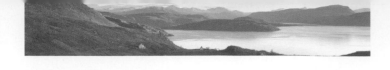

Shutter A mechanism that can be opened and closed to control the length of exposure.

Shutter speed The length of time light is allowed to pass through the open shutter of the camera. Together, the aperture and shutter speed determine the exposure.

Shutter release The button or lever on a camera that causes the shutter to remain open.

Sidelighting Light shining across the subject, illuminating one side of it. The preferred light of most photographers, it gives shape, depth and texture to a landscape, particularly when the sun is low in the sky.

SLR (single lens reflex) A type of camera that allows you to see the view through the camera's lens as you look in the viewfinder.

Soft focus filter A filter used to soften an image by introducing spherical aberration. It is not the same as out of focus and a sharp image is necessary in order for the effect to succeed.

Spot meter An exposure meter that measures a small, precise area. It enables a number of exposure readings to be taken of different parts of a subject and therefore provides a very accurate method of metering.

Standard lens A lens with a focal length approximately equal to the diagonal measurement of the film format. It produces an image approximately equivalent to that seen by the human eye, and equates to the following focal lengths: 35mm for digital APS-C cameras, 50mm for 35mm (film or digital equivalent), 80mm for 645, 90mm for 67 and 150mm for 5x4in.

Telephoto lens A lens with a long focal length and narrow angle of view. When used at a large distance from the subject, a telephoto lens can help create the impression of compressed distance, with subjects appearing to be closer to the camera than they actually are.

Through-the-lens (TTL) metering A meter built into a camera that determines exposure for the scene by reading light that passes through the lens during picture-taking.

Vignetting The cropping or darkening of the corners of an image. This can be caused by a lens hood, filter holder or by the lens itself. Many lenses do vignette, but to a minor extent. This can be more of a problem with zoom lenses than prime lenses.

UV filter A filter that reduces UV interference in the final image. This is particularly useful for reducing haze in landscape photographs.

Warm filter A filter designed to bring a warm tone to an image or compensate for a blue cast which can sometimes be present in daylight, particularly with an overcast sky. The filters are known as the 81 series, 81A being the weakest and 81E the strongest.

White balance A function on a digital camera that allows the correct colour balance to be recorded for any given lighting situation.

Wideangle lens A lens with a short focal length and wide angle of view.

Zoom lens A lens with a focal length that can be varied.

About the author

Peter Watson took up photography as a teenager, concentrating on black and white landscapes, doing his own developing and printing in a home-made darkroom. He sold his pictures in a local art shop, and this early success encouraged him to pursue his hobby more seriously. He began to photograph in colour, still specializing in landscapes, and became a professional photographer in 1988, using large-format equipment (5 x 4in).

Peter is a contributing photographer with Imagestate Colour Library and his work appears in books, magazines, travel guides and calendars, on greetings cards, on CD and DVD covers, in exhibitions and in print and television advertising. As well as landscapes, Peter undertakes commissioned work for clients, primarily architectural and travel photography, in addition to studio work. He also holds practical photography workshops throughout the UK. Peter has previously written three books for Photographers' Institute Press: *Capturing the Light, Light in the Landscape: A Photographer's Year* and *The Field Guide to Landscape Photography*.
www.peterwatson-photographer.com

Acknowledgements

My thanks go to Oli Dujardin of EOPhotos for his ongoing support and assistance, which I greatly appreciate.

I am also indebted to Louise Compagnone of GMC Publications for the immense and invaluable contribution she has made in the production of this book. Thank you Louise, it has been a pleasure working with you.

Index

Captions to photographs are indicated by page numbers in **bold**.

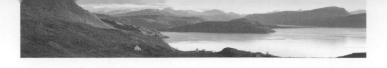

To place an order, or to request a catalogue, contact:
Photographers' Institute Press, Castle Place, 166 High Street,
Lewes, East Sussex BN7 1XU United Kingdom
Tel: 01273 488005 Fax: 01273 402866
www.pipress.com